OSE SCHOOL

Hogarth and the
Times-of-the-Day Tradition

Hogarth and the Times-of-the-Day Tradition

By SEAN SHESGREEN

CORNELL UNIVERSITY PRESS · *Ithaca and London*

Copyright © 1983 by Cornell University Press

All rights reserved. Except for brief quotations in a review, this book,
or parts thereof, must not be reproduced in any form without permission
in writing from the publisher. For information address
Cornell University Press, 124 Roberts Place, Ithaca, New York 14850.

First published 1983 by Cornell University Press.
Published in the United Kingdom by Cornell University Press Ltd.,
Ely House, 37 Dover Street, London W1X 4HQ.

International Standards Book Number 0-8014-1504-7
Library of Congress Catalog Card Number 82-71597

Printed in the United States of America

*Librarians: Library of Congress cataloging information
appears on the last page of the book.*

*The paper in this book is acid-free, and meets
the guidlines for permanence and durability of
the Committee on Production Guidelines for Book Longevity
of the Council on Library Resources.*

Contents

Illustrations

Preface

THE scholarship on William Hogarth in this and previous centuries
has been of a broad cultural, historical, and biographical nature.
As a result recent studies have tended toward increasingly precise
scrutinies of particular progresses and individual works. Arthur S.
Wensinger and W. B. Coley's *Hogarth on High Life: The* Marriage à la
Mode *Series from Georg Christoph Lichtenberg's* Commentaries (1970)
offers a comprehensive critical account of a single progress, placing it
within Hogarth's canon and demonstrating its relationship to tradi-
tional historical genres. Hildegard Omberg's *William Hogarth's* Portrait
of Captain Coram: *Studies on Hogarth's Outlook around 1740* (1974) de-
scribes Hogarth's oeuvre, attitudes, and ideas in the crucial years
of the mid-century, all with reference to a single work of art. My
work here establishes the historical nexus of an ensemble of
Hogarth's paintings and engravings composed of eleven separate
designs. It chronicles a venerable tradition in the history of art
which, despite its richness and importance in painting and poetry,
was not the subject of scholarly investigation until such recent
books as Nicolas J. Perella's *Midday in Italian Literature* (1979). In
addition, it shows how Hogarth's ensemble is a response to and
commentary on this theme and its varied history.

By isolating a body of Hogarth's works small enough to be exam-
ined in detail and by demonstrating how it reflects contemporary
reality and certain developments in the history of art, this book

illuminates the relation between tradition and the individual talent as expressed in the life and art of a major eighteenth-century figure. In its treatment of convention and innovation, this book shares the concern of Ronald Paulson's *Emblem and Expression* (1975), which contrasts in general terms traditional iconography with its reinterpretation in the Hogarthian progress; it also shares the focus of Wensinger and Coley's *Hogarth on High Life,* which contrasts in a less detailed way traditional and modern history painting with reference to *Marriage à la Mode.*

I am grateful to the following institutions and bodies for permission to publish reproductions of artworks in their care: the Bibliothèque Royale, Brussels; The Newberry Library, Chicago; the Trustees of the British Museum; The National Trust (Bearsted Collection, Upton House); The Huntington Library, San Marino, California; and the Rijksmuseum, Amsterdam, where Mrs. D. de Hoop Scheffer was most helpful. This book was completed with the aid of grants from the American Philosophical Society and from the Graduate School and the College of Liberal Arts and Sciences at Northern Illinois University. I am especially appreciative of the support of Jon Miller of the Graduate School and James Norris, who comes as close as possible to being an ideal dean of liberal arts and sciences. Samuel Huang, James Newburg, Robert Fischer, and Myrtie Podschwit of Founders' Memorial Library here on campus responded to my many queries with promptness and diligence, and I am in their debt.

My colleague Philip Dust translated the Latin verses that accompany the prints of Vos, van Mander, and Verhaecht, and my friend Grier Davis those of Stevens, van de Velde, and de Passe. It is a special pleasure to acknowledge those who took time to read the manuscript and comment upon it. Jeffry Spencer and Robert Lang helped me with the first draft. Stephen Kern and Gustaaf van Cromphout assisted me with countless problems of detail. Samuel Kinser offered me a useful critique of the penultimate draft, and James Smith, Christopher Lee, and Deirdre Shesgreen helped at every stage of the work. David Scott Moore and Ann Bates Congdon assisted in the preparation of the manuscript for the publisher in the busy days immediately prior to my departure for Xian Foreign Languages Institute. Ann Bates Congdon prepared the index. To all these friends, I am thankful.

This book is dedicated to the memory of my mother, Ruperta Regan Shesgreen.

<div align="right">SEAN SHESGREEN</div>

DeKalb, Illinois

Hogarth and the
Times-of-the-Day Tradition

$$\left\{\!\left[\; 1 \;\right]\!\right\}$$

Introduction

I

ENDURING art arises from the tension between traditional and individual forces. While the aesthetic heritage plays a vital role in the process by which a work comes into being and in its final shape, no vital art can draw its inspiration and its subject matter exclusively from other art, as André Malraux has argued in *Les voix du silence* (1953).[1] Tradition and creativity are rivals; from the productive struggle between them come the masterpieces of literature and the visual arts.

The tension between the conventional and individual aspects of art is nowhere more important than in satire, where individual referents are drawn more from the broad social interests of the artist rather than from his or her personal concerns. In satire, the obvious mimetic functions of a work of art often obscure its formal referentiality: social commentary will always be expressed by means of aesthetic tradition no less than in terms of the artist's perception of contemporary reality. Evidence for this view is to be found in what happens when the balance between formal and

1. André Malraux, *Les voix du silence* (Paris: La Galerie de la pléiade, 1953), pp. 279, 310, 313.

social elements is lost in a given work. At one extreme, if a satire has an imbalance in favor of its social referents, it may—among other things—appear as a biting documentary or an especially mordant form of journalism. At the other extreme, if a work of art has an imbalance in favor of its formal referents, it may appear as an academic piece in the narrowest sense of that term. Or it may seem nothing more than a footnote on a technical nuance in the history of art itself. When formal and social referents are in harmony in a work, they constitute the source of its power. Both act and react together, cooperating in the creation of a meaning more varied and rich than can be ascribed to either one individually.[2] Each galvanizes the other and vivifies it, extending its scope at the same time as it intensifies its meaning.[3]

From the point of view of the critic, the formal-social duality of satire is so fundamental that it must inform any approach to a work of art. Failure to take either of these aspects into account can only lead to the most basic kinds of misreading. The critical material surrounding William Hogarth's *Four Times of the Day* offers an instructive example of the distortions that result when a work of art is interpreted without reference either to its formal history or to the way its critique of artistic conventions is subtly intertwined with its many-pronged topical satire—in the case of Hogarth's unique ensemble, its commentary upon social conditions and its humorous reflection of certain well-known London settings.

II

The Four Times of the Day was Hogarth's principal achievement in oil (1736) and on copper (1738) in the late 1730s, when he was reaching the pinnacle of his artistic powers. Its critical history has been dominated by the presumption that this cycle, like all of Hogarth's others, is an original work for which there are no formal referents or models of any kind. Horace Walpole best articulated this presumption when he described Hogarth as a "great" and "original" genius, indebted neither to models nor to books for what he produced but rather drawing his style, thought, and forms directly from observation of "nature" and from his own fecund imagination. "Hogarth had no model to follow and improve upon. He

2. I. A. Richards, *The Philosophy of Rhetoric* (New York: Oxford University Press, 1936), p.100.
3. Arthur Pollard, *Satire* (London: Methuen, 1970), p.33.

created his art; and used colours instead of language," wrote the amateur art critic and connoisseur in his *Anecdotes of Painting in England* (1762–1771). "He could not bend his talents to think after any body else. He could think like a great genius rather than after one."[4] Walpole's influential impression, with its emphasis on critical concepts like "originality" and "genius," reveals his dependence on Edward Young's *Conjectures on Original Composition* (1759) and on the fashions of literary study in England at mid-century more than it illumines the context or character of Hogarth's art. This deceptively flattering judgment conceals within it the anti-intellectual implication that Hogarth was ignorant of the traditions of his own discipline. Walpole himself draws out this implication in the same essay when he charges Hogarth with "having never studied, indeed having seen, few good pictures of the great Italian masters . . .";[5] subsequent eighteenth-century commentators seldom failed to repeat this judgment, the effect of which was to affirm subtly their own superiority over the artist.

As a consequence of Walpole's assertion and its many modern restatements, readings of *The Four Times of the Day* have viewed the progress as exempt from that formal determinant of art adverted to by Hogarth himself when he observed in his *Apology for Painters* that "all painting, it is true, is but Imitation [of other painting]."[6] Ranked in importance with the *Harlot's Progress*, the *Rake's Progress* and *Marriage à la Mode*, the *Times of the Day* has long been the subject of popular and critical acclaim. However, it has been viewed within a framework of assumptions which has continued, with little interpretive variation or development, to assert the independence of the progress from all forms and conventions, excepting perhaps certain literary models. A victim of the sociologizing tendency of historians and critics to regard pictures of all kinds as illustrations of the contemporary scene, the suite was received by its first commentators as a journalistic narrative of London life and as a work of art having affinities of the most general kind with

4. Horace Walpole, *Anecdotes of Painting in England*, IV (London, 1782), 148, 153.
5. Ibid., 166.
6. William Hogarth, *Apology for Painters*, ed. Michael Kitson, *Walpole Society 1966–1968*, 41 (Glasgow: The University Press, 1968), 92. For an account, more balanced than Malraux's, of how art grows out of, builds upon, and criticizes other art, see Sir Ernst H. Gombrich, *Art and Illusion* (New York: Pantheon, 1960). For the chief modern restatements of Walpole's view, see Frederick Antal, *Hogarth and His Place in European Art* (New York: Basic Books, 1962); "Hogarth and His Borrowings," *Art Bulletin*, 29 (1947), 36–48; Joseph Burke and Colin Caldwell, *Hogarth: The Complete Engravings* (New York: Abrams, 1968), p. 19; Ronald Paulson, *Hogarth's Graphic Works*, rev. ed. (New Haven: Yale University Press, 1970), I, 33.

nature poetry describing the day's progress from dawn to dusk.[7] In his *Hogarth Moralized* (1768), John Trusler, the first person to comment systematically on all the artist's major progresses, read the *Times of the Day* as a satire upon pastoral poetry and an account of the British capital so accurate that it would serve to acquaint people who had never been in London with the city's life:

> Poets have been frequently luxurious in their rural descriptions of the different parts of the day, and by a faithful delineation of nature, have pleased the imagination and delighted the understanding. Our Author, in the prosecution of his studies in the sister art, has, in his turn, given us a humourous representation of such scenes as occur, at those particular times in the metropolis; which may serve as a burlesque to the other, and will give those who have not an opportunity of being present, some idea of what passes without the circle of their knowledge.[8]

In the fortunes of a work of art, the first critical opinions to appear in print frequently are more influential than they deserve to be. This axiom holds true in the case of the commentary of John Ireland, the great admirer and collector of Hogarth's works. In opposing his *Hogarth Illustrated* (1791) to Trusler's *Hogarth Moralized*, Ireland thought to illuminate the satirist's art by means of a commentary that was analytical and historical rather than primarily didactic; however, the opinions of his predecessor proved more insidious than he imagined, and he often ended up repeating or elaborating upon them. When he came to write about the background of the *Times of the Day*, he described it as poetic, just as Trusler had: "In the series before us, he treads poetic ground. A description of *the day*, particularly *the morning*, has been generally deemed the *bard's* peculiar province."[9] And when he turned to the progress itself, he shifted ground only a little when he praised it for its accurate reflection of London's sartorial fashions and social customs: "In Mr. *Hogarth's* Four Times of the Day, there is only one scene laid out of town; and that may, I think, be properly enough called a *London pastoral*, for it is in the pleasant village of *Islington*. The three others are described as in the most public parts of the metropolis, and exhibit a picture which will give a very correct idea of the dresses and pursuits of London in 1738."[10]

7. Arnold Hauser, *The Philosophy of Art History* (New York: Knopf, 1959), p. 3.
8. John Trusler, *Hogarth Moralized* (London, 1831), p. 155.
9. John Ireland, *Hogarth Illustrated*, 2d ed., I (London, 1793), 127.
10. Ibid., 129.

In the course of the nineteenth century, a quiet time for Hogarth studies, *The Four Times of the Day* evoked little critical curiosity. It is fair to say that the further into the past that Georgian London receded, the more critics identified *Morning, Noon, Evening,* and *Night* as its transcripts. This trend reached something of a climax in the present century. Marjorie Bowen characterized the pictures as "essentially London scenes, treated very satirically"; Peter Quennell had much the same thing to say: "With *Times of the Day* we return to London; and none of Hogarth's London impressions is more evocative of the spirit of time and place than the first of the series, which he entitled *Morning.*"[11] And Geoffrey Grigson went about as far in this direction as he possibly could when he stamped the cycle's first design "the authentic London of Hogarth's visual experience."[12]

The recent renaissance in Hogarth studies, which began about the time of Quennell's *Hogarth's Progress* (1955), has been dominated by the scholarship of Ronald Paulson. Paulson has brought fresh, provocative perspectives to virtually every work in Hogarth's oeuvre and has singled out *The Four Times of the Day* for special attention, declaring that the artist "never produced better work than these paintings, as exemplified by *Morning.*"[13] Paulson's greatest contribution to an understanding of this cycle has been his explication of its panorama of temporal themes and structural contrasts:

> These four pictures represent Hogarth's 'town pastorals', progressing from winter to autumn, dawn to midnight, and youthful freedom (compare the cold adult presence of the old lady in 'Morning') to aged freedom, with grown-ups playing like children with wooden swords and masonic regalia; from young couples kissing to errant husbands and magistrates drunkenly wending their way home after masonic ceremonials. The scenes are all structured on a contrast between the straight lines, closures, controls, and supports of the architectural structures, repeated in the rigid old church-goers, who carry with them their own confining chambers, and the cheerful, messy crowd of people doing their own thing.[14]

11. Marjorie Bowen, *William Hogarth: The Cockney's Mirror* (New York: Appleton-Century, 1936), pp. 190–191; Peter Quennell, *Hogarth's Progress* (New York: Viking, 1955), p. 149.

12. Geoffrey Grigson, *Britain Observed* (London: Phaidon, 1975), p. 42.

13. Ronald Paulson, *Hogarth: His Life, Art, and Times* (New Haven: Yale University Press, 1971), I, 405.

14. Ronald Paulson, *The Art of Hogarth* (London: Phaidon, 1975), p. 12.

While Paulson's classification of this suite as "town pastorals" is particularly illuminating in a formal vein, his specification of other analogues, referents, and sources is on the whole less helpful. In the visual arts, he points to Pieter Bruegel's work: "An analogue for paintings like these would be something like Bruegel's *Battle of Carnival and Lent* (Vienna, Kunsthistorisches Museum)."[15] In literature, he identifies John Gay's *Trivia* as conceptually important[16] and Henry Fielding's drama as an antecedent, though his tone here lacks its characteristic conviction:

> In vague and uncertain ways Hogarth's whole project [*Strolling Actresses*] owes something to Fielding's *Tumble-down Dick, or Phaeton in the Suds* of 1736. This most flagrant of all Fielding's travesties apparently made a strong impression on Hogarth; many of its elements appear in one form or another in the five prints he published in 1738 [*Times of the Day* and *Strolling Actresses*]. It was, with its emphasis upon the reality of stage properties, the play of Fielding's that most inspired *Strolling Actresses*. . . . But Fielding's farce also introduces a rascally justice, once again (as in *Rape upon Rape*) based on the notorious Thomas De Veil, and in close proximity to him songs about gin and allusions to the Gin Act of 1736; the justice indeed ends the play as a merrily-singing Harlequin, materializing his true personality. There are also a barber shop and a cuckolded cobbler quarreling with his wife. *The Four Times of the Day* could have been put together from such hints.[17]

Other recent Hogarth commentators, such as Derek Jarrett and Jack Lindsay, ignore the question of formal referents, on the conventional assumption that *The Four Times of the Day* is a reportorial account of London life, a kind of four-part journal of eighteenth-century urban manners, executed in a vivid but untutored slice-of-life realism.[18]

III

Literary models, analogues, and parallels of the kind proposed by Paulson and previous commentators are not the only source for an understanding of the conception and meaning of Hogarth's *Times of the Day*. Useful as these literary texts are, they serve chiefly to

15. Ibid., commentary to pl. 52.
16. Paulson, *Hogarth: His Life, Art, and Times*, I, 403.
17. Ibid., 398.
18. Derek Jarrett, *The Ingenious Mr. Hogarth* (London: Michael Joseph, 1976); Jack Lindsay, *Hogarth: His Art and Life* (London: Hart-Davis, 1977).

establish a connection of taste and a community of interest without explaining the program of the four pictures and establishing the formal category of art to which they were intended to belong. As a consequence, our present understanding of this progress and its satellite pictures is necessarily partial and incomplete. For while the series' social referents appear to have been largely identified by those critics who regard the cycle as a humorous documentary of London life, its formal referents have neither been acknowledged nor chronicled, even though they constitute a recognized tradition with its own history. This neglect calls for redress on a number of accounts. A full familiarity with the formal referents of Hogarth's *Times of the Day* is essential to an understanding of its diminution of other works of art. And because formal and social referents cannot be separated entirely, a knowledge of the progress's art historical context has the effect of uncovering and vivifying aspects of its social comedy which, until now, have been ignored or not fully appreciated. This cycle is simultaneously a reflection of a concrete landscape, a commentary on contemporary social realities, and an attack on artistic themes and conventions that had become stale by mechanical repetition. It is precisely the coexistence of these different but closely related and interwoven levels which constitutes the complex nature of the visual satire of Hogarth—and the literary wit of Jonathan Swift in such poems as "A Description of the Morning," with its topographical, social, and formal perspectives. Finally, quite apart from Hogarth's ensemble, the times of the day or *points du jour* is a rich (or overrich) tradition: one of the great commonplaces of thought and expression deserving of study in its own right. Begun in Greece and crystallized in Rome, the times-of-the-day theme became a leitmotif in the art of the sixteenth and seventeenth centuries. Widely known, widely admired, and widely practiced, this topos was at once an open invitation and a standing challenge to artists of these periods and one that engaged the energies of such different people as Michelangelo Buonarotti, Martin de Vos, Carl van Mander, Jan van de Velde, Nicholas Berchem, Claude-Joseph Vernet, Francis Wheatley, and Alphonse Mucha.

The times-of-the-day tradition is as venerable as that of the four seasons. Since the natural day can be divided into any of a number of parts with equal logic, the notion of four periods may have evolved gradually on the basis of an analogy with the seasons. In Western art the theme reaches back at least as far as the early classical period (475–450 B.C.) in Greece when Eos, Helios, Selene, and Nyx appear separately on Attic red-figure vases to represent in lyrical terms the values, moods, conditions, and feelings the

Greeks associated with the different periods of the day.[19] Toward the end of the fourth century B.C., when genuine allegorical representation becomes more and more common with the decline of classical Hellenic culture, the cosmic deities who personify diurnal time appear (often in pairs) in eschatological roles on Attic and later on Italian red-figure vases—most frequently on volute craters—where they conjure up imaginatively the melancholy pleasures of remembrance. As the divinities of morning and evening, of day and night, they depict the progress of the natural day from its "birth" to its "death" and so allegorize the entire course of human life, perpetuating in universal terms the earthly memory of the person in whose honor the vase was bestowed.

By the second century A.D. the four deities of the heavens had migrated from Greek to Roman funerary vases and thence to Roman sarcophagi, where they typically appear together. This presentation clearly symbolizes the Roman belief in the afterlife as an elevation to an entirely different sphere of existence, in contrast to the dreary prolongation of earthly life which so many of the Greeks had imagined. Faith in celestial immortality was elaborated and propagated by Pythagoreans and Platonists to become widespread by the first century A.D. As a result of the new emphasis on a heavenly afterlife, the significance of the celestial deities in funerary imagery becomes prospective instead of retrospective: before the second century A.D. the gods and goddesses were images of the departed person's past life on earth; subsequently they became emblems of his or her future life after death.[20] According to this prospective or forward-looking eschatology, the deities who preside over the parts of the day are allegories of the deceased person's soul. By appearing to die at the end of their cycles to be born again with renewed vitality, the celestial luminaries dramatize the fate of the human spirit that flees this world when the flame of life is extinguished only to have that flame rekindled more brilliantly after its ascent to the luminous realm of the gods and goddesses, who are the source of all light.[21]

The definitive codification of the "times of the day" as a single artistic ensemble occurs in the Renaissance and is the work of Michelangelo Buonarotti. His statues *Aurora, Giorno, Crepuscolo,*

19. For a general survey of this topic, see Eduard Gerhard, "Ueber die Lichtgottheiten auf Kunstdenkmaelern," *Gesammelte akademische Abhandlungen und kleine Schriften,* I (Berlin, 1866), 143–156.

20. Erwin Panofsky, *Tomb Sculpture* (New York: Abrams, 1964), p. 14.

21. Franz Cumont, *Recherches sur le symbolisme funéraire des romains* (Paris: Paul Geuthner, 1942), pp. 64–103.

and *Notte* for the sarcophagi in the Medici Chapel, San Lorenzo, Florence, revive the ancient allegories in their eschatological roles, transforming them from remote, deterministic powers that preside over the fate of the soul to personifications of time in naked human form. On the Medici tombs, the *Allegories* show the four periods of the day as mere mortals who suffer and die. As emblems of time, the figures are vanquished by Christianity, which triumphs over them through its unique promise of an immortality that is personal.

Michelangelo's *Allegories* inaugurated a tradition of interpreting the four periods of the day, which was to find its most dramatic success not in sculpture but in engraving, painting, and drawing. The first expression of this theme in the graphic arts occurred in the countries of Northern Europe which were England's immediate predecessors in bourgeois preeminence. Appearing in Flanders in the second half of the fifteenth century, it was interpreted with greatest frequency and imagination by Dutch draftsmen and engravers in the early seventeenth century. The set piece expressing this theme, which was called the *"points du jour"* by artists of the baroque period, represents morning, noon, evening, and night in three principal ways, as allegorical genres, landscapes, and mythological allegories. Though it first appeared in the Low Countries, it soon spread to Germany and to France, where it was popular in the late sixteen and early seventeen hundreds and took the form of courtly *fêtes galantes* in the manner of Boucher.

Hogarth's *Four Times of the Day* belongs to the *points du jour* as that topos is represented by its three chief strains in Dutch and Flemish art. In this, its native aesthetic milieu, his progress stands as a satire on what, by the late seventeenth century, had become a stale set piece in style and content. Ranked as the foremost of his paintings in *The Battle of the Pictures* (issued in February 1744/5 as a bidder's ticket for an auction of nineteen of Hogarth's major oils),[22] the progress is a condemnation of certain interpretations of a theme in the history of art made banal by the mechanical imitation

22. In 1752 the English Parliament replaced the Julian calendar with the Gregorian. Eleven days were dropped from the year (thus the banner "Give us our Eleven Days" in Hogarth's *Election Entertainment*), and the beginning of the new year was changed from March 25 (called "Lady Day" and commemorating, nine months before Christmas, the conception of Christ) to January 1. Dates from January 1 through March 25 prior to 1752 are here expressed in terms of both the old calendar and the new. Thus "February 1744/5" indicates that the year was 1744 under the Julian calendar ("Old Style") but 1745 under the Gregorian ("New Style").

of past models. In addition it is a repudiation of the conventional messages which the times-of-the-day tetralogy offered: its ideological perspective with its idealized conception of nature, its high appraisal of mythology, and its optimistic view of man's place in the cosmos. The cycle is also an attack on the corruptions Hogarth saw growing out of these messages, the fashionable tastes they nurtured, and the kind of social conduct he felt they must foster. But this cycle not only treats the subject of artistic imitation, it is itself an imitation. So while it addresses the question of slavish copying of style and content, it also demonstrates concretely how an understanding of a given tradition and its spirit can lead to genuine innovation. As both a retrospective critique and a new interpretation of the *points du jour*, Hogarth's *Morning, Noon, Evening,* and *Night* serve as a compelling if iconoclastic invitation to a survey of the times-of-the-day theme.

<center>IV</center>

In *Pagan Mysteries in the Renaissance,* Edgar Wind remarks that of the many historical disfigurations to which art has been subjected, one of the saddest is that pictures which were conceived in a cyclical spirit have come down to us as solitary paintings.[23] *Strolling Actresses Dressing in a Barn* (Fig. 42), perennially popular among Hogarth's prints and justly esteemed by Walpole as that unique picture "which for wit and imagination without any other end, I think the best of all his works," was painted around 1737, during the same period as *The Four Times of the Day* (oils, Figs. 34–37; prints, Figs. 38–41); all five oils were engraved together and published simultaneously as a suite of prints in 1738.[24] Not only was this seemingly miscellaneous collection of prints issued under one subscription and sold as a unit; it was characterized by Hogarth, in carefully chosen words, as a "set." In his publication announcement in the *London Daily Post and General Advertiser,* he identified the group of prints not as *The Four Times of the Day* and *Strolling Actresses* but as "a Set, Five Prints, four of which represent in a humorous Manner, the Four Times of the Day, and the fifth a Company of Strolling Actresses dressing themselves for the Play in a Barn," thus specifying all the engravings as a single ensemble.[25]

23. Edgar Wind, *Pagan Mysteries in the Renaissance* (1958; rpt. New York: Norton, 1968), p. 129.

24. Walpole, IV, 156.

25. *London Daily Post and General Advertiser,* 4 May 1738. The notice is repeated with considerable frequency through 17 May 1738.

Furthermore, a superior sense of purpose and unity was implied by the fact that the set was issued under the banner of *Boys Peeping at Nature*, the "subscription ticket" or pictorial receipt used to acknowledge deposits upon engravings of the *Harlot's Progress*. A kind of artistic manifesto, this small but historically significant print was created to usher in Hogarth's new art form and to underline its special features, its penetrating realism and its aesthetic iconoclasm.

Some scholars have connected *Strolling Actresses* with the Licensing Act of 21 June 1737, authored by Sir Robert Walpole to stifle opposition playwrights.[26] Others have paired it with *Southwark Fair* (January 1733/4) and viewed both pictures either as imaginative satires devoid of Hogarth's characteristic didacticism or as statements about the metaphor of life as a stage.[27] As a final part of the argument of this book, I wish to suggest that while *Strolling Actresses* is, on one level, a social satire with a number of topical allusions (some of which—including the reference to the Licensing Act— have been identified and some of which remain unrecognized), the engraving is, on another level, a commentary on the same kinds of pastoral and mythological paintings and engravings that are the targets of *The Four Times of the Day*. Like *Morning, Noon, Evening,* and *Night, Strolling Actresses* satirizes contemporary history painting; it too claims that this genre by its overborrowing and redundancy has come to resemble Alexander Pope's famous mock rainbow, "the reflection of a reflection."[28] Like *The Four Times*, this witty, teeming engraving makes certain connections between corruption in art and corruption in human behavior. With *Boys Peeping at Nature, The Battle of the Pictures,* and *Times of the Day, Strolling Actresses* forms one coherent artistic unit designed to educate native connoisseurs, collectors, and painters, whom the satirist considered naive in aesthetic matters, no doubt because Puritan antipathy to the visual arts had inhibited the development of such matters in seventeenth-century England. Proclaiming Hogarth's new program for English art, this single structure with its many different designs identifies and addresses certain central ethical and methodological issues in eighteenth-century aesthetic thought, issues that involve the subject matter and the proper function of art and the role of imitation in the

26. Quennell, p. 148; Austin Dobson, *William Hogarth* (London: Heinemann, 1902), p. 59.

27. Bowen, pp. 194–195; Paulson, *Art of Hogarth,* commentary to pl. 48.

28. Alexander Pope, "'The Preface of the Editor' to *The Works of Shakespeare* (1725)," *Eighteenth-Century Critical Essays,* ed. Scott Elledge (Ithaca: Cornell University Press, 1961), I, 279.

creative enterprise. These concerns have provided the substance for recurring and vexed debate throughout the history of British painting.[29]

29. For a discussion of how imitation underlined the commercial value of old master works and threatened the livelihood of contemporary artists, see Kathleen Nicholson, "Turner's 'Appulia in Search of Appulus' and the Dialectics of Landscape Tradition," *Burlington Magazine*, 122 (1980), 679–686.

The "Times of the Day" in Graphic Art

THE first task of this book is to explore the history of the "times of the day" as an aesthetic form. No attempt is made to provide an exhaustive formal history. The times-of-the-day topos, protean in its capacity for adaptation, changes with fascinating ease, and this adaptability helped perpetuate the tetralogy to create a rich, extended course of reiteration. In the face of an overwhelming amount of material and some repetition, my survey is restricted to a selective retracing of examples that are central or typical, or that exhibit special facets of the interplay between the tradition and the individual works of art within it. Even though the culmination of this study is a reinterpretation of Hogarth's *Times of the Day* in the new light of the *points du jour*, there is no implication in what follows that the English artist was familiar with all the examples discussed; the task here is to construct an account of the *points du jour* theme based upon works of art that illuminate its history, evolution, and scope.

The "four times of the day" is a popular allegorical theme, one of a group that are paradigms of aesthetic expression. It belongs with such rhetorical set pieces as the four ages of man, the five senses, the four temperaments, and the four seasons. Its popularity in the sixteenth and seventeenth centuries and its continued acceptance

up to the end of the nineteenth century are attributable to its special character. Its subject is time, and time is not only one of the most enduring of human preoccupations, it is one of the most variable. The interpretive possibilities of time appear in the variations on temporal themes within the *points du jour:* the transitoriness of earthly existence, the cyclical character of man's and nature's lives, the moments of abiding significance in the daily life of men and women of all classes, the vast epochs in the world's "progress" from an Eden to a wasteland. But the "times of day" is not limited to temporal subjects, broad and inviting though they may be. By its nature, the trope is a general set piece, with parameters that are wide and an outline that is sketchy and abstract. Its abstraction facilitated adaptation and metamorphoses and encouraged the development of new interests and new perspectives. The *points du jour* was equally adaptable for promoting the revival of interest in the antique and for investigating the narcissistic concern of the artist with his own craft. Besides offering the possibilities of a subject matter ranging all the way from the lyric to the epic, the four-part cycle held the potential for a broad spectrum of aesthetic and dramatic effects involving earth, sky, light, and the human figure.

I

The *points du jour* has its modern beginnings in Michelangelo Buonarotti's *Allegories* for the Medici Chapel.[1] The numerous and varied reproductions, copies, and interpretations of these monuments offer vivid evidence of the fascination that their enigmatic, tortured beauty held both for the sculptor's contemporaries and for artists of all subsequent periods, from Daniele da Volterra on.[2] The first artist to translate Michelangelo's *Aurora, Giorno, Crepuscolo,* and *Notte* into independent graphic form was Martin de Vos (1534–1603).[3] Vos's *Four Times of the Day* (Figs. 1–4), executed

1. For a rare example of the "Four Times of the Day" in medieval art, see J. E. Cirlot, *Dictionary of Symbols,* 2d ed. trans. Jack Sage (1962; rpt. New York: Philosophical Library, 1971), pl. XXXII; it is placed in the twelfth century by James C. Webster, *The Labors of the Months* (Evanston: Northwestern University Press, 1938), p. 87, catalogue 89.

2. Charles de Tolnay, *Michelangelo,* III, *The Medici Chapel* (Princeton: Princeton University Press, 1948), 155–156; Claus Virch, "A Study by Tintoretto after Michelangelo," *Metropolitan Museum Bulletin,* 15 (1956), 111–116; David R. Coffin, "Tintoretto and the Medici Tombs," *Art Bulletin,* 33 (1951), 119–125.

3. A useful thumbnail sketch of the development of the *points du jour* in the sixteenth and seventeenth centuries is provided by J. Richard Judson, *Dirck Barentsz.* (Amsterdam: Van Gendt, 1970), pp. 84–86.

about 1562, was engraved by four different artists:[4] Jan Sadeler and Adrian Collaert in the Low Countries, and Paul Fürst and Gregorius Fentzel in Germany.[5]

Collaert's (c. 1560–1618) prints after Vos's original drawings juxtapose the allegorical, the sculptural, and the idealized Italianate idiom of the top register against the generic, the pictorial, and the detailed Northern interest of the bottom.[6] This formula of counterpointing the monumental allegory and the many-faceted landscape is borrowed from a series of depictions called the "planet pictures," visual codifications of astrological lore which show the deities of the heavens riding chariots across the skies and, below them, the people whose destinies they govern and whose temperaments, callings, and social circumstances they determine.[7]

The landscapes of Vos's *Times of the Day* contain a repertory of spatial motifs and metaphors, many inherited from medieval painting and Renaissance engraving. Executed from high points of view and resembling pictorial maps, these mannerist fusions stretch into fantastic mountains where imposing if diminutive castles stand against the horizon and dominate the countryside much as the Duke of Berry's chateaux do in the *Très Riches Heures*.[8] A toylike *staffage* (the human figures and animals enlivening the scene) proliferates throughout the landscapes, which, in the final analysis, are not depictions of nature but pictorial arrangements that allow for a rich accumulation of detail. The engraved prints are accompanied by verses filled with literary abstractions to match the dominant visual personifications. These texts offer explications of the prints' actions and themes. Often they juxtapose didactic state-

4. F. W. H. Hollstein, *Dutch and Flemish Etchings, Engravings, and Woodcuts ca. 1450–1700*, IV (Amsterdam: Hertzberger, n.d.), 204; Hollstein, *German Engravings, Etchings, and Woodcuts, ca. 1400–1700*, VIII (Amsterdam: Hertzberger, 1968), 46. Judson dates Vos's *Times of the Day* after a set of 1582 by Dirck Barentsz.; I think Vos's suite, based upon its Italiante character, was executed around 1562, not too long after his return from Rome. The direction of influence between Antwerp and Amsterdam at this time would also point to Vos as the originator of the theme in graphic art.

5. The Fürst engravings are not recorded by Hollstein; however, I have received photographic reproductions of them from the Staatsgalerie, Stuttgart.

6. An unsigned drawing of *Meridies* attributed to Vos is held by the Ecole Nationale Supérieure des Beaux-Arts in Paris.

7. F. Lippmann, *The Seven Planets*, trans. Florence Simmonds (London, 1895), pp.1–12. This volume reproduces all the major renditions of the planet pictures. Lippmann's historical account has been superseded by Kautzsch and Warburg's work, reproduced in Raymond Klibansky, Erwin Panofsky, and Fritz Saxl, *Saturn and Melancholy* (New York: Basic Books, 1964), pp. 205–207.

8. *The* Très Riches Heures *of Jean, Duke of Berry* (New York: Braziller, 1969).

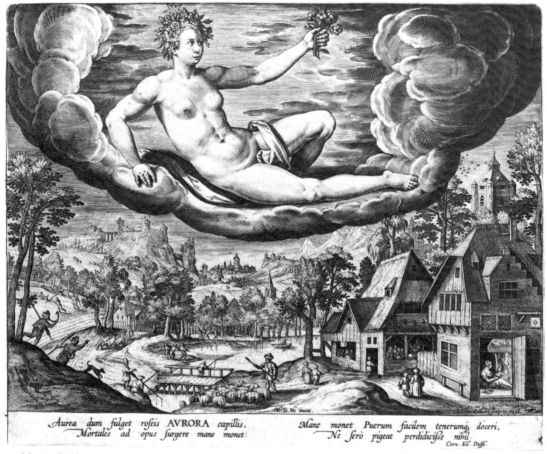

1. Martin de Vos, *Aurora,* engraved by Adrian Collaert. 20.8 × 26.2 cm. (Courtesy Rijksmuseum)

While golden Aurora shines with rosy curls,
At morning she warns mortals to hurry to work.
At morning she admonishes light and tender childhood to be taught,
Lest at a late hour it be ashamed to have wasted anything.

Behold mid and torrid noon, between rising
And setting, stirs the limbs of the living.
Hence may youth learn to bear hard labors,
Lest it waste time in extravagance and inactivity.

2. Martin de Vos, *Meridies,* engraved by Adrian Collaert. 20.8 × 26.2 cm. (Courtesy Rijksmuseum)

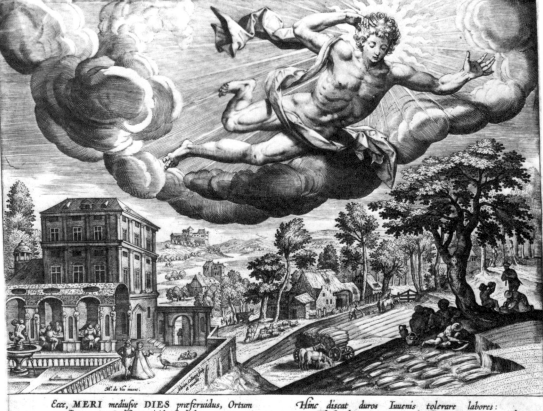

Ecce, MERI mediusve DIES præferuidus, Ortum
Inter & Occasum, viuida membra mouet.

Hinc discat duros Iuuenis tolerare labores:
Ne luxu ætatem desidiaq; terat.
Corn. Kil. Duffl.

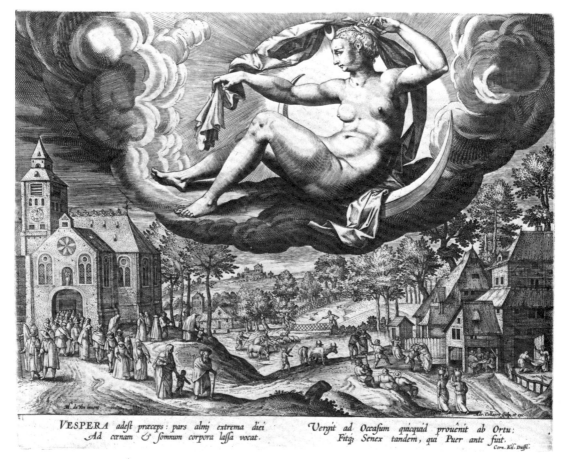

3. Martin de Vos, *Vespera,* engraved by Adrian Collaert. 20.8 × 26.2 cm. (Courtesy Rijksmuseum)

Suddenly evening is present. The last part of a nourishing day
Summons weary bodies to dinner and sleep.
Whatever springs forth at sunrise declines at sunset.
And he who before was a boy finally becomes an old man.

Black night wraps all things in blind darkness
And cherishes trifles, sleeps, dreams, apparitions.
Everywhere the living bend their courses toward the night of death.
Together with childhood, youth and old age perish.

4. Martin de Vos, *Nox*, engraved by Adrian Collaert. 20.8 × 26.2 cm. (Courtesy Rijksmuseum)

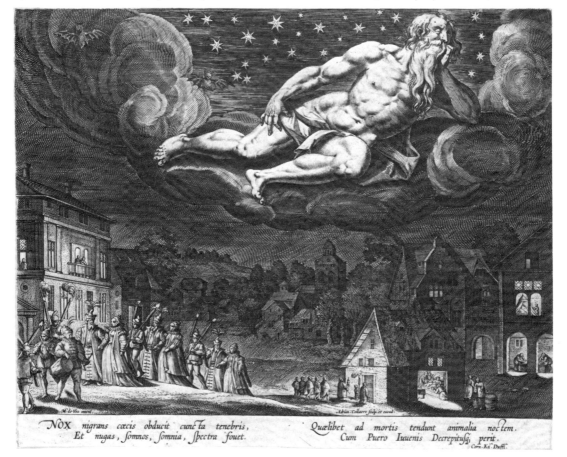

NOX nigrans cœcis obducit cuncta tenebris,
Et nugas, somnos, somnia, spectra fouet.

Quælibet ad mortis tendunt animalia noctem.
Cum Puero Iuuenis Decrepitusq, perit.

ments about work and duty with verses, vaguely Homeric in flavor, about the charms and terrors of the day's different parts.[9]

On the surface, Vos's *Times of the Day* seems to offer a direct transcript of reality, a plain account of recurring duties and tasks. But it would be a mistake to assume that Vos's cycle is primarily a chronicle of sixteenth-century daily life any more than Hogarth's progress, executed a little over one hundred and fifty years later, is primarily a literal account of everyday life in eighteenth-century London. On the contrary, as subsequent analysis will show, both are highly conventionalized, ideogrammatic works of art in which symbolic and allegorical meanings abound. And despite the chronological separation between them, in certain basic ways each is related more closely to the other than either one is to the daily life of the period in which it was created.

Just as Hogarth's *Times* adapts its imagery from the art of Vos and his followers, so Vos's *points du jour* draws upon the designs of those preceding him and finds its motifs and subjects in depictions of the planets, the months, the ages of man, the seasons of the year, and the four temperaments. Of all these sources, the planet pictures are the most important. Conceived in the Orient, appearing first in Northern Europe during the fourteenth century, and introduced into Italy in the course of the Renaissance, the planet pictures illustrate the influence of the heavenly bodies on earthly matters.[10] In particular, they chronicle the planets' governance of certain sevenfold designations of human time—the ages of man, the days of the week, and the parts of the day.[11] In the representation of planetary rule over the day's seven parts and the human "children" associated with each, Luna governs the first part of the day and those compelled to rise early to work or play. Mercury presides over the day's second part; his energetic progeny, intellectuals and scholars, rise just after Luna's peasants. Venus controls the third part of the day; her adepts—lovers of pleasure—are the next to make their appearance. Sol rules the fourth part of the day. Those whom the sun shines on, the wealthy and fortunate, are the very last to start their activities. Mars rules the fifth part of the day; his progeny are associated with that division of diurnal time requiring endurance. The day's sixth part is Jupiter's; his children belong

9. The verses to Vos's *points du jour* were added by the engravers and vary from one version to another.

10. Jean Seznec, *The Survival of the Pagan Gods*, trans. Barbara Sessions (1953; rpt. Princeton: Princeton University Press, 1972), p. 70.

11. Henri Stern, "Astronomy and Astrology," *Encyclopedia of World Art*, II (New York: McGraw-Hill, 1960), 51.

to the hour in which wisdom and judgment are in demand. The last part is Saturn's. The disciples of this planetary god are the revelers preparing for the saturnalia and the people who limit their lives or whose lives are limited for them: the infirm, the aged, the decrepit. These planet pictures, and Georg Pencz's (1500–1550) *Planets* in particular, provided Vos with ready sources of themes, concepts, and iconography appropriate to the *points du jour*.[12] What his *Times of the Day* contains by way of direct observation, consequently, is limited to details that supplement but do not supplant artistic topoi such as the planet pictures.

Vos's *Aurora* (Fig. 1) is presided over by a boyish, attenuated adolescent female similar formally to Michelangelo's *Dawn*. Posed like the sculptor's allegory, Aurora elevates herself by her right arm, pulling her leg back as if to stand, much as Dawn does. However, unlike the sculptor's lethargic woman who cannot seem to free herself from her pallet, this embodiment of the sanguine humor has already raised her torso from her cloudy bed. With her youthful appearance and energetic manner, she personifies the first of man's four ages. Offering daisies (the "eyes of the day") to the rising sun, she represents the birth of the day and the life-giving principle of the year.[13]

The landscape beneath Aurora is typical of the views that complement the four allegories; it is a world panorama of a composite kind set against a Gothic background of villages and mountains. In its foreground a rural scene appears beside an asymmetrical town-scape; both are populated by puppetlike men and women, who dramatize in everyday activities the themes that the goddess allegorizes. In the pastoral landscape the shepherds and the hunters who must rise at dawn are drawn from pictures of Luna, the titular deity of the day's first part. In the village the magisterial pedagogue and his classroom of attentive children are taken from depictions of Mercury, patron of the day's second part, whose artists

12. Among the most accomplished and influential of the pictorial compendia of planetary lore, Georg Pencz's family of designs is patterned upon Florentine engravings of the spheres executed about 1461 and attributed to Maso Finiguerra (1426–1464) after originals made in collaboration with Antonio Pollaiuolo (c. 1432–1498). Pencz's sketches were engraved in 1531, had a wide circulation, and were published in a variety of editions; the many weak impressions on paper of late manufacture point to a popularity continuing long after the prints' first appearance (John G. Phillips, *Early Florentine Designers and Engravers* [Cambridge: Harvard University Press for the Metropolitan Museum of Art, 1955], p. 46).

13. In the iconography identifying her with spring, Aurora evokes such personifications of vernal abundance as "May" of the Salzburg Calendar of 818 (Webster, pl. X).

and sages rise just after Luna's hardworking rustics. Nearby, the woman sitting by the fire cradling an infant represents a combination of two themes from graphic art: "warming oneself by the fire" from the labors of the months and "childhood" from the four ages of man.[14] The burgeoning foliage covering the countryside and the tilled fields just beginning to bud identify the season as spring.[15]

Vos's *Meridies* (Fig. 2) is ruled by a personification who bears little discernible relation to the sculptured *Giorno* in the Medici Chapel. Rather than copying programmatically Michelangelo's four *Allegories*, which reflect a mood of haunting and unrelieved ennui, Vos devises a figure for each part of the day based upon man's cycle of waking, rising, retiring, and sleeping; and he identifies them with the sanguine, choleric, melancholic, and phlegmatic humors. While Aurora is an awakening girl, Meridies' representative is a fully active male figure, who flies energetically forward in the manner of a descending angel. An Apollo who blesses the land he moves above, this modestly draped sun god resembles the imperious deity of the Sistine Chapel, the *sol justitiae* who confounds the powers of darkness. By a historical irony, the Christian God who creates the world (himself fashioned after an Olympian) is reborn in Vos's figure as the smiling Phoebus Apollo who makes the earth fruitful.

The landscape of social distinction accompanying *Meridies*, like so many calendar illuminations of peasants working while their masters picnic, balances rural labor against urbane leisure. The elegant pleasure seekers from the beau monde are the descendants of the children of Venus, the patron of the day's third part and the goddess of the garden. For them, the midday is a period of pleasure and relaxation; they dine in a vine-covered bower and promenade in a formal garden whose artful symmetry is heightened by the cornfield *sub specie naturae* across from it. Two peacocks mirror—and satirize—them: obligatory inhabitants of the paradise garden since Calypso's romantic grotto in the *Odyssey*, they are also emblems of worldly vanity and pride, particularly the pride of

14. In an Arundel Manuscript miniature of the *Four Ages of Man*, Infantia is a nurse with a child in her arms, sitting in front of a fire that heats a large pot (Samuel C. Chew, *The Pilgrimage of Life* [New Haven: Yale University Press, 1962], fig. 104).

15. The youthful spirit of the landscape and its inhabitants is aptly codified in the motto to Pieter Bruegel the Elder's (c. 1515–1569) engraved *Spring*, "Ver Puerite compar" (*Graphic Worlds of Peter Bruegel the Elder*, ed. H. Arthur Klein [New York: Dover, 1963], pl. 19).

maturity.[16] Across from the gentry's walled plot of civilized and private pleasure, a group of farmers, whose lives fuse with nature, work and relax in the open fields. Nearby, two horses (emblems of ennobling labor) mirror their rustic masters.

The landscape of *Meridies* is an undulating, hilly countryside divided in the distance by a river stretching to the horizon. The river meanders below a castle set in monumental counterpoint to an imposing country villa, itself leading to a humble peasant dwelling. The reaping and tilling in the foreground, common in pictures of July and August, identify the season as summer. This panorama of peasant toil and recreation prefigures the century's most influential painting of high summer, *The Harvesters* (1565) by Pieter Bruegel, whom Vos, his townsman, met in Rome in 1552 and subsequently traveled with.[17] Like the energetic allegory of noon, most of the men and women in *Meridies* are youthful and vigorous; in this ideal world, man's and nature's chronologies are perfectly synchronized.

Vespera, in Vos's third picture (Fig. 3), shares the same reclining pose as the virginal Aurora but is strikingly maternal; her body, with its heavy limbs, betrays her autumn years and distinguishes her as the most sculptural of Vos's personifications. The associations among twilight, the inevitable passage of time, and sadness are ancient ones, and they are united in this woman, whose mood marks her as a figure of melancholia. Leaning slightly forward, her head drooping, and her torso turned to reveal pendulous breasts and a heavy stomach, she pulls her left leg sharply up and stretches her right out in an attitude reminiscent of Michelangelo's *Notte*. She wears a small crescent on her brow, resembling the moon on *Notte*'s forehead, and pulls the heavenly mantle of darkness over her head in the antique manner.

The crepuscular landscape that complements *Vespera* is framed on one side by a church and on the other by a village. The imagery in the right half of the picture comes from a print of Jupiter, the titular deity of the day's fifth part and the patron of religious performances.[18] The pious and devout children of Jupiter, the melancholics, are set off against the lively, secular descendants of Mars, the god of the sixth part of the day. Mars' children are often cast as

16. Mario Praz, *Studies in Seventeenth-Century Imagery*, rev. ed. (Rome: Edizioni di storia e letteratura, 1964), pp. 149, 227.

17. F. Grossman, *Pieter Bruegel: Complete Edition of the Paintings*, 3d ed. (London: Phaidon, 1973), p. 15. For *The Harvesters*, see pl. 101.

18. The most likely source of this imagery is Pencz's *Jupiter* (Lippmann, pl. E, 5).

soldiers, robbers, and plunderers; however, in a more general interpretation, Vos renders them as people of action.

Vespera's background is a partially harvested field of grain, a stock inventory item in representations of autumn. Like Vespera herself, many of the men and women in the evening landscape are in the autumn of their lives; some are stooped, others walk with canes, still others are led home by children. All are memories of the traditional figure of Decrepitas, who leans on a staff or on the shoulder of a youth (representing the appearance of the next generation) in medieval miniatures and Renaissance engravings of the "Ages of Man."[19]

In the fourth time of the day, Night (Fig. 4) is an aged, twisted man. His posture and countenance with its forked beard recall Michelangelo's Saint Paul struck from his horse in the Cappella Paolina. Fully recumbent, Nox completes with his sleep the progression begun by the awakening Aurora. He presents the phlegmatic temperament. He also personifies the last age of man and symbolizes winter, traditionally connected with old age in pictures of the seasons and the months.

Nox's bottom register is not so much a night landscape as a daylight scene decorated with nocturnal devices. It is peopled by a band of men and women inspired by depictions of the children of Saturn, the god who governs the last part of the day. Dressed in masquerade costumes and walking in a torchlight parade, they represent the fashionable world previously encountered in *Meridies,* now engaged in their nightly entertainments. In moralistic juxtaposition to this heedless revelry, a religious procession halts at the door of a burgher dying in the company of other devout villagers. This melancholy and pious drama showing the peaceful demise of Infirmitas is a didactic set piece tutored by the deathbed scene that concludes such medieval miniatures as the Arundel illuminations of the *Four Ages of Man.*[20] The culmination of the cycle of germination, growth, maturity, and decay, *Nox*'s emphasis is eschatological and religious; it is an essay on man's inevitable passage from the impermanent and sorrow-filled world of time to the unchanging bliss of eternity.

Martin de Vos's translation of the "times of the day" from sculpture into graphic art attracted the attention of his contemporaries and inspired imitators and rivals: Carl van Mander, Dirck Barentsz., Hendrick Goltzius, and Adrian Collaert. Among these, van

19. See Chew, fig. 104.
20. See ibid.

Mander (1548–1606) stands out; his innovative reinterpretation brought a new sophistication and urbanity to the theme.[21] Executed in or around 1601 and engraved by Jacob Matham (1571–1631), van Mander's cycle (Figs. 5–8) is perhaps the most ingenious of the allegorical genres.[22] Its iconography is novel, its structure is involved, its mood is often tinged with eroticism, and it builds to a witty, enigmatic climax that has defied explication.

Van Mander's tetralogy is a reaction to Vos's, which in retrospect seems pious and stiff. For example, while Vos separates the earthly and heavenly registers in his design, van Mander interweaves the two in stylistic and thematic ways, sometimes to the point where they are inextricable. *Aurora*'s tiers (Fig. 5) are joined formally by the nudes appearing in both and thematically by the winged Pegasus in his double role as morning's steed and the horse that causes the fountain of Hippocrene to spring from Mount Helicon. Moreover, instead of populating each of his upper fields with a single deity, van Mander varies the number so that this fluid realm now harbors as few as one Olympian and as many as seven. And he shows the gods and goddesses in possession of a startling range of emblems, properties, and attributes: *putti*, horses, lions, chariots, and castles.

But van Mander's boldest departure from Vos is in the subject matter of his *Times of the Day*, which, behind the traditional imagery of early-rising intellectuals, lunching shepherds, strolling lovers, and slumberers, is an allegory about art and the creative process. The pivotal scene in the tetralogy is *Aurora*. A crowded fantasy in which Demeter and Neptune (harbingers of spring) preside over a colony of writers, thinkers, songsters and musicians, the landscape and its figures with their studied poses and distinctive props echo representations of Parnassus, such as Raphael's fresco in the Stanza della Segnatura, Rome. The stream and the grove identify the picture's idyllic setting as the sacred place on Mount Helicon where the fountain of inspiration bubbles up from the earth.[23]

The people in the landscape are the Muses and their companions. The attributes of these divine sisters have varied in artistic

21. Judson, p. 85.
22. Hollstein, *Dutch and Flemish Etchings, Engravings and Woodcuts*, XI (Amsterdam: Hertzberger, 1955), 230. The 1601 date is Judson's, p. 85.
23. While this composition's larger sense of design seems essentially derived from Giorgione's (c. 1478–1511) *Pastoral Symphony* or a work related to it, the individual figures placed about the stream recall the intellectuals and artists who populate planet pictures of Mercury.

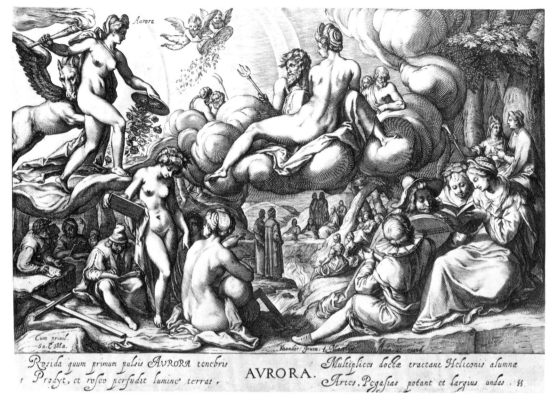

Kaander Inuen: I. Mat

*Rosida quum primum pulsis AVRORA tenebris
Prodyt, et roseo perfudit lumine terras.*

AVRORA.

*Multiplices doctæ tractant Heliconis alumnæ
Artes, Pegasias potant et largius undas . H*

5. Carl van Mander, *Aurora*, engraved by Jacob Matham. 20 × 29 cm. (Courtesy Rijksmuseum)

When at first dewy Aurora from banished night
Has sprung forth, and sprinkled lands with rosy light,
The learned foster-daughters of Helicon practice many
Arts, and drink more plentifully the Pegasean streams.

38

Fiery Phoebus thrusts forth his golden-haired head in the high
Heaven. Scattering clouds, he brings back pleasing
Light to the world. He divides the day into fixed hours,
Also recalling mortals to accustomed labors.

6. Carl van Mander, *Meridies*, engraved by Jacob Matham. 20 × 29 cm. (Courtesy Rijksmuseum)

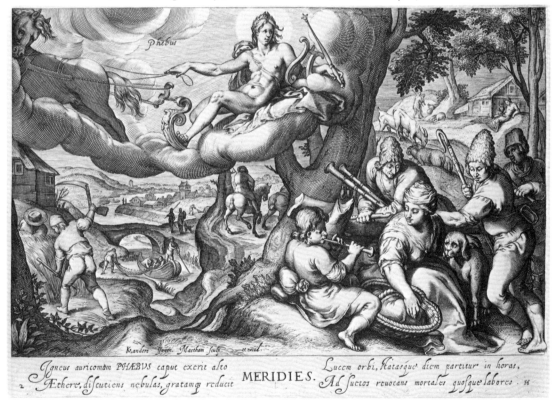

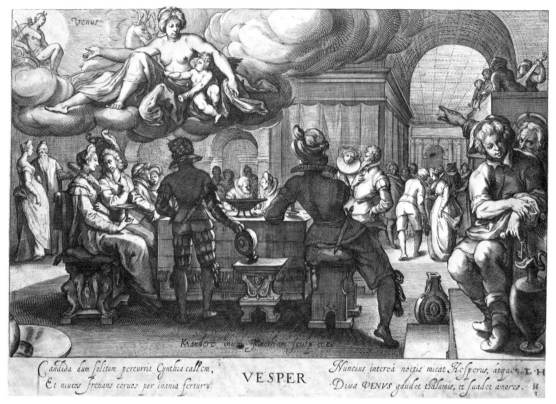

7. Carl van Mander, *Vesper*, engraved by Jacob Matham. 20 × 29 cm. (Courtesy Rijksmuseum)

While white Cynthia hastens over her accustomed path,
And bridling her snowy stags, is born through the emptiness,
Meanwhile Hesperus, the messenger of the night, shines, and
Divine Venus rejoices in weddings and encourages loves.

Morpheus, whose father is Somnus, wears two horns,
Out of which he now and then introduces into the minds of men either true
Or false dreams through the blind night,
Bringing many phantasms of all kinds of things.

8. Carl van Mander, *Nox*, engraved by Jacob Matham. 20 × 29 cm. (Courtesy Rijksmuseum)

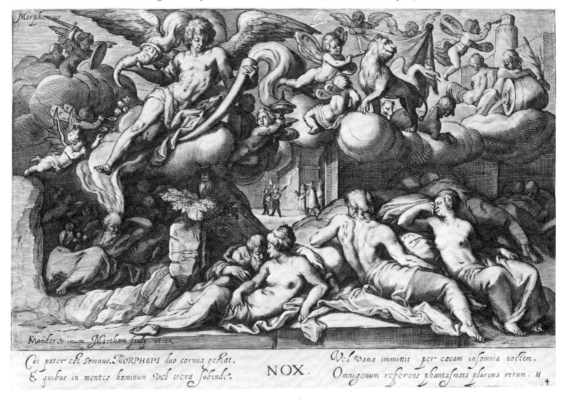

representation from one period to another, making identification difficult. However, in this case, some of the goddesses are easy to recognize. In the left foreground Clio is surrounded by her disciples; the muse of history wears a laurel wreath and writes on a tablet. The young woman with a book who stands to Clio's left is Calliope. The deity of epic poetry, she also patronizes the visual arts as shown by the sculpture behind her and her own emblematic nudity—enhanced by a drapery cloth. Calliope converses with Urania (astronomy), who holds a globe and a set square. In the middle distance Terpsichore (song and dance) sits by the Muses's stream with her harp by her side. Behind her, Thalia (pastoral poetry) is accompanied by two men on viols, and Euterpe (music and lyric poetry) gestures with her trumpet. Van Mander's Parnassus differs from similar pictures (such as Raphael's) in its identification of Calliope as patron of the visual arts. The motive behind this novel identification is in the struggle of sixteenth- and seventeenth-century artists to legitimize their claims to higher rank by freeing themselves from their associations with the guilds, whose medieval roots were with the crafts. *Aurora*'s theme is the nobility of the plastic arts; the prestige of painting and sculpture as elevated mental activities is established by reason of their ties with music and poetry (specifically *epic* poetry, the noblest kind) through *invenzione*.[24]

This allegory of artistic inspiration is complemented by two scenes of artistic executions arranged as a contrasting pair. *Meridies* and *Vesper* both depict musical performances in progress; however, the first is set out of doors, the second inside; the first takes place among shepherds, the second among the beau monde at a soiree.

In the fluidity of its form and the complication of its subject, *Nox* resembles its pendant *Aurora*. But what exactly is the subject of this erudite and complicated fantasy, which J. Richard Judson has characterized as purveying an impenetrable allegory?[25] The key to this enigmatic and convoluted design is Ovid's *Metamorphoses*, which van Mander had explicated in print around 1604.[26] In the "Painter's Bible," as the *Metamorphoses* was often entitled in the seventeenth century, Ovid describes the kingdom of sleep and its inhabi-

24. E. H. Gombrich, *Symbolic Images: Studies in the Art of the Renaissance* (London: Phaidon, 1972), p. 76; Madlyn Millner Kahr, "Velázquez and *Las Meninas*," *Art Bulletin*, 57 (1975), 239.

25. Judson, p. 148.

26. Madlyn Millner Kahr, "Danaë: Virtuous, Voluptuous, Venal Woman," *Art Bulletin*, 60 (1978), 53.

tants; van Mander's *Nox* is a pictorial translation of that literary text.

According to the mythographer's visually suggestive account, the dwelling place of sleep is a cave in a hollow mountain. There, Somnus (left foreground) slumbers on a bed of stone in his palace without doors, while several of his offspring rest around him. Among the rhythm of sleeping forms, two of Somnus' children (center foreground) stand out by reason of their comic amorousness, an amorousness that echoes the erotic spirit of *Aurora*, with its naked, lounging Olympians. Above the soporific god "lie, imitating divers shapes, as many vain dreams, as a field of corn bears ears, or a wood leaves, or the shore sands, thrown out upon it."[27] These emerge from the horns of Morpheus (top register, left of center) who springs himself out of the foggy vapor issuing from his father's head. Playing on the received notion of Morpheus as a mimic and a creator of shapes, *Nox* shows the god of dreams as an artist, an impresario at the head of a little army of *putti* who work in his heavenly atelier. The picturesque dream, a favorite mannerist image, is constructed according to the strict jurisdictional system administered by Somnus' three children. The *putti* are under the government of Morpheus, whom Ovid characterizes as "an artist indeed, and an *admirable* counterfeiter of *any* [human] shape."[28] Next to them a menagerie is cared for by Phobetor, who, according to Ovid, "becomes a wild beast, becomes a bird, becomes a serpent; with a long body."[29] The final section of the murallike dream, showing a sculptured river god pouring water from an urn and a *putto* painting a castle or a picture of a castle, is under the rule of Phantasos, who "successfully passes into ground, and stone, and water, and beams, and all things which are without life."[30]

This surrealistic tableau combining actual and fanciful details in an imaginary setting is a picture about the nature of pictures, a witty statement about the elusive and paradoxical character of art. Somnus' dream is a perceptual and an intellectual labyrinth, a hallucination in which it is impossible to distinguish between the process of the illusion and the product, between the matter of the vision and the form, between the appearance of the tableau and the reality. In these respects it is a parable about art itself—a dream, an illusion, and a vision with its origins in the unconscious,

27. Ovid, *Metamorphoses*, trans. John Clarke (Glasgow, 1787), Bk. XI, 615. All quotations are taken from this edition of the *Metamorphoses*.
28. Ibid., 634.
29. Ibid., 639–640.
30. Ibid., 642–644.

which weaves a tangled web of appearance and reality, truth and falsehood, matter and form.

The final interpretation of the topos to appear as an allegorical genre is Tobias Verhaecht's (1561–1631) *Times of the Day* (Figs. 9–12). Executed after 1590 when Verhaecht had returned to Antwerp from long visits to Florence and Rome (his ensemble begins and ends with Italian settings), the work was engraved by Egbert van Panderen (1581–c. 1637) and published by Theodore Galle (1571–c. 1633).[31] From a formal standpoint, Verhaecht's sequence is derivative, though its subject matter is not. Its imitative character foreshadows the more egregious banalities that provoked Hogarth's satire and prophesies the demise of allegorical-genre depictions of the "times of the day." Verhaecht's indebtedness is to his townsman Vos. His motifs and structural ploys are paraphrases of Vos's, though more articulate and less wooden than their prototypes. So too are his allegories, which echo the gestures, attitudes, and poses of their forerunners. However, Verhaecht's gods and goddesses are reduced in scale and devoid of vitality. Shrunk from cosmic forces to tiny apparitions set above an earth that no longer pays homage to their authority, they reflect the waning influence of the original allegorical concepts and the new importance of the natural landscape. So while Verhaecht's Aurora shares the same pose as Vos's, she displays a langorous ease and a narcissism that makes her (and the concept behind her) seem flaccid and decadent by contrast with the eager, delightfully naive personification of morning in the first "times of the day."

Verhaecht's sequence, testifying to the capacity of the trope for adapting itself to new viewpoints, introduces into the commonplace its own crucial innovation. It superimposes on the *points du jour* theme a related commonplace of classical discourse involving the passage of time, the myth of the four historical ages of man. By the "ages of man" Verhaecht (who was Peter Paul Rubens's [1577–1640] first master) means the mythic epochs named after the four elemental metals: gold, silver, bronze, and iron. This myth, codified by Ovid in a set piece that was imitated, plagiarized, parodied, and reinterpreted by poets and painters alike, chronicles human nature's decline and fall from a past edenic innocence to a present urban degeneracy.[32]

31. Hollstein, *Dutch and Flemish Etchings, Engravings and Woodcuts*, XV (Amsterdam: Hertzberger, n.d.), 101.

32. Harry Levin, *The Myth of the Golden Age in the Renaissance* (1969; rpt. New York: Oxford University Press, 1972), p. 19. Throughout this section, I am indebted to Levin's discussion.

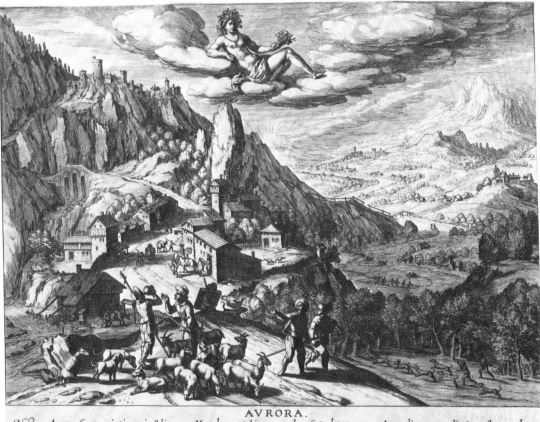

AVRORA.

Noctem Aurora fugat venientis nuncia Solis:
Atque almum roseo ore diem, lucemq; reducit.

Mortales vocat hinc opera ad consueta. latentes
Hic fallit pisces: canibus nemora ille fatigat:

Atque alia exercent alij. Quem stertere multam
In lucem iuuat, hunc pannosa sequetur egestas.

Tobias Verhaecht inuent . *Egbert. van Panderen sculpsit.* *Theodor. Galle excud.*

9. Tobias Verhaecht, *Aurora*, engraved by Egbert van Panderen. 18.4 × 22 cm. (Courtesy Rijksmuseum)

Aurora, the messenger of the coming sun, puts night to flight.
And with a rosy face she brings back nourishing day and light.
She calls mortals hence to accustomed tasks. This man
Tricks the hiding fish. That one disturbs the forest with dogs.
And others carry on other activities. He whom it pleases to snore late
Into the day, ragged need will follow.

Already Phoebus has arrived at the height of day.
And from on high he burns the fields. Wherefore living things avoid the torrid
Heat in the spreading shade. Tired with work,
Reapers care for their bodies with food and sleep.
Thus has Nature, the parent, granted things to be and has established
Changes and order so that all create a stable course.

10. Tobias Verhaecht, *Meridies*, engraved by Egbert van Panderen. 18.4 × 22 cm. (Courtesy Rijksmuseum)

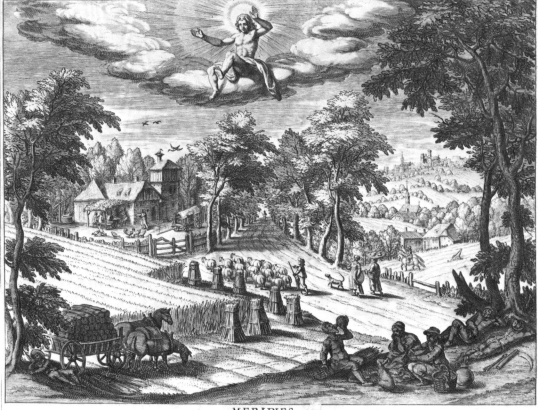

MERIDIES.

Iam medium cæli Phœbus peruenit ad axem:
Urit et altus agros. Quare æstum animalia in vmbra

Torrentem patula vitant: fessique labore
Messores, dapibusq3, et somno corpora curant.

Sic Natura parens dedit esse vicesq3, modumque
Constituit, stabilem seruent vt cuncta tenorem.

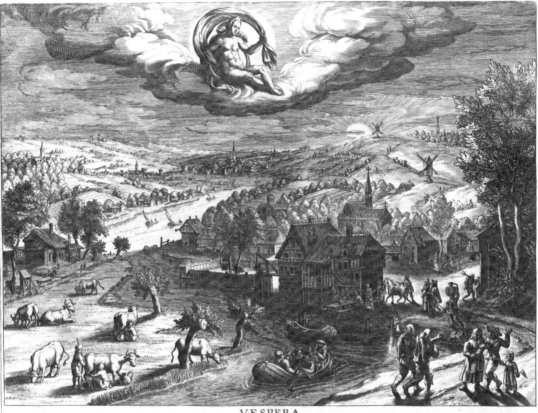

VESPERA.

Solis vt Aurora est, nigræ sic nuncia Noctis *Agricolas quoque suspensis hortatur aratris,* *Defessas reparent: placidæ dent membra quieti:*
Vespera. consueta hæc pecus ad præsepia cogit: *Mortales pariter; Cereali vt munere vires* *Solamen grauium quam Dij statuere laborum.*

11. Tobias Verhaecht, *Vespera*, engraved by Egbert van Panderen. 18.4 × 22 cm. (Courtesy Rijksmuseum)

As Aurora is the messenger of the sun, so evening is the messenger of night.
She drives the herds to their accustomed folds.
She calls farmers in from idled plows,
And others as well, to repair with Ceres' gift
Their failing strength. They give their limbs to a gentle quiet.
How the gods have established a respite from heavy labors!

47

Black night leads deep darkness into the land.
Although she often supplies torches for crimes and offers an opportunity
To the man who dares to commit any evil to which a blind spirit is impelled,
Nevertheless, she sometimes has her games, her gods of jest, and her
Opportunities. But the man who is discreet, while he hates the dark
Lest by chance he do wrong, will love the light.

12. Tobias Verhaecht, *Nox*, engraved by Egbert van Panderen. 18.4 × 22 cm. (Courtesy Rijksmuseum)

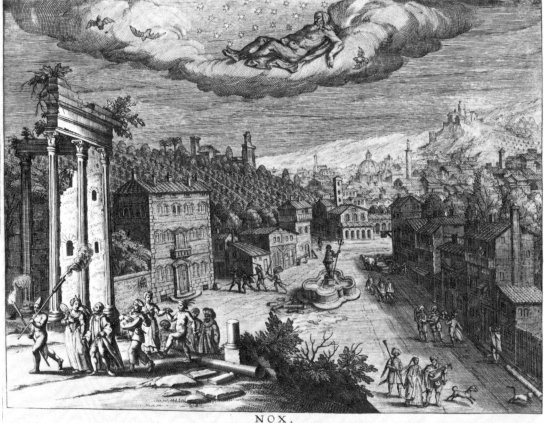

NOX.

Inducit terris densas Nox atra tenebras.
Ad mala sæpe faces licet hæc, ansamqj miniſtret

Audenti quodcunque ſcelus, quo cœca ruit mens:
Attamen ipsa ſuos et habet ludoſque, Iocoſque,

Commodaqj interdum. Sed, qui sapit, ille tenebras
Exoſus; lucem, ne forte offendat, amabit.

Any restatement of the "four ages of man" is necessarily a recoil from a present wasteland and a lament for a paradise lost. The two functions are intertwined. Pictures of the Golden Age (paradoxically defined by Arthur O. Lovejoy and George Boas as "the discontent of the civilized with civilization") are inventories of everything that the present age is not—in terms of ethics, geography, and climate.[33] At the other extreme, accounts of the Iron Age are critiques of the present deterioration of man and nature with specific reference to an Eden past. Thus the four-ages-of-man topos is at once an elegy and a jeremiad.

Both impulses are present in Verhaecht's tetralogy. The elegiac motives, the weaker of the two, are contained in *Aurora* and *Meridies*, picturesque designs in the tradition of "soft" primitivism. *Aurora* (Fig. 9), an idealized landscape similar to Bruegel's *Saint Jerome in the Wilderness* in its emphatic diagonal structure, is defined as a wistful portrait of the Golden Age by its grazing flocks, its Theocritean population, its vernal setting, and the trees that line its steep ridges and its Vergilian lowlands.[34] These are pines, the trees characteristic of man's first age, according to Ovid, whose account is the controlling influence and the ideal commentary on representations of this commonplace. "The pine-tree being not yet cut down in its mountains, had not descended into the liquid waves, to visit a foreign part of the world; and mortals knew no shores besides their own."[35]

The Golden Age is the most difficult of the four to describe because it is conceived from a negative point of view—that is, by what it lacks: it is a period without war, toil, private property, and so on. Its virtues—like all positive characteristics—are elusive and hard to articulate in a compelling way. It is not too surprising then to find that *Aurora*'s principal motif (a goatherd expostulating with his comrade over a share of the morning's refreshment) is at witty variance with Ovid's account of the Golden Age, which "of its own accord practiced faith and honesty without law."[36]

Verhaecht's rendition of the Silver Age, when people were agriculturalists, is more thoroughly Vergilian than his account of man's

33. Arthur O. Lovejoy and George Boas, *Primitivism and Related Ideas in Classical Antiquity* (Baltimore: The Johns Hopkins University Press, 1935), p. 7; Lovejoy and Boas are actually writing about cultural primitivism here.

34. *Graphic Worlds of Peter Bruegel*, pl. 2.

35. Ovid, Bk. I, 94–96. Thomas Worthen reminds us that Poussin took up painting only after he had learned Latin and acquired a knowledge of myth ("Poussin's Painting of Flora," *Art Bulletin*, 61 [1979], 586).

36. Ovid, Bk. I, 89–90.

first age. Showing a folk living in harmony with nature and each other, *Meridies* (Fig. 10) features a Flemish landscape in which one field in harvest is divided by a tree-lined avenue from another in tillage. It is a simple, Arcadian elaboration of Ovid's words, "Then first of all were the seeds of Ceres [*i.e.* corn], buried in long furrows, and bullocks groaned, pressed by the yoke."[37]

The tone of Verhaecht's cycle shifts sharply from the panegyric to the critical in *Vespera* and *Nox. Vespera* (Fig. 11), its emphatic diagonal recalling Bruegel's *Euntes in Emmaus* (which also depicts a striking sunset), delineates the Bronze Age as a burlesque of village life.[38] The classical account of this period when men were "more cruel in their tempers, and more inclinable to horrid arms, yet not villainous"[39] is given a light, comic treatment with the idle burghers who divert themselves in an overcrowded rowboat, a kind of diminutive ship of fools in the Land of Cockaigne (center foreground) and a more censorious expression in the drunk, disorderly peasant being led home by his wife and child (right foreground).

A certain progressiveness in Verhaecht's landscape design is evident in *Vespera*'s river canal, a compelling Northern waterway and not a generalized and timeless idea from nature. Verhaecht was one of the most successful landscape painters of his day, and he was drawn to the *points du jour* for the opportunity it provided for topographical delineation. In spite of the formal dependency on Vos previously mentioned, all the pictures in his quartet are carefully harmonized and unified in terms of space and conception. They possess a sure sense of structure that invites the eye into the representation and guides it suavely through the design into the distance by such devices as *Meridies'* tree-lined avenue with its remote vanishing point. All four pictures reflect a responsiveness to sunlight and atmosphere, prophesying the developments of a not-too-distant future when the *points du jour* would be devoted entirely to the effects of these phenomena.

In narratives of the "four ages of man" a rapid degeneration takes place from the Bronze to the Iron Age when, according to our guide, "men live by plunder; the lodger is not safe from the person entertaining him; nor the father-in-law from the son-in-law. A good agreement of brothers too is *a* rare *thing*. The husband is ready for the destruction of his wife, and she *for that* of her husband."[40] This falling off is immediately evident in *Nox* (Fig. 12),

37. Ibid., 123–125.
38. *Graphic Worlds of Peter Bruegel*, pl. 62.
39. Ovid, Bk. I, 125–127.
40. Ibid., 143–148.

where the dominant mood is no longer comic but tragic and condemnatory. In this climactic winter diatribe, Verhaecht lashes the vices of his age. His attack is most obvious in the sinister cast filling his picture: a motley crew of aristocratic revelers, a collection of serenaders (their lascivious purposes mimicked by the animals near them), and a gang of murdering soldiers whose affray appears to be observed by an impassive Neptune decorating a fountain—a mute, noble image from the past standing in judgment on a debased present.

The "four ages of man" is a chronological and temporal myth, not a geographic one. Wisely sequestered from the potential embarrassments of a local habitation and a name, it speaks of a series of times, not places. In *Nox*, however, Verhaecht transposes the myth's final trope to a spatial idiom, giving it a topographical dimension that is actual and identifiable. Set in Rome, *Nox* presents an evening scene and a cityscape showing the dome of Saint Peter's in the distance. In the late sixteenth century, the Eternal City was still regarded as the cradle of civilization and its capital. In *Nox*, however, Rome has become Babylon, underlining the jeremiad in Verhaecht's apocalyptic conclusion. The decayed classical facade (a piece of nostalgia for which this artist's pictures were famous) and the crumbling colonnades lament the passing of a heroic age; the wild vegetation growing up around them tells of the rankness of the present period.

The paradoxes surrounding accounts of the "four ages of man" are numerous and elusive. One of the most fascinating of them is suggested by the narratives of Ovid, Verhaecht, and Hogarth. Looking back to a Golden Age from his perspective in the Renaissance, Verhaecht unhesitatingly identifies his period as the Iron Age. Two centuries after him, Hogarth (borrowing Verhaecht's conflation of the "ages of man" with the times-of-the-day theme and even making use of specific motifs, such as the statuary image from the noble past) glances back toward Verhaecht's age and claims the title "Iron" for Augustan England—itself another apogee of culture by present-day standards. But of course both of these "moderns" had been "scooped" by Ovid, who had made his own retrospective and named his period ferrite. "The dimness of the ultimate horizon," writes Harry Levin, who has elucidated so many of the ironies of this trope, "favors the irenic presupposition that once upon a time the life of man was sociable, abundant, pleasant, gentle, and long."[41]

41. Levin, p. 31.

By the beginning of the seventeenth century, the vogue of mannerist landscape with its tour-de-force eclecticism was virtually exhausted. The time was past when the rendering of nature had to be justified by mythological or allegorical meaning, and optical truth was now regarded as valuable in itself: landscape had emerged as a separate and independent branch of Northern art. Among popular seventeenth-century themes, the *points du jour*'s broad outline offered the widest of applications; it was a standing invitation to landscape and topographical artists to compare and contrast the countryside of one nation with that of another, to explore the changing expressions of light and darkness, and to describe the dramatic interaction of earth, sky, and water from one part of the day to the next. The *points du jour* became firmly entrenched in the art of the North and was repeatedly employed because of its protean capacity for adjustment, particularly by seventeenth-century landscape artists, whose fresh techniques and subjects made a distinctive contribution to the theme.

The story of the "times of the day" as a quartet of landscapes is much the same as the story of landscape painting itself in the great period of Flemish and Dutch art. The selective history to follow is an account of the successive fortunes of the *points du jour* in the seventeenth century and a narrative in microcosm of the growth, flowering, and decay of Northern landscape art as well. The first example of the "times of the day" from this age is that of Pieter Stevens II (Figs. 13–16) and belongs to the transitional period (1595–1610) when Netherlandish landscape was still under the lingering influence of international trends like mannerism.[42] The second quartet, Jan van de Velde's (Figs. 17–20), comes from the most creative epoch in Dutch landscape art, which witnessed the birth of realism and its maturity (1610–1660). The final tetralogy, by Nicholas Berchem (Figs. 21–24), derives from the Italianate period of Dutch landscape. During this time Northern artists cultivated views of the Roman campagna and evoked Mediterranean light, sometimes without ever leaving Holland. Often exaggeratedly idyllic, their scenes enjoyed a vogue that was unusually long-lived, particularly in England. Recently resuscitated by connoisseurs, these glamorous, nostalgia-filled views of Rome and its environs foretell (if they do not actually demonstrate) the decline of the creative impulse in Holland at the end of the seventeenth century.

42. Irene de Groot, *Landscape Etchings by the Dutch Masters of the Seventeenth Century* (Maarssen: Gary Schwartz, 1979), intro., n.p.

The *Aurora, Meridies, Hesperus,* and *Nox* (Figs. 13–16) of Pieter Stevens II (c. 1567–c. 1624) are the first of their kind to appear as pure landscapes.[43] Engraved by Hendrick Hondius II (c. 1597–c. 1644) from designs of 1605, Stevens's *points* is realized as four detailed Flemish views of the external world, all of them devoid of the allegorical motifs of Italian origin present in the suites of Vos and Verhaecht.[44] The transitional character of Stevens's quartet is clear from its residual mannerist influences. Despite the series's use of a low vantage point in *Aurora,* its comparatively restrained accumulation of incident, and its experiments with atmosphere (however clumsy) in *Hesperus* and *Nox,* its sixteenth-century heritage is betrayed by its emphasis on a fixed, static nature in contrast to van de Velde's world in which land, atmosphere, and water are shifting and dissolving.

The mannerist character of Stevens's *Aurora, Meridies, Hesperus,* and *Nox* is evident in the way they fit together to make up a comprehensive world view, exhibiting nature's manifold aspects in a four-part panorama. Moving from a romantic forest view (Fig. 13), to a townscape (Fig. 14), to a picturesque river scene (Fig. 15), and concluding in a moonlit harbor view (Fig. 16), the series is a *universa terra* constructed to enlarge systematically the range of physical perception. Within the individual pictures, the impact of mannerism is most evident in *Aurora* and *Nox.* With its massive outcropping of rocks and trees, the first of these borders on the overstated and estranged; clearly, *Aurora* belongs to the Flemish tradition of aggrandized mountain landscapes in the style of Joachim Patinir and Pieter Bruegel. The nocturne, with its mysterious and somewhat amateurish chiaroscuro, is actually the theatrical mannerist seascape (wild oceans, imperiled ships, and terrifying monsters) metamorphosed into a drama of light and shadow.

For the most part, Stevens's quartet depicts an external world that is fixed, imaginary, and archetypal. Two of his designs seem to "present town" (*Meridies*) or "present river" (*Hesperus*). All four are based upon conceptual models and not on visual experience, in accordance with the mannerist aesthetic, which valued the artist's ideas above any mere transcript of the external world. Their universal character and composite structure display an improbability that stands in vivid contrast to later town views by such painters as Gerrit Berckhyde (1638–1698) and Johannes Vermeer (1632–1675).

43. *Dictionnaire des peintres, sculpteurs, dessinateurs et graveurs* (Paris: Librairie Gründ, 1966), VIII, 122.

44. Hollstein, *Dutch and Flemish Etchings, Engravings and Woodcuts,* IX (Amsterdam: Hertzberger, n.d.), 93.

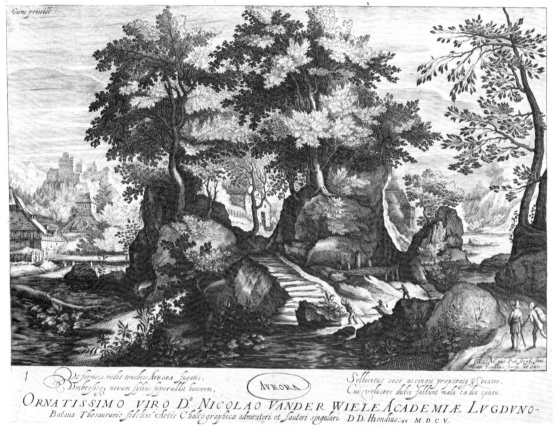

1 Et formosa redit tenebris Aurora fugatis,
 Umbrosisęę novum sylvis superaddit honorem, AVRORA Sollicitus sese accingit properatę Viator.
 Cui volucres dulci fallunt mala tædia cantu.

ORNATISSIMO VIRO D.º NICOLAO VANDER WIELE. ACADEMIÆ LVGDVNO-
 Bataua Thesaurario fideliss.º Artis Chalcographicæ admiratori et fautori singulari D D. Hondius.ᴍᴠ M D C V.

13. Pieter Stevens II, *Aurora*, engraved by Hendrick Hondius II. 23 × 33 cm. (Courtesy Print Room, Royal Library, Brussels)

When beautiful Aurora returns with the darkness put to flight, and
She adds new honor to the shady woods,
The traveler, aroused, girds himself and hastens on
For whom the birds beguile harmful weariness with sweet song.

When golden Phoebus ascends mid Olympus
And touches the lofty palace of the sky with his shining chariot,
Then everything laughs, then the most beautiful earth
Relaxes its curves, about to drink in the pleasing heat of the sun.

14. Pieter Stevens II, *Meridies,* engraved by Hendrick Hondius II. 23 × 33 cm. (Courtesy Print Room, Royal Library, Brussels)

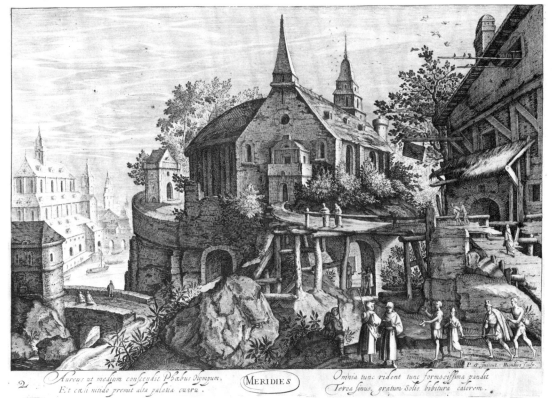

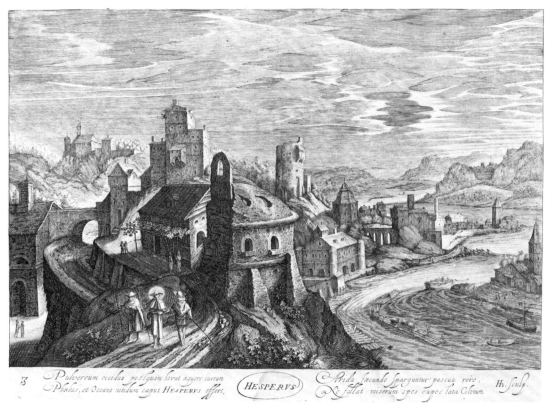

15. Pieter Stevens II, *Hesperus*, engraved by Hendrick Hondius II. 23 × 33 cm. (Courtesy Print Room, Royal Library, Brussels)

After Phoebus washes his dusty chariot in the western sea,
And evening lifts her shining head out of the ocean,
Dry pastures are sprinkled with fecund dew,
Nor does the awaited hope deceive the weary farmer.

When black night takes away the color from all things,
And Cynthia alone shines with fraternal light,
The fisherman stirs the shallows and is weary with his oars
And holds his dripping nets filled with the scaly tribe.

16. Pieter Stevens II, *Nox,* engraved by Hendrick Hondius II. 23 × 33 cm. (Courtesy Print Room, Royal Library, Brussels)

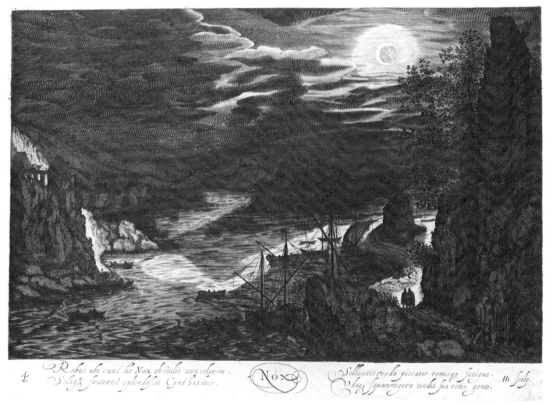

57

Other pictures of Stevens's, like *Nox*, are abstract, while still others are overstuffed and primitive. Within the designs eccentric trees and foliage resemble decorative arabesques, while buildings and bodies of water are more picturesque than realistic and individualized. The static quality of the entire ensemble is clear from the accessories in *Meridies* and *Hesperus*. The former shows the aged Abraham meeting the three angels whom God employs as his disguises when he foretells the birth of the patriarch's son. The biblical anecdote (Gen. 18:1) is suited to noon, the hour of the crisis of clarity, because the three angels revealed themselves to Abraham (interpreted by Christians as an epiphany of the Trinity) at exactly midday.[45] *Hesperus* shows Christ urged by two disciples (who do not recognize him) to rest for the evening in Emmaus.[46] Old-fashioned even in the early seventeenth century, these motifs moralize the scenes by directing attention to values that are spiritual and eternal. Drawn from the timeless and complete book of nature, they underline the artist's attempt to represent what is unchanging, ideal, and collective in human experience.

Flemish landscapes such as those of Stevens declined in frequency and popularity after the beginning of the seventeenth century. In counterbalance to this decline, Dutch artists of the bourgeoisie, especially those living in the town of Haarlem, displayed a growing interest in delineating nature realistically. The rise of national chauvinism after 1609 (when the United Provinces began a twelve-year truce with Spain) gave impetus to an identifiable Dutch treatment of nature. The result of this surge of national feeling was a keen interest in the countryside of the North, in landscape painting generally and within the *points du jour*.[47]

Around 1618, one of the pioneers of Dutch landscape art, the Haarlem painter and printmaker Jan van de Velde (1593–1641), created two versions of the "times of the day" devoted to poetic studies of nature.[48] Both of van de Velde's series belong to the early phase of Dutch realism (c. 1610–1640), when restful coun-

45. Nicolas Perella, *Midday in Italian Literature* (Princeton: Princeton University Press, 1979), p. 28.

46. More commonly rendered as a supper scene in an interior setting—in the paintings of Steen, Rembrandt, Rubens, and Caravaggio, for example—this popular religious subject is most memorably combined with a landscape in Bruegel's sunset, *Euntes in Emmaus*. Bruegel's large landscape influenced the structure of Verhaecht's *Vespera* directly, and Stevens's *Hesperus* indirectly.

47. Jakob Rosenberg, Seymour Slive, and E. H. ter Kuile, *Dutch Art and Architecture 1600–1800* (New York: Pelican, 1977), 241.

48. Daniel Franken and J. Ph. van der Kellen, *L'oeuvre de Jan de Velde* (1883; rpt. Amsterdam: G. W. Hissink, 1968), nos. 187–190; 191–193.

trysides and simple village scenes displaced the imaginary concoctions of previous generations. In these two ensembles, the movement away from mannerist conventions and the fresh approach to landscape, based on observation, may be traced. Reactions against the complex designs of artists such as Stevens, van de Velde's compositions are quiet, clear, and true to nature. They reject views that are diverse, ornamental, and managed, in favor of simple landscapes composed of a few forms. They abandon the high vantage points of the mannerists and their birdseye techniques in favor of low viewpoints, foregrounds that are empty or nearly so, and backgrounds composed of Dutch and Italian horizons, sometimes flat, sometimes forested. Unlike the mannerists, who examined their subjects under the glare of daylight, van de Velde models his landscapes in planes of light and darkness. It is not the detailed topographies themselves that are of interest any more, but the contrasts of light and shadow reflected across them and the image produced by the interplay between earth and sky. Chiaroscuro replaces decorative form.

The more subtle and picturesque of his two *Times*, van de Velde's *Aurora, Meridies, Vesper,* and *Nox* (Fig. 17–20) were engraved by Claes Janz. Visscher (1587–1652), a talented draftsman who was himself among the earliest to produce drawings based upon his observations of the external world. Though van de Velde's compositions look as if they were topographical views—as mannerist landscapes do not—in fact they are elements of several different landscapes combined and unified in one work of art. Studies of actual landscapes lie behind these synthetic views in the sense that they are composed of discrete parts—trees, farmhouses, bodies of water, and the like—that are created on the basis of ocular evidence. If van de Velde's views are invented and the places shown nonexistent, the landscapes themselves are plausible, carefully constructed, and true to nature. Designed to contrast the countrysides of various nations, they offer four subtly different compositions of untrammeled nature: a Dutch harbor scene executed with morning clarity as a paean to industry and expansionism (Fig. 17); two Mediterranean landscapes (Figs. 18, 19), one of which is modern, the other of which is antique in mood; and a second Northern view (Fig. 20). The culmination of the sequence, this last scene shows an extensive riverscape with a low horizon. This riverscape is of special significance. As the first compelling Dutch countryside to appear in the *points du jour*, it indicates an appreciation of the pictorial qualities of flat terrain and heralds a new degree of sophistication and realism in the theme.

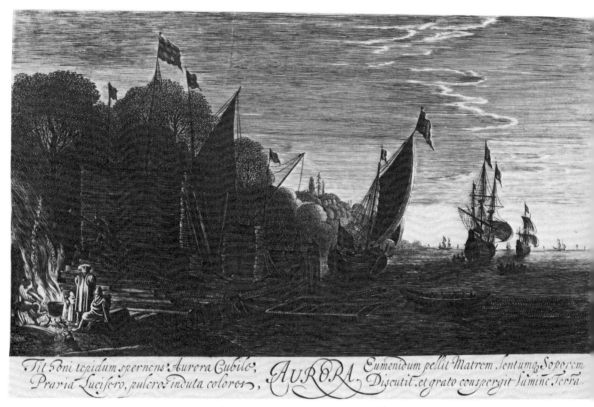

Aurora, leaving the warm bed of Tithonus,
Preceding the morning star, clothed with beautiful colors,
Strikes the mother of the Eumenides and
Dispels rough sleep and sprinkles the land with pleasing light.

Now Phoebus was balancing his chariot in the middle of the pole
When heat, heavy and scarcely able to be conquered by men,
Attacked. The sun-struck goats stand in the best grass,
And sluggish sweat drips from the weak body.

18. Jan van de Velde, *Meridies*, engraved by Claes Janz. Visscher. 13.5 × 21 cm. (Courtesy Trustees of the British Museum)

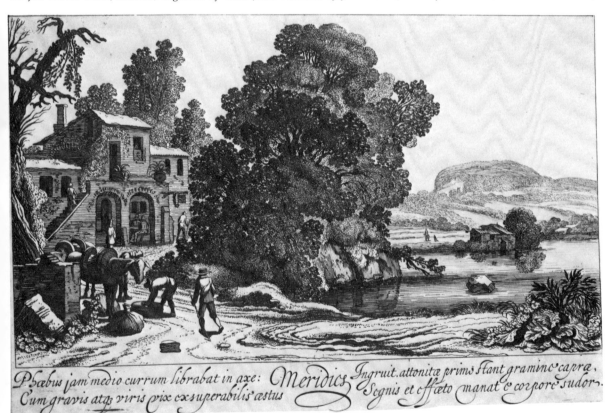

Phœbus jam medio currum librabat in axe: *Meridies* Ingruit, attonitæ primis stant gramine capræ,
Cum gravis atq; viris pix exsuperabilis æstus Segnis et effæto manat & corpore sudor.

61

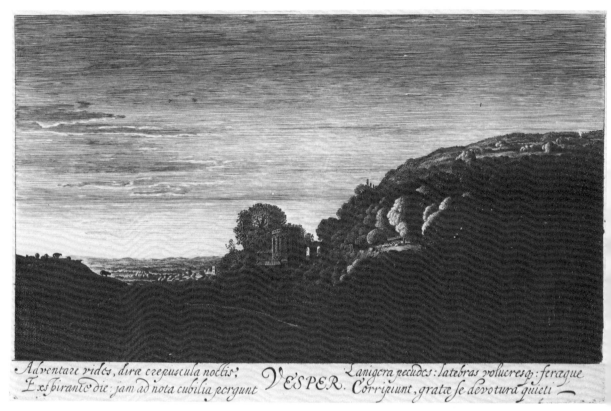

Adventare vides, dira crepuscula noctis;
Exspirante die; jam ad nota cubilia pergunt

VESPER.

Lanigera pecudes; latebras volucresq; feraque
Corripiunt, gratæ se devotura quieti

19. Jan van de Velde, *Vesper*, engraved by Claes Janz. Visscher. 13.5 × 21.5 cm. (Courtesy Trustees of the British Museum)

You see the twilight of fearful night arrive,
With the day breathing out its last; now the wool-bearing beasts go to their
Familiar beds; and the birds to their hiding places; and the wild beasts
Hasten away about to devote themselves to pleasing rest.

Where night flies around the earth with black wings
Everything lies down tired out. Now the sadder fire gleams
In the sky; gentle sleep seizes the limbs of all,
So that they may rise up again in a better place when Phoebus returns.

20. Jan van de Velde, *Nox,* engraved by Claes Janz. Visscher. 15.5 × 22 cm. (Courtesy Trustees of the British Museum)

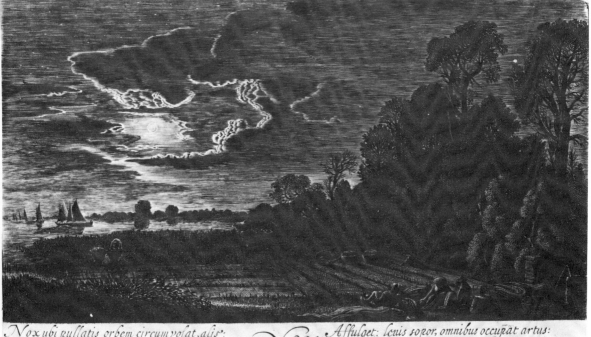

Nox ubi pullatis orbem circumvolat, alis:
Omnia fessa jacent, coelo jam tristior ignis

Nox.

Affulget: levis sopor, omnibus occupat artus:
Ut Phoebo redeunte, situ meliore, resurgant.

In Stevens's tetralogy nature is static and unchanging, but in van de Velde's it appears in constant flux. Nature's mutability is manifest in the whole series's devotion to picturing atmosphere—its shifting clouds, its dramatic life, its contrasts and variations, and, especially, its changing moods from one part of the day to another. *Meridies'* glaring, cloudless sky, under which things expand to become most fully themselves, is a development of that tiny portion of *Aurora*'s atmospheric heavens where the ocean melts into the horizon before the rising sun. *Vesper*'s thin, wispy clouds arranged in horizontal lines that reflect the setting sun's waning light is a preparation for *Nox*'s masses of cumulus that catch the moonlight, infusing the land, river, and sky with a luminous unity.

The impression of nature's mutability is not confined to the representation of atmosphere within the individual compositions. It is everywhere, especially in *Aurora* and *Nox*. The water ripples in *Aurora*; the sails of the ships fill with the rising wind and their banners flutter. Soon the passengers on the two ferries will embark, the waiting vessels will set sail, and the harbor will be empty. Even in *Nox*, where the figures in the foreground are motionless and resting, the clouds moving across the windswept sky will bring new patterns of light to the landscape below, while the sailboats on the horizon are in motion in the river.

Van de Velde's series shows little interest in *staffage* as it expresses the traditional themes of the *points du jour*. *Aurora* is the most conservative of his prints in this matter of accessories. Counterbalancing the natural light of the rising sun, a tiny fire silhouettes a decorative group of people in the heart of the picture's dark space. These men and women represent a unitary interpretation of two time-honored themes—"warming oneself at fire" from the winter landscape and "family breakfast at the hearth" from the *points du jour*, here rendered as out-of-doors activities.[49] The heroes of the marine are not these stock accessories, however, but those instruments of Dutch overseas expansionism which they serve: the line of herring boats and noble merchant vessels overlapping the horizon. Each of these masters of the ocean has a physiognomy of its own and is rendered in ship portraits so detailed that they include minute accounts of rigging. As a document in the heroic epoch of bourgeois life in Holland, *Aurora* suggests that van de Velde's audience was made up of well-to-do Dutch merchants

49. Wolfgang Stechow, "The Winter Landscape in the History of Art," *Criticism*, 2 (1960), 176.

and tradesmen then disputing the empire of the sea with English entrepreneurs.[50]

Nox's *staffage* is an ingenious modernization and localization of a theme from one of the sources of the *points du jour*. Woodcuts of Saturn, the patron of necessary work and the regent of the day's last part, generally include women who wash clothes in a tub or by a stream. Van de Velde's *Nox* reinterprets this activity in contemporary terms as "La blanchisseuse," an outdoor bleachery where workers wash linen (imported from Brabant and Flanders by Dutchmen like the artist's own family, who were active in this trade). By contrast, *Vesper* is a work of deep solitude. Its only emphatic human association is a classical temple. Overshadowed by a tall tree, the temple counterpoints the art of man with the art of nature, and serves as a nostalgic reminder that once in a Golden Age people lived in this hushed countryside now enjoyed by cows and sheep. Landscapes such as this one, which deify nature as something beyond man's scope, were rare phenomena, even among the most romantic examples of seventeenth-century Dutch art.[51]

Jan van de Velde was a popular printmaker in his own era. The many editions and states (engravings retouched or revised by the artist) of his *Seasons, Months,* and *Times of the Day* bear witness to the success that greeted his labors; his reputation and work traveled far. The presence of his art in England in the late seventeenth century and its inescapable influence there during Hogarth's lifetime was due in large measure to the patronage that Charles II and James II showered on several Dutch painters of marine subjects and, with special generosity, on the van de Velde family.[52] The British Museum is the only major European institution to hold complete sets of his *Times of the Day* in all its states.

Nicholas Berchem's (1620–1682) *Times of the Day* (Figs. 21–24) explores new ground by extending the *points du jour* to include among its subjects those Theocritean countrysides from Italy which flourished in the work of artists born between 1595 and 1655, supplanting to a greater or lesser degree native landscapes

50. Jan van de Velde was married to Christina F. Non, the daughter of a wealthy shipowner (Jan Gerritt van Gelder, *Jan van de Velde* ['s Gravenhage: Nijhoff, 1933], p. 7).

51. Wolfgang Stechow, *Dutch Landscape Painting of the Seventeenth Century*, Kress Foundation Studies in the History of European Art, no. 1 (London: Phaidon, 1966), p. 7.

52. *Bryan's Dictionary of Painters and Engravers*, rev. ed., ed. George C. Williamson, V (London: Bell, 1905), 234–235.

21. Nicholas Berchem, *Aurora*, engraved by Jan Visscher. 29.8 × 36.2 cm. (Courtesy Rijksmuseum)

22. Nicholas Berchem, *Meridies*, engraved by Jan Visscher. 29.8 × 36.2 cm. (Courtesy Rijksmuseum)

MERIDIES.

VESPER.

23. Nicholas Berchem, *Vesper*, engraved by Jan Visscher. 29.8 × 36.2 cm. (Courtesy Rijksmuseum)

24. Nicholas Berchem, *Nox*, engraved by Jan Visscher. 29.8 × 36.2 cm. (Courtesy Rijksmuseum)

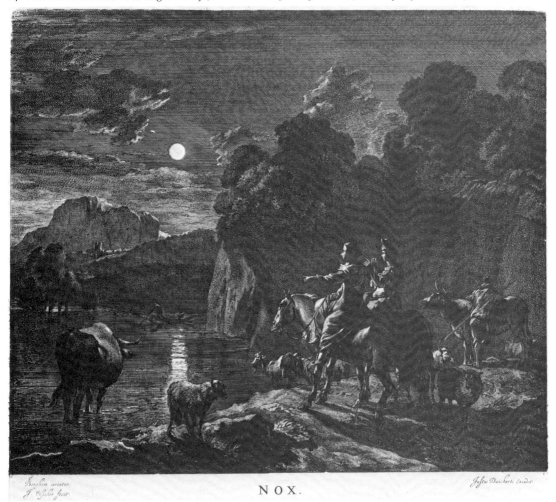

NOX.

such as van de Velde's.[53] Engraved by Jan Visscher and published by Dancker Danckerts, this quartet was reproduced from drawings or paintings now lost.[54] Executed after 1646 when Berchem had returned to Haarlem from Italy with sketches of landscapes, peasants, and animals, this ensemble is classified as the *points du jour* based upon the titles by which the individual prints are designated and catalogued: *Aurora, Meridies, Vesper,* and *Nox.* It is further strengthened by the appropriateness of the prints' subject matter to the "times of the day": *Aurora* (Fig. 21) prominently exhibits a rustic saddling his donkey for a journey, a motif that goes back to representations of Luna in planet pictures; *Meridies* (Fig. 22) depicts a woman nursing her child and men resting or carousing under a clump of trees. *Vesper* (Fig. 23) offers a scene of shepherding, and *Nox* (Fig. 24) shows an imaginative country saturnalia set in a poetic moonlit landscape. The tranquil sublimity of the nocturne is tempered by a scatalogical note—the urinating horse; the playfulness, recalcitrance, or willful behavior of Berchem's animals endeared him to collectors of the French Rococo.

The Haarlem painter's pastorals differ from the works of van de Velde in marked ways. His compositions move away from simple Dutch countrysides in the direction of views that are more rustic than Arcadian. Berchem, a member of the second and most important generation of Italianate landscapists, avoids the antique in scenery, mood, and composition. His countrysides, which replace an Italian presence with a nostalgia for Italy, are marked by a contentment, an optimism, a harmony, and a peacefulness.[55] In execution, they show acute technical powers of observation together with a certain degree of conviction.[56] More generalized than the countrysides of van de Velde, Berchem's are also stronger in their ability to show depth and compositional diversity. They do share one important quality of van de Velde's work—its composite character. Fantasy landscapes based upon the observation of nature, they depict places that exist only in the mind of the artist. All are invented and varied in conformity with an idealizing formula

53. Hollstein, *Dutch and Flemish Etchings, Engravings and Woodcuts,* I (Amsterdam: Hertzberger, 1949), 279.

54. John Smith, *A Catalogue Raisonné of the Works of the Most Eminent Dutch, Flemish and French Painters,* V (London, 1834), 104–105; Cornelis Hofstede de Groot, *Beschreibendes und kritisches Verzeichnis der Werke der hervorragendsten holländischen Maler des XVII. Jahrhunderts,* IX (Esslingen: Neff, 1928), nos. 854–857.

55. Stechow, *Dutch Landscape Painting of the Seventeenth Century,* p. 148.

56. Wolfgang Stechow, "Introduction," in *Italy through Dutch Eyes: An Exhibition* (Ann Arbor, 1964), n.p.

whereby each design is made up of a certain number of shepherds, shepherdesses, cows, goats, horses, trees, rocks, and mountains. Berchem's quartet eschews any suggestion of urbanity or even human civilization in the form of architecture. Its mood is light and artificial; its tone is poetic to the point of seeming studied.

Unlike van de Velde, Berchem does not transform the peasants of the *points du jour* into bourgeoisie or sanitize them completely. Setting them off against foils of rocks and trees, he magnifies their presence and gives them a prominence that has caused some scholars to describe his pictures as genre scenes with Italian backgrounds.[57] His campagna shepherds and their families are anecdotal, convincingly wedded to the land, and individualized to an unprecedented degree. Each of the wayfarers in *Meridies* (Fig. 22) has a distinct personality. Sharing in the restful, untroubled animality of the cattle that surround them, these insouciant men and women are almost low-life figures but have a kind of everyday believability to them. Berchem's characters are not completely free of the comedy in which Verhaecht often clothes his peasants (Figs. 9,11). Some are even caricatured in appearance or behavior; the herdsman who courts the shepherdess in *Vesper* (Fig. 23) is a grotesque, Brouwer-like gnome.

While Berchem's pictures include detailed studies of campagna types, they focus even more closely on animal life, in the manner of Aelbert Cuyp (1620–1691). In Berchem's art, the cattle, donkeys, goats, and sheep steal the show. His *points* studies the postures, dispositions, and habits of animals, their "souls," the peace they share with nature, and their behavior at different times of the day. These glorified beings appear in harmony and interdependence with the bucolics nominally superintending them, in scenes convincing to those who have never ventured into the countryside to witness the fierce cruelty of herders and the stubbornness of cattle. *Aurora* and *Nox* depict scenes of pastoral life enacted under lyrical skies against primitive formations of trees, rocks, and shrubs; *Meridies* and *Vesper* set similar idylls against more panoramic views stretching off to distant summits, whose contours are echoed by the monumental shapes of the cattle in the foreground.

By the mid-seventeenth century, the *points du jour* had become an artistic commonplace, a well-recognized and popular set piece identified with landscape and, as we shall see in what follows, with mythological allegory. These identifications were established not only in the art of the Netherlands but also in that of Switzer-

57. Ibid.

land, France and Germany.[58] The idiomatic status of the *points* as a familiar category of landscape art in particular is indicated by the fact that paintings by several masters were grouped together and published in sets of prints as *Les quatre points du jour*; reproductive engraving has always been a reliable guide to prevailing tastes and viewpoints.

Berchem's pastorals were especially popular as the subject of engraved sets of the "times of the day," no doubt because of their obvious glamor. They were also very much in vogue with connoisseurs and collectors (this painter had more engravings made after his work than any other Northern contemporary), especially in France and England, where Berchem's preeminence among Italianate landscapists was undisputed. Dancker Danckerts (1634–1666) engraved four unrelated landscapes of Berchem's and published them as the *Times of the Day*; these were scenes of peasant life depicted with skill and sympathy in poetic countrysides.[59] Dutch engravers were not the only artists to represent Berchem's paintings as the *points du jour*. Evidence for the strength and continuity of this practice beyond the Netherlands and into the eighteenth century is to be found in the work of the French engraver J. P. Le Bas (1707–1783), who reproduced yet another unrelated group of Berchem's paintings as *Les quatre points du jour*.[60] These four romantic landscapes, chosen from his later paintings, depict countrysides of delicate pictorial beauty. Monumental, refined, more Arcadian than rustic, they are populated by elegant ladies and their retinues and by shepherds of a more perfumed character than those in his earlier paintings.

Nor were his works the only ones that the popular taste for thematic art caused to be classified as the *points du jour*. Four of Claude's landscapes with religious subjects, executed for Henri van Halmale (1624–1676) and now in the Hermitage, Leningrad, were also entitled the *Four Times of the Day*.[61] Modern critics brand this denomination, first recorded in the eighteenth century but probably of earlier origin, a romantic misnomer. Whatever the date of misclassification, there can be little doubt that the tendency to identify suites of paintings and prints that treat pastoral subjects or

58. A. Pigler, *Barockthemen* (Budapest: Akadémiai Kiadó, 1974), II, 519–520.

59. Hollstein, *Dutch and Flemish Etchings, Engravings and Woodcuts*, V (Amsterdam: Hertzberger, n.d.), 130. Hollstein records yet another *points du jour* executed after pictures by Berchem, these engraved by P. Schenck (I, 277, no. 266).

60. Ibid., I (Amsterdam: Hertzberger, 1949), 274.

61. Marcel Röthlisberger, *Claude Lorrain: The Paintings* (New Haven: Yale University Press, 1961), I, 361–362.

examine the effects of light on certain countrysides testifies to the connection between the "times of the day" and landscape in the minds of artists and patrons of the seventeenth and eighteenth centuries.

The decline of Dutch art in general and of landscape in particular directly affected the fortunes of the *points du jour* dedicated to the painting of light and the representation of Arcadia.[62] This decline into an empty virtuosity, following the widespread imitation of imported styles, began early in Hogarth's lifetime and reached something of a climax in the course of the eighteenth century. The reputation of all Northern landscapes suffered a parallel deterioration, as John Constable's *Discourses* suggest. Looking back over the late seventeenth century, Constable characterizes Dutch nature painting as "this wretched art [that] was produced under the very worst stimulus." He singles out Nicholas Berchem for special abuse, saying of his paintings that they were "produced by his wife's broomstick laid over his shoulder."[63] These caustic remarks are not too surprising in themselves. However, what Constable writes about Hogarth's role in the subsequent history of landscape art in England seems very much worth pondering.

> Landscape was afterwards still further debased by Vernet, Hakert, Jacob Meer, and the English Wooten, the last of whom, without manual dexterity, left it in unredeemed poverty and coarseness, until Hogarth and Reynolds aroused the minds of our countrymen, and directed them to nature by their own splendid examples.[64]

III

The myths, deities, and art of the ancient world were always on the minds of artists of the seventeenth century. Classical antiquity served baroque painters and draftsmen in numerous ways. One of the most common functions of ancient images was as a vehicle for allegories of all kinds. Northern artists, intrigued by the study of myth which had been stimulated by the archeological rediscovery of antiquity in Italy, personified as pagan gods and goddesses the seven liberal arts, the four parts of the world, the seasons, the months, and the times of the day.[65]

62. For the classic modern account of this decline, see Kenneth Clark, *Landscape into Art* (1949; rpt. New York: Harper & Row, 1976), p. 65.

63. John Constable, *Discourses*, compiled and annotated by R. B. Beckett, XIV (Ipswich: Suffolk Records Society, 1970), 56.

64. Ibid., 58.

65. Seznec, pp. 214–215.

Carl van Mander pioneers the transposition of the times-of-the-day theme into the sphere of mythology (Figs. 5–8). His is the first *points* to identify systematically the day's periods with gods and goddesses from Roman legend. His series allegorizes each division of the day as not one but several mythic characters. By reducing the portion of the designs devoted to genre, he gives a new importance to these identifications, which could hardly have been missed by later artists who knew the work of this famous man.

Crispijn de Passe the Elder (c. 1556–1637) is the first artist to take van Mander's interest in ancient myth to its logical conclusion. He adds new range to the times-of-the-day theme by rendering it primarily as a set of ancient gods and goddesses. De Passe created three different versions of the *points du jour*.[66] One set attributed to him or his atelier is part of a development sometimes identified as *fêtes galantes*. The others belong to (and are typical of) the allegorical branch of the *points*. Both suites are undated. It is likely that they were done around 1635, when the artist devoted himself to studies of the human body and its functions.[67]

Under de Passe's burin, the *points du jour* is realized in numerous guises and attitudes as those deities identified by the ancients with the sun, the moon, and other heavenly bodies closely associated with the passage of time. These pagan divinities are clothed in an iconography that draws upon Italian or Northern archetypes (themselves based upon models that provided the Renaissance with its first images of the ancient deities). The figures represent studies in the anatomy of the nude or in the contrasts of male and female beauty, but most of all, they are illustrations of the attitudes and postures of the human body.

De Passe's two series are dramatically different from one another and are essays in the major styles of the engraver's own lifetime. The first of these rival ensembles is articulated in a baroque vocabulary (Figs. 25–28), the prevailing idiom in painting and sculpture when the series was executed. It is marked by a robust naturalism and stresses painterly virtues. Its goddesses appear in graceful, natural attitudes free of tension and are arranged in pairs so that the action of one counters that of her companion. They are a dignified and solemn quartet, a sisterhood in the bloom of sensual attractiveness.

The second suite (Figs. 29–32) is realized in a mannerist style, an

66. Hollstein, *Dutch and Flemish Etchings, Engravings and Woodcuts*, XV, 203–204; XVI (Amsterdam: Van Gendt, 1974), 80. D. Franken, *L'oeuvre gravé des van de Passe* (Amsterdam, 1881), pp. 211–213.
67. *Bryan's Dictionary*, V, 232.

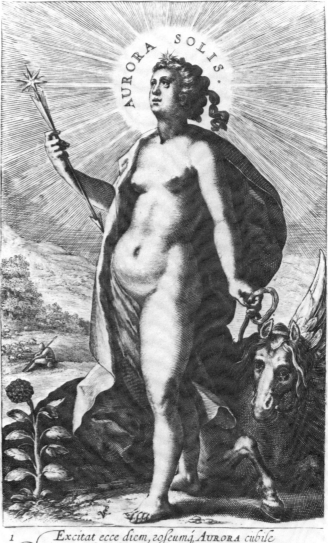

25. Crispijn de Passe the Elder, *Aurora.*
20.9 × 11.8 cm. (Courtesy
Rijksmuseum)

Behold Aurora stirs up the day;
She leaves the bed of her husband Tithonus.

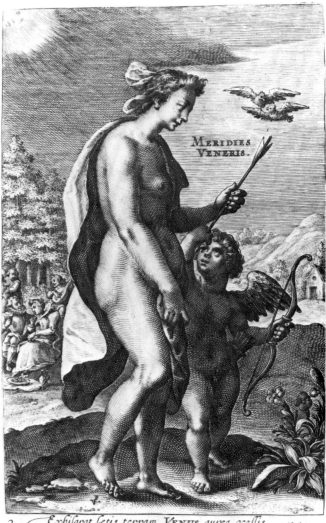

MERIDIES
VENERIS.

26. Crispijn de Passe the Elder, *Meridies*. 20.5 × 12.2 cm. (Courtesy Rijksmuseum)

Golden Venus makes the earth cheerful with happy eyes
And spreads out the midday with clear light.

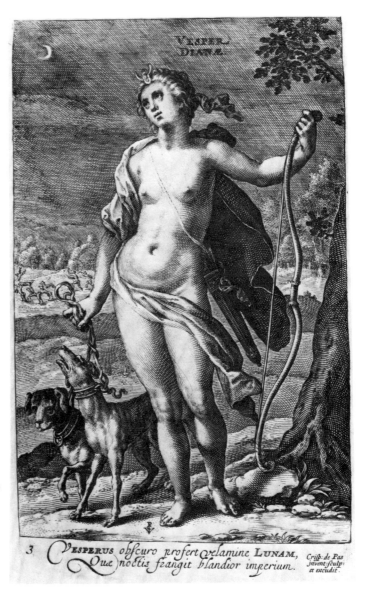

27. Crispijn de Passe the Elder, *Vesper*.
21 × 12.6 cm. (Courtesy Rijksmuseum)

Evening brings forth the moon with a dark covering
Which [moon], more enticing, breaks the rule of night.

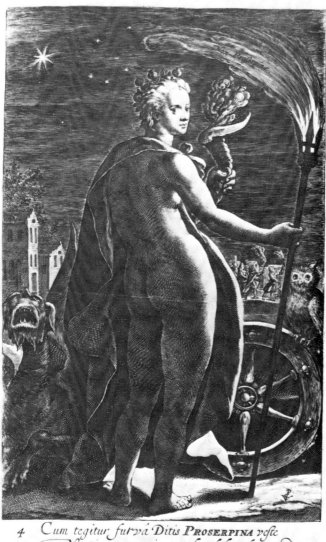

4 *Cum tegitur furvâ Ditis* **PROSERPINA** *veste*
Noctis amica quies membra labore levat.
Crisp de Pas invent sculp et excusor.

28. Crispijn de Passe the Elder, *Nox.*
21.4 × 12.4 cm. (Courtesy
Rijksmuseum)

When Proserpina is covered with the black garment of Dis,
The friend of night, sleep, frees limbs from labor.

old-fashioned and anachronistic language in 1635. It emphasizes artifice, and its values are sculptural. Its figures renounce the charms of mere physical beauty. They adopt instead stressful or impossible poses, which look like classical *contrapposto* carried to extreme lengths and show the body twisting, bending, turning, and reaching under the pressures of the mind.

De Passe's *Times of the Day* in the baroque style is a celebration of mythological scholarship (Jean Seznec calls it "fever") and a study in the physical beauty of women. The series's mythic interest is expressed in the identity of the four goddesses and in the emblems they carry. Morning, following literary and artistic tradition, is personified as Aurora (and is modeled closely after van Mander's Aurora [Fig. 5]). Her emblems are the well-known Pegasus (also derived from van Mander), the flower blooming before her (symbolic of her fertility), and the somewhat more arcane arrow, which may denote the power of this goddess to "sting" people into spiritual and physical activity each morning. Evening, also following the conventions of art and literature, is allegorized as Diana. Cast in her role as a huntress, she is endowed with emblems of the simplest kind: a crescent on her brow identifying her with the moon, a pair of retrievers, and a bow and arrow.

In mythological pictures noon is usually personified as Apollo, but de Passe allegorizes it as Venus. *Meridies'* goddess of love has apparently been wounded by Cupid's missile and "burned" in an amatory sense by the rays of Apollo, who gazes down on her from the intense noontime sun. The association between midday and sexual love (in contrast to evening's connection with chastity through Diana), or between erotic passion and midday torpor (Venus droops) is related to the notion that at noon—the most dangerous moment in the day—the passions are at the zenith of their powers; the conjunction may originate in Ovid's accounts of two different kinds of midday sexuality, one involving Callisto (raped by Jove at the height of a fiercely hot noontide) and the other Corinna (with whom the poet of the *Amores* [I, 5] has a midday tryst).[68]

The most singular of de Passe's personifications is Night, who is not the withered old man of Vos's and Verhaecht's series, but the goddess of the underworld (shown beside the chariot of night). A dreaded, unknowable, and unspeakable deity, Proserpina appears with her back to us in keeping with her anonymous character. A dramatic chiaroscuro figure, she is richly endowed with emblems,

68. Perella, p. 9.

as are so many allegories of night after Michelangelo's *Notte*. Her burning trident represents the underworld, winter, and night; her cornucopialike torch stands for Proserpina's second empire, the earth, spring, and day. The goddess is accompanied by her dog, Cerberus, a zoomorphic symbol of time; the monster's three heads were conventionally identified with dawn, midday, and "dusky eve" or past, present, and future.[69]

The four goddesses stand in landscapes filled with lush vegetation; this unity between figure and setting bears witness to the belief in a harmony between man and nature which is such an important part of the baroque aesthetic. The natural backgrounds contain depictions of recurrent human pleasures and obligations, all simplifications of van Mander's genre imagery. The bourgeois couple lunching behind Venus (Fig. 26) is drawn from van Mander's courtly lovers (Fig. 7), who are considerably reduced here and given an outdoor setting with a sylvan background. The pair eloping (Fig. 28)—their servants carry two caged birds, a popular emblem of marriage—are virtually indistinguishable in formal terms from van Mander's saturnalian revelers (Fig. 8). Reflecting the disintegration of the encyclopedic vision of the medieval age, the series makes no systematic attempt to illustrate the ages of man or the temperaments. These topics and similar subjects like the continents and the winds were engraved by de Passe and others to form a comprehensive account of the world's cosmology.

A graphic compendium of mythological personages like his earlier version, de Passe's *points du jour* in the mannerist style (Figs. 29–32) was executed perhaps as an academic exercise and certainly as a pendant to the baroque set. More elaborately crafted, more contrastive, and celebrating a different pantheon of gods and goddesses, the mannerist *Aurora, Meridies, Hesper,* and *Nox* enthrone two male and two female deities as rulers of the day.[70] The divinities identified with the day's parts are those familiar gods and goddesses sanctioned by tradition; evening is, however, personified as Hesperus, the grandfather of the Hesperides or "daughters of twilight," who live at the western border of Oceanus. Shown as a mature, athletic river god, this herdsman also resembles Hercules

69. Erwin Panofsky, *Meaning in the Visual Arts* (New York: Anchor, 1955), pp. 161–162.

70. De Passe's four deities are actually ordered in contrasts that mirror the arrangement of Michelangelo's *Allegories* for the Medici tombs. The Dutch engraver's gods and goddesses no longer lie prone and dying, of course; filled with a life-giving vigor, they are inspired to this existence by a less ambivalent attitude to pagan divinities on the part of their creator than the master held.

(with whom Hesperus was sometimes conjoined in legend), for he calls out to his flock as if on Amphitryon's farm ("ite capellae") and tips over the urn from which the ocean and its creatures issue.[71]

If the beauty of the mythographer's earlier goddesses is the expression of their perfection, the energy of his second pantheon is the metaphor for their divinity. All appear in complicated, almost distorted poses. As figures of asymmetrical elegance, the women have a power, fullness, and weight suggesting—especially in the case of Aurora—the beneficence of Rubens. By contrast, the men are athletic and muscular but no less exquisitely attitudinized or cultivated in their tense stances.

The artful, paradoxical quality of this series is manifest in the emblematic accessories of the gods and goddesses. For example, while in de Passe's baroque *points* the flower that identifies Aurora with spring grows out of the earth, in this version a bouquet sits in an elegantly wrought vase. The same artful effect is even more emphatically present in the sculptural realization of the four divinities: the deities' attitudes are self-conscious and monumental; their gestures are tutored, precious, and refined. "The gods are jealous of their own statues," Seznec observes, "they it is, and not the gods themselves, that inspire devotion."[72] This statuesque quality is due to the fact that the images are based upon sculptural archetypes or values derived from such archetypes. Aurora is modeled upon Giambologna's (1529–1608) statue of *Astronomy* or on one of its hundreds of imitations; the goddess of dawn has the same formulaic pose, the same tiny head, the same vigorous gesture, and the same sense of *disegno* or pattern, though she is much less attenuated, more abundant, and more full figured.[73] Her exposed pelvis and the Oriental prominence of her breasts also associate her with Leonardo's *Leda*, with whom she is an allegory of generation.[74] Apollo, the most authoritative of the four Olympians, takes his stance and architecture from a memory of the *Apollo Belvedere*, such as one of the drawings of it in the *Codex escurialensis*, or a derivative, perhaps Andrea Mantegna's (1431–1506) *Baccanal with the Vat*, showing a bacchant with a cornucopia in his right hand and a bunch of grapes in his left.[75] And Proserpina, who ascends the podium that Aurora leaves, does so

71. *Oxford Classical Dictionary*, 2d ed., (Oxford: Clarendon Press, 1976), p. 511.
72. Seznec, p. 212.
73. Kenneth Clark, *The Nude: A Study in Ideal Form* (1956; rpt. New York: Doubleday, 1956), p. 196, fig. 103.
74. Ibid., p. 176.
75. Panofsky, figs. 77, 79.

Aurora, friend to the Muses.

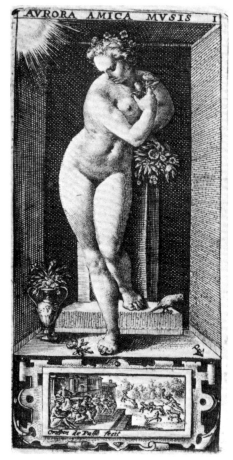

29. Crispijn de Passe the Elder, *Aurora.*
8.7 × 4.2 cm. (Courtesy Rijksmuseum)

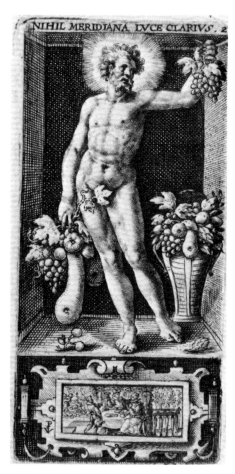

30. Crispijn de Passe the Elder, *Meridies.*
8.7 × 4.3 cm. (Courtesy Rijksmuseum)

Nothing clearer than the light of noonday.

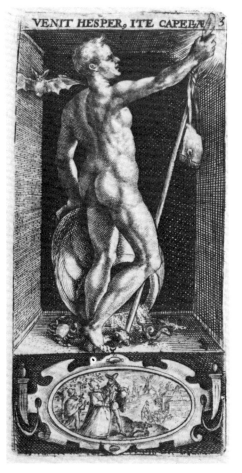

Evening is coming, go [home], goats.

31. Crispijn de Passe the Elder, *Hesper*.
8.7 × 4.2 cm. (Courtesy Rijksmuseum)

32. Crispijn de Passe the Elder, *Nox*.
8.6 × 4.3 cm. (Courtesy Rijksmuseum)

Night, persuading nothing moderate.

in a manner that displays the formal beauty of her back, an aspect of the female nude not commonly exhibited in post-medieval art before the eighteenth century, but appreciated in antiquity, as we know from the *Venus of Syracuse*.[76]

The impression of plasticity under discussion here is also due in some measure to the way the backgrounds of the scenes are constructed. The natural landscapes of the earlier prints are replaced by simple schematic backgrounds. These accommodating spaces intensify the figures' sculptural impact, which is further enhanced by the way the deities move in and out of the niches or even violate them, as Hesperus does with his crook. Because they are artifacts, the spaces also stress the primacy of the figures over that unity between man and nature which is underlined by de Passe's baroque sequence. Verses—more properly, epigrams—are inscribed at the top of each design; these legends imitate the content and form of monumental inscriptions and serve to stress further the whole illusion of plasticity. They are chosen from well-known literary accounts of pastoral life; for example, *Hesper*'s epigram, "Go home my goats, the evening star is come," is drawn from the seventy-seventh line of Vergil's tenth *Eclogue*.

While niches replace landscapes in de Passe's mannerist sequence, genre scenes with outdoor backgrounds are not expelled, though they are reduced in importance. Set in the prints' bottom registers, they are executed illusionistically as murals. In witty contrast to the "sculptured" gods and goddesses above them, these decorations are framed by mock bas-relief cartouches and given an emphatic painterly character. They are paired off in sets of popular juxtapositions, such as work and play, and tied formally or thematically to the deities who stand over them. In *Hesper*, the staff that Hesperus holds aloft is a variation on the crook used by the shepherd to drive his flock homeward. In *Meridies*, the sun god offers up a reminder of the season of his preeminence: a bountiful cluster of grapes; within the oblong cartouche below, two Dionysian celebrations take place: in the foreground, lovers sit at a table and sip wine from tasters while, in the background, a couple picnic on the ground and quaff wine from a common jug.

If the scroll-like settings of these miniature murals are elaborate and the style painterly, the subject matter is simple and realistic. *Meridies* (Fig. 30) shows two bourgeois lovers at lunch, a demonstrative man and a reserved woman. *Hesper* (Fig. 31) features the same couple, or analogues for them, at a later, more staid time in

76. Clark, *The Nude*, p. 209.

their lives, when they have married and raised a child. The original idea for portraying family life in evening comes from Verhaecht's *Vespera* (Fig. 24), where it receives a robust, satirical reading in the peasant woman and child dragging home from the town an unruly, tipsy father. Translated into bourgeois terms in de Passe's *Hesper*, the tableau is very much refined or conventionalized: the peasants become a typical middle-class household; the father's drunkenness is changed into courteousness and solicitude, the mother is made pregnant, the female child becomes male, and the family gains a dog. These alterations in the subject matter of de Passe's series indicate an advanced state of ossification in the *points du jour*'s social referents. Although they have been disguised by a little bourgeois coloring, de Passe's subjects are essentially Arcadian. Remote from existence and narrow in appeal, they are drawn not from seventeenth-century Dutch life but from the work of other artists such as Vos and Verhaecht. The balance between art's formal and social aspects is gone from the *points du jour*.

The proliferation of mythological allegories of the "times of the day" after humanistic learning had reintegrated the world of classical antiquity offers evidence—repetitious and bleak—of the sterility of the human imagination.[77] With the rise of "scientific" interest in classical antiquity, these compositions multiplied as independent suites of engravings and as illustrations to emblem books. In both formats, the images' social referents—always feeble—became more and more derivative and shadowy until they finally vanished. As independent suites of engravings, the compositions exchanged social content for special aesthetic effect. They attempted to convey the physical reality of ancient statuary, to elaborate the mythological character of a god or goddess, or to define the ideal nature of classical beauty, tasks for which Dutch art (with its realistic bias) was inherently ill-suited. The appeal of these prints was to an audience composed primarily of amateur classicists, antiquarians, and dilettanti.

As illustrations to emblem books (of which Cesare Ripa's *Iconologia* [1593] is the prototype), mythological allegories of the "times of the day" converted the deities and their images into ethical truths and philosophical abstractions—hieroglyphs essentially.[78] Moralized and allegorized, the deities were no longer important from an aesthetic or formal point of view. Instead the notions the gods and goddesses stood for became paramount and

77. Seznec, p. 211.
78. Praz, p. 201.

their antique appearance was intended only to give a patina of ancient authority to modern abstractions.[79] The conventions by which the divinities were depicted became fixed and hackneyed. As a consequence, the *points du jour* theme was increasingly expressed in an iconography evolving in the direction of greater erudition and formula. Its elements were repeated and interchanged from one example to another; its backgrounds and motifs were obscured entirely or replaced by emblematic trappings designed only to amplify and refine nonvisual definitions. The greater the emphasis on the abstraction, the paler and more etiolated the images became, until as E. H. Gombrich points out, they were finally as incorporeal as the notions they were intended to symbolize.[80]

Something of the ultimate fate of the mythological-allegorical division of the *points du jour* may be gathered from the emblematic version of *Les quatre parties du jour* (Fig. 33) in Cesare Ripa's *Iconologie,* published in Paris in 1643. In this work, illustrated by the Fleming Jacques de Bie (c. 1581–1643) and edited by Jean Baudoin, a classical scholar and charter member of the Académie Française, the extensive letterpress of the "times of the day" is accompanied by four emblems, "Le Matin," "Le Midy," "Le Soir," and "La Nuict."[81] These devices are based directly upon de Passe's baroque *points du jour.* In fact, de Bie's compositions amount to little more than reinterpretations and reworkings of de Passe's formulas. And timid reworkings they are at that. Cast as tondos instead of as rectangles, robbed of their painterly aspect, and reduced in size to miniatures, the emblems omit social referents entirely. They further simplify the visual image by leaving out secondary details and symbols, such as animals and heavenly bodies.

Designed, in the words of one of their apologists, Christophoro Giarda, to leap to the eyes of the beholder, penetrate the mind at once, and declare their natures even before they are scrutinized, the symbolic images enlarge and exaggerate detail.[82] The result is a form of allegory and myth which is as clear as it is mechanical and obvious. Stripped of mimetic and social dimensions, these secondhand pictographs are reduced to mere decorations or visual supplements, rhetorical in nature and insular in appeal. Some are executed carelessly; Diana has a large bow but no quiver and no

79. Seznec, p. 278.
80. Gombrich, *Symbolic Images,* p. 183.
81. Cesare Ripa, *Iconologie* (Paris, 1643), II, 176.
82. Quoted by Gombrich, *Symbolic Images,* p. 145.

LES QVATRE PARTIES DV IOVR.

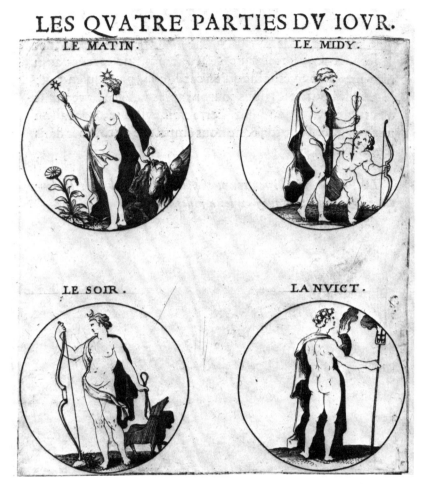

LE MATIN. LE MIDY.

LE SOIR. LA NVICT.

33. Jacques de Bie, "Les quatre parties du jour" from Cesare Ripa's *Iconologie*. 13 × 13.5 cm. (Courtesy The Newberry Library, Chicago)

arrows. Others are rendered in ways to suggest misreadings of the source; Prosperpina's cornucopialike torch, emblematic of spring and day, blazes away alongside her trident, emblematic of winter and night. Still others are executed crudely: postures are overstated or accessories are out of proportion.

In the conception of these emblems, an academic concern for ideas and pedantries eclipses an interest in beauty and form. The creative force behind mythological allegory fails as memory replaces imagination and repetition supplants vitality. Almost one hundred years before Hogarth had plotted his satirical assault against the *points du jour*'s imitation of past models and its use of clichéd themes, the topos had become impoverished and insipid, anticipating by only a short period the general decline of Dutch art after 1670.

{ 3 }

"The Four Times of the Day"

O<small>N</small> the continent, allegorical and mythological art had become convention-bound by the end of the seventeenth century. Jean Seznec gives an accurate account of the decline of curiosity in the mythological and the causes behind that decline, primarily in France.

> Increasingly erudite and diminishingly alive, less and less felt but more and more intellectualized—such, from now on, it seems, is to be the inescapable evolution of mythology. Indeed, the discussions which take place in seventeenth-century France, for example, on the topic of the "merveilleux païen"—the arguments advanced by the defenders of the gods, as well as by their adversaries—give proof of the drying up of poetic sentiment in the realm of Fable, which is now regarded as no more than "un amas de nobles fictions" and "ornements reçus" or as an adjunct in teaching, intended for the edification of the young, and especially for the instruction of princes.[1]

In England, at the end of the seventeenth and the beginning of the eighteenth century, such forces as empiricism, rationalism, and

1. Jean Seznec, *The Survival of the Pagan Gods,* trans. Barbara Sessions (1953; Princeton: Princeton University Press, 1972), p. 321.

Christianity further altered the attitude of the ascendant middle classes toward myth.[2] The pagan gods and goddesses who had been first the subject of love and later of study finally became the object of attack and grew progressively less acceptable and less common as the métier of art and belles-lettres.[3] This antimythological development, perhaps most closely related to the rationalistic spirit of the natural sciences, was intensified by the widespread acceptance of common sense as a standard of judgment in all matters. A classic case against mythology, Thomas Sprat's hortatory argument in *The History of the Royal Society* (1667) exiles the ancient deities from the realms of poetry because they are fictive beings: "The *Wit* of the *Fables* and *Religions* of the *Ancient World* is well nigh consum'd: They have already serv'd the *Poets* long enough; and it is now high time to dismiss them; especially seing [sic] they have this peculiar *imperfection*, that they were only *Fictions* at first: whereas *Truth* is never so well express'd or amplify'd as by those Ornaments which are *Tru* and *Real* in themselves."[4]

Perhaps the most familiar aesthetic pronouncement of the age on mythology's "parcel of School-boy Tales" is Joseph Addison's stricture published in *The Spectator* of 30 October 1712. "If you read a Poem on a fine Woman, among Authors of this mythologizing Class," Mr. Spectator laments wittily, "you shall see that it turns more upon *Venus* or *Helen,* than on the Party concerned. I have known a Copy of Verses on a great Hero highly commended, but upon asking to hear some of the beautiful Passages, the Admirer of it has repeated to me a Speech of *Apollo* of a Description of *Polypheme.* At other times when I have searched for the Actions of a Great Man, who gave a Subject to the Writer, I have been entertained with the Exploits of a River-God, or been forced to attend a Fury in her mischievous Progress, from one end of the Poem to the other."[5] Addison argued against the employment of gods and goddesses in literature on the basis of their incompatibility with religious beliefs. A satirical "Edict" in this *Spectator* essay (not binding on women and schoolchildren) includes the provision that "do hereby strictly require every Person, who shall write on this Subject, to remember that he is a Christian, and not to Sacrifice his

2. K. K. Ruthven, *Myth* (London: Methuen, 1976), p. 48.

3. Seznec, p. 321.

4. Thomas Sprat, *The History of the Royal Society,* ed. Jackson I. Cope and Harold W. Jones (St. Louis: Washington University Press, 1958), p. 414.

5. Joseph Addison, *The Spectator,* ed. Donald Bond (Oxford: Clarendon Press, 1965), IV, 362.

Catechism to his Poetry."[6] Addison makes one important exception to this general prohibition. "In Mock-Heroick Poems, the use of the Heathen Mythology is not only excusable but graceful, because it is the Design of such Compositions to divert, by adapting the fabulous Machines of the Ancients to low Subjects, and at the same time by ridiculing such kinds of Machinery in Modern Writers."[7]

William Hogarth's philosophy of myth (he calls it "antiquity") in art differs very little from the views of these two contemporaries. It stands in vivid contrast, however, to the attitude of Sir Joshua Reynolds (1723–1792), the most distinguished portraitist of eighteenth-century England and the first president of the Royal Academy, who saw the classical as a means of ennobling the contemporary by endowing it with an atemporal character, with a universality and a sublimity. In his unfinished "Autobiographical Notes" in a strongly worded observation (not least interesting as a testimonial to the artist's fear—quite justified—that his work was misunderstood), Hogarth defends his manner of painting, with its independence and its empiricism. He contrasts it with the styles of those academicians devoted to traditions that are book-learned, false, obsolete, and unintelligible. "As my notions of Painting differ from those Bigots who have taken theirs from books, or upon trust I am under some kind of necessity, as an apology for works to submit mine to the public, but not with the least hopes of bringing over either those Interests . . . or such as have been brought up to the old religion of pictures who love to deceive and delight in antiquity and the marvelous and what they do not understand, but I own I have hope of succeeding a little with such as dare to think for themselves and can believe their own Eyes."[8]

These are burning issues for Hogarth, and he returns to them again and again. In his *Apology for Painters*, he attacks the blind, fashionable attachment to "great masters," using as his example mythological subjects that he associates with the sublime style. "I

6. Ibid., 363.
7. Ibid., 362.
8. William Hogarth, *The Analysis of Beauty*, ed. Joseph Burke (Oxford: Clarendon Press, 1955), p. 209. Hogarth's "Autobiographical Notes" and *Apology for Painters* were reproduced from rough drafts; Burke's transcript of the "Notes" and Kitson's of the *Apology* (see below, n. 9) are difficult and sometimes even impossible to follow because Hogarth's jottings are elliptical and virtually unpunctuated. In quoting from these two sources, I have emended punctuation, spelling, and capitalization and have supplied missing words to the extent necessary to clarify the artist's meaning.

have seen many Pictures in collections valued at large sums which, placed at brokers' doors unknown as great masters, would not fetch one shilling to cover a bare wall, particularly of the historical kind called the Sublime, such as Venuses and Cupids, etc." If picture jobbers and connoisseurs love only what is in vogue, who are the true judges of painting? To his own question Hogarth replies: "The only true judge would be the man who makes himself master of everything, so as to be capable of carrying things to the utmost height himself and at the same time a man of honour, veracity, and destitute of prejudices as far as that is possible. . . . He bids a fair chance for judging of the most material part of a Picture with more precision than even a good Painter wanting his understanding."[9] This statement is remarkable both for the way it illuminates the artist's conception of his ideal audience and for the way in which it anticipates Samuel Johnson's democratic philosophy of literary merit in his *Life of Gray* (1779). "By the common sense of readers uncorrupted with literary prejudice," Johnson declared, "after all the refinements of subtlety and the dogmatism of learning, must be finally decided all claim to poetical honours."[10]

Hogarth's antimythological philosophy is perhaps sharpest and most particularized in his "Britophil Essay" written in defense of Sir James Thornhill (*St. James Evening Post,* 7–9 June 1737). Again exhorting English patrons "to see with their own Eyes" and let "Comparison of Pictures with Nature be their only Guide," he angrily attacks *"Picture-Jobbers from abroad"* who sell sham virtuoso-pieces and dark masters by means of their fashionable cant, which confuses the judgment and misleads the natural taste of Britons. Addressing one such jobber in the persona of "a Man, naturally a Judge of Painting," he has him charge, "Mr. *Bubbleman,* That Grand *Venus* (as you are pleased to call it) has not Beauty enough for the Character of an *English* Cook Maid."

The same issue of the *St. James Evening Post* that carried the "Britophil Essay" also contained Hogarth's announcement of his proposals for publishing by subscription *Morning, Noon, Evening, Night,* and *Strolling Actresses Dressing in a Barn;* it describes the pictures as completed and the "Five large Prints" as "now engraving (and in great forwardness)."[11] Since one of the characters from

9. William Hogarth, *Apology for Painters,* ed. Michael Kitson, *Walpole Society 1966–1968,* 41 (Glasgow: The University Press, 1968), 103.

10. Samuel Johnson, *Lives of the English Poets,* ed. G. B. Hill (Oxford: Clarendon Press, 1935), III, 441.

11. The subscription was advertised initially in the *St. James Evening Post* of 10–12 May, and it was repeated with some frequency in subsequent issues.

Noon is a strikingly beautiful English cook-maid with an amorous, sanguine humor marking her as a London Venus, perhaps it is not too improbable to surmise that Hogarth's most elaborate manifesto on mythology in art is to be found not in his writings but in his pictures, and specifically in the progress he seems to refer to in the "Britophil Essay," *The Four Times of the Day.*

While the gods and goddesses of the ancient world were being banished from English art and belles-lettres, so were their earthly bowers and habitats. The highly artificial system of pastoral conventions, which was fostered by court circles and fundamentally indifferent to the daily life of the ordinary person, fell into disrepute. No writer makes the basis of this disfavor clearer than Samuel Johnson. In an attack on Arcadianism in his *Life of Gay* (1781), he identifies the pastoral's nemesis as the same common-sense empiricism that had exiled the pagan divinities from Britain. Dismissing the entire convention as tiresome and infantile, he writes, "There is something in the poetical Arcadia so remote from known reality and speculative possibility, that we can never support its representation through a long work. A Pastoral of an hundred lines may be endured; but who will hear of sheep and goats, and myrtle bowers and purling rivulets, through five acts? Such scenes please barbarians in the dawn of literature, and children in the dawn of life; but will be for the most part thrown away as men grow wise, and nations grow learned."[12]

While England's devotion to Arcadianism was falling off, its interest in landscape was growing. By the early eighteenth century, the taste for topographical landscape painting had become firmly established.[13] To the disappointment and anger of some native artists such as Hogarth, however, British landscape art was dominated by Netherlandish and Italian influences. During the first three decades of the century in particular, Dutch and Flemish landscapes were unrivaled in popularity. The dominance of the Northern School was due partly to the availability of fresh supplies of paintings and engravings at no great distance; English dealers frequently made purchasing excursions to the Netherlands. It was further bolstered by the influx of Northern craftsmen (most of them without significant ability) who had come to England to seek their fortune. One of the consequences of Dutch and Flemish influence was that British landscape art appeared imitative and deriva-

12. Johnson, II, 284–285.

13. Luke Herrmann, *British Landscape Painting of the Eighteenth Century* (London: Faber & Faber, 1973), p. 18. In the following discussion of British landscape art, I am indebted to Herrmann's study.

tive. In his retrospective account of 1782, the anonymous author (Joseph Holden Potts, 1759–1847) of *An Essay on Landscape Painting* writes, "In this branch of the art particularly, our countrymen have contented themselves with imitating the ideas of other masters, when they should have copied nature only."[14] It was precisely this concern with copying and imitation that colored Hogarth's attitude to landscape and was responsible for the low esteem in which he held it. In his "Autobiographical Notes" he writes, "Landscip painting, ship painting, &c may be ranked with still life" which he defines as "a species of painting in the lowest esteem because it is in general the easiest to do & is least entertaining."[15] Hogarth's low estimate of landscape painting is not very remarkable in itself, for it represents the received wisdom of his own and former ages about the hierarchies of styles and periods. He further qualifies his view, however, in reflecting on the skills of landscape painters. "If only copied as they chance to it, composition is required; yet judgment, *that* the copiest has no need of and therefore may be a man of but mean abilities and yet with those who do not consider, may be thought great men as Artists."[16] Cryptic as his content and difficult as his syntax is here, even in an edited form, it is still perfectly evident that Hogarth's estimate of the achievement of landscape "copiests" is even lower than the general regard in which it was then held. It is equally clear that for Hogarth landscape, as he saw it practiced, was a mechanical and a derivative art.

The most celebrated and enduringly popular assault on mythology, Arcadia, and ideal landscape "painting" in English literature is Jonathan Swift's "Description of the Morning." Published in *The Tatler*, number 9 (28 April 1709), the poem is attributed by Isaac Bickerstaff to his relation, Humphrey Wagstaff, whose revolutionary and militant empiricism has "run into a way perfectly new, and described things exactly as they happen: he never forms fields, or nymphs, or groves, where they are not, but makes the incidents just as they really appear."[17] Frequently regarded as a vivid but uncomplicated essay in realism, the poem is indeed a detailed, eyewitness account of eighteenth-century London life as it unfolds amidst a unique, identifiable cityscape. But it is also a volley aimed at mythological accounts of morning in the sublime style, a broadside against literary landscapes "gilded" with metaphors, figures,

14. Quoted by Herrmann, p. 16.
15. Hogarth, *Analysis*, pp. 214–215.
16. Ibid., p. 215.
17. *The Tatler*, ed. George A. Aitken (1898–1899; rpt. New York: Adler, 1970), I, 81–82.

and other rhetorical embellishments.[18] Aurora's biga (chariot drawn by two steeds) appears as a hackney coach in "Morning's" opening line. The saffron-robed goddess herself, who dutifully leaves Tithonus' couch to bring light to the world, is transformed into the prostituted chambermaid Betty, who "flies" from her master's sheets to discompose the bed she should be making. Instead of an Arcadian landscape, the poem delineates an urban wasteland. Here people are awakened not by the cock's shrill clarion or the lark's dulcet song but by the London coalman's street call and the chimneysweep's grating advertisement; here the shepherd swain about to sound his oaten pipe is none other than the jailer counting his criminal flock as they return from night-pasture to their fold, the prison.[19]

In a postscript to his kinsman's verses, Bickerstaff says, "All that I apprehend is, that dear Numps will be angry I have published these lines; not that he has any reason to be ashamed of them, but for fear of those rogues, the bane of all excellent performances, the imitators. Therefore, beforehand, I bar all descriptions of the evenings; as, a medley of verses signifying, grey-peas are now cried warm: that wenches now begin to amble round the passages of the playhouse: or of noon; as, that fine ladies and great beaux are just yawning out of their beds and windows in Pall Mall, and so forth."[20] There is no record that any poet published verses on morning, noon, or evening in violation of Mr. Bickerstaff's wish. Some twenty years after this humorous prohibition, however, its spirit was violated by a man whom Jonathan Swift had called upon for assistance in 1736 and had characterized as his own counterpart in the visual arts:

> How I want thee, humorous *Hogart?*
> Thou I hear, a pleasant Rogue art;
> Were but you and I acquainted,
> Every Monster should be painted.[21]

These verses in which Swift likens his own satiric methods to those of Hogarth are drawn from his "Description of the Legion Club." The poem is both an extensive allusion to and a commentary upon

18. Roger Savage, "Swift's Fallen City," in *The World of Jonathan Swift*, ed. Brian Vickers (Cambridge, Mass.: Harvard University Press, 1968), p. 176.

19. Ibid., p. 177.

20. *The Tatler*, I, 82.

21. Jonathan Swift, *Poems of Jonathan Swift*, ed. Harold Williams, 2d ed. (Oxford: Clarendon Press, 1958), III, 839.

the literary traditions of the epic in general and the Sixth Book of Vergil's *Aeneid* in particular. At the same time it is one of Swift's most explicit and urgently topical satires. Using as its setting the immediate environs of Dublin's Trinity College, it transforms the new Irish Parliament House designed by Sir Edward Lovett Peach into the image of a madhouse:

> As I strole the City, oft I
> Spy a Building large and lofty,
> Not a Bow-shot from the College,
> Half the Globe from Sense and Knowledge.[22]

In the year the "Legion Club" was published, Hogarth (who rests his self-portrait on the works of Shakespeare, Milton, and Swift in *Gulielmus Hogarth*) produced the oils to *Morning, Noon, Evening,* and *Night*; the progress is dated in *Noon*, where the year "1736" may be seen in the tympanum of John the Baptist's sign. Like the "Legion Club," Hogarth's *Times of the Day* reflects the contemporary London cityscape and its architectural features and attacks the conventions of a specific artistic tradition. In their shared social, geographical, and aesthetic referents, Swift's poem and Hogarth's suite of pictures both combine diverse but interconnected levels of meaning and perspectives in a pattern typical of the complex nature of eighteenth-century satire.

II

Hogarth often used newspapers as a forum for elucidating and defending his aesthetic, as his "Britophil Essay" shows. There is a specific indication of his intention concerning *The Four Times of the Day* (oils: Figs. 34–37; engravings: Figs. 38–41) in the notice he composed to announce that the engravings were ready for their buyers. In the *London Daily Post and General Advertiser* of 25 April 1738, he wrote that he had "finish'd a Set of Prints, four of which represent, *in an humorous Manner*, the four Times of the Day, and the fifth a Company of Strolling Actresses dressing themselves for the Play in a Barn." Both the studied qualifier *"in an humorous Manner"* and the continental title of the work (the "Times of the Day" rather than "Morning," "Noon," "Evening," and "Night" employed in later, less critical announcements) are carefully calculated to distinguish the artist's own comic interpretation from the

22. Ibid., 829.

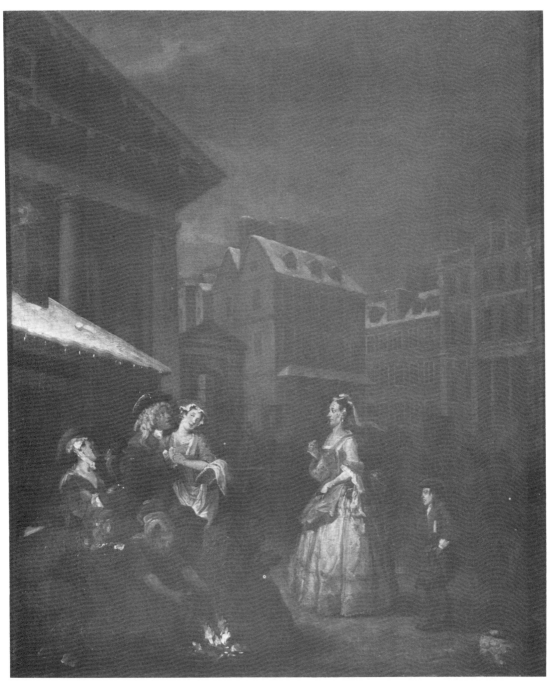

34. William Hogarth, *Morning*. Oil, 73.6 × 60.9 cm. (Courtesy The National Trust, Bearsted Collection, Upton House)

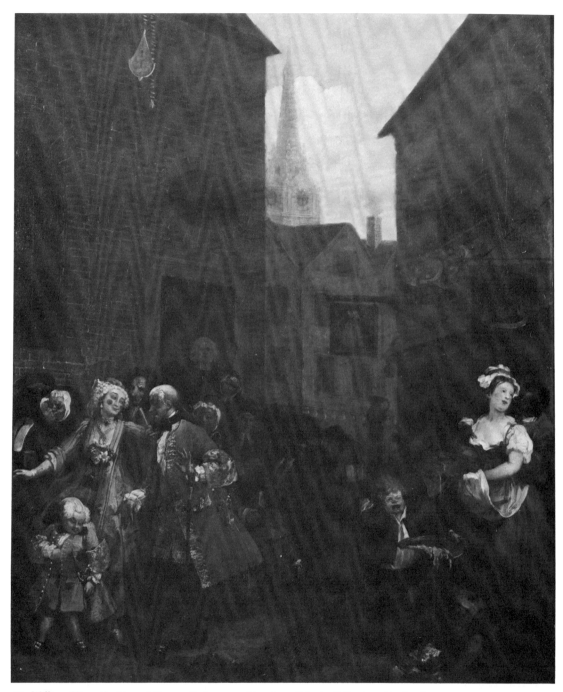

35. William Hogarth, *Noon*. Oil, 74.9 × 62.2 cm. (Courtesy Private Collection, England)

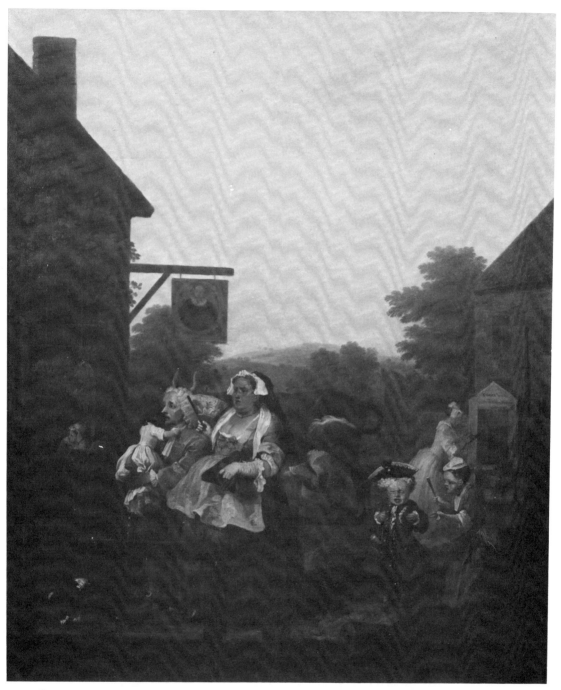

36. William Hogarth, *Evening*. Oil, 74.9 × 62.2 cm. (Courtesy Private Collection, England)

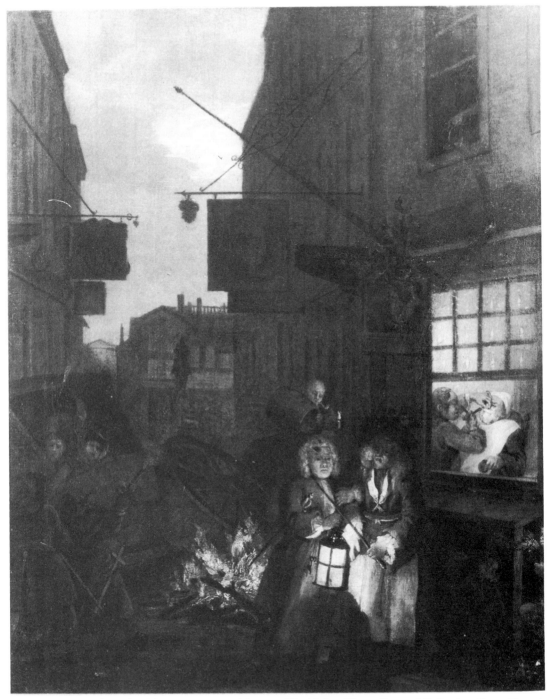

37. William Hogarth, *Night*. Oil, 73.6 × 60.9 cm. (Courtesy The National Trust, Bearsted Collection, Upton House)

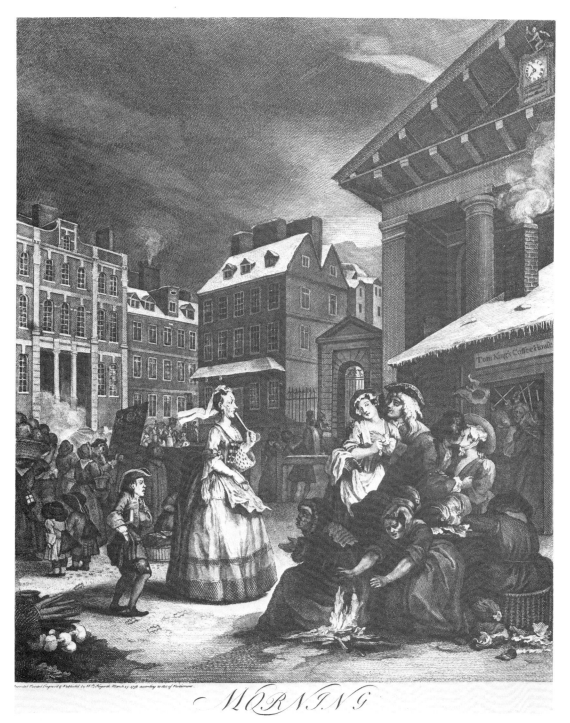

MORNING

38. William Hogarth, *Morning*, First State. 45.4 × 37.9 cm. (Courtesy The Huntington Library, San Marino, California)

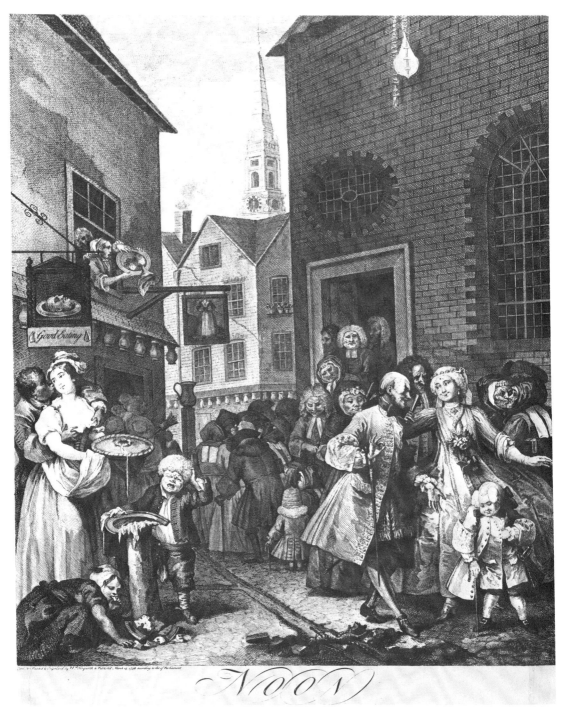

39. William Hogarth, *Noon*, First State. 45 × 38.1 cm. (Courtesy The Huntington Library, San Marino, California)

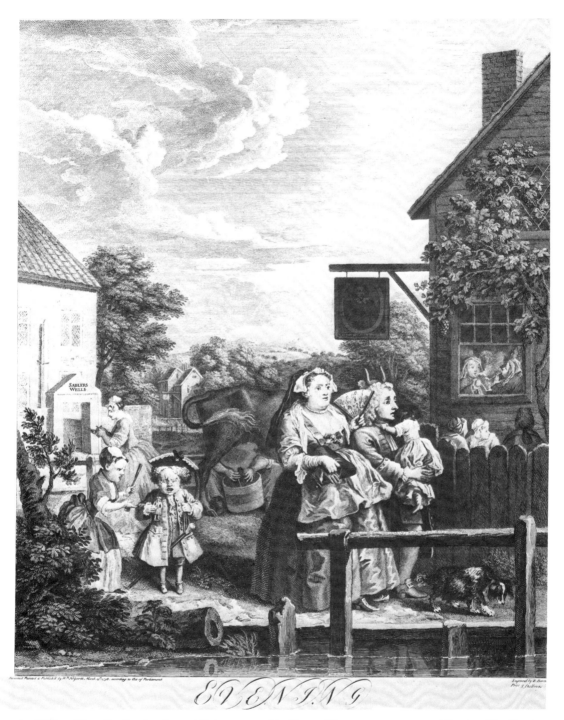

EVENING

40. William Hogarth, *Evening,* Second State, engraved by Bernard Baron. 45.4 × 37.4 cm. (Courtesy The Huntington Library, San Marino, California)

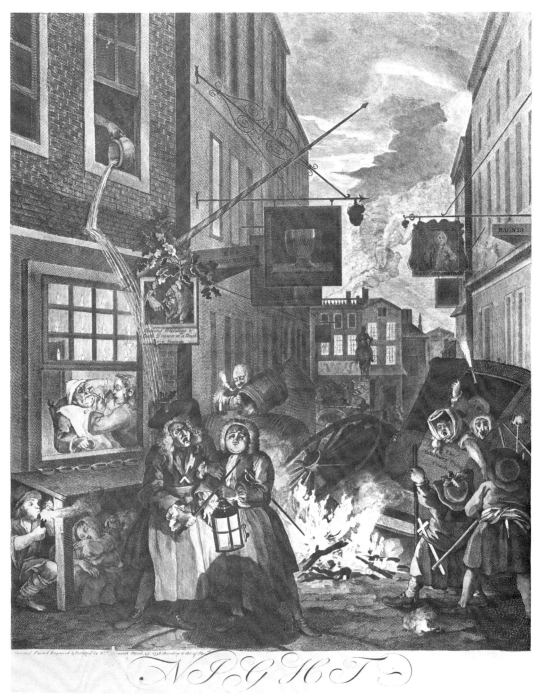

41. William Hogarth, *Night*, First State. 43.9 × 36.8 cm. (Courtesy The Huntington Library, San Marino, California)

sublime manner of the *points du jour*. With its emphatic authorial italicization of *"in an humorous Manner,"* the advertisement indicates in his own words Hogarth's familiarity with serious versions of the topos. But his knowledge of the theme is verified in other ways as well.

Hogarth was academically trained, having studied for some years at the Cheron-Vanderbank Academy in Saint Martin's Lane. On the basis of the orthodox schooling he obtained from continental artists there, he would have automatically become acquainted with the *points du jour* and other popular themes in the oeuvres of the old masters and their successors.[23] His schooling would also have introduced him to allegorical and mythological versions of the *points du jour* in that great textbook for artists by Cesare Ripa, the *Iconologia*. By the early eighteenth century, Ripa had become so widely diffused throughout Western culture that all artists were inevitably familiar with him.[24] Most probably Hogarth knew the topos in several of the many editions of the *Iconologia*. He certainly knew Jacques de Bie's version. One of the most popular of all Ripa editions, de Bie's volume describes itself in its long subtitle as an essential handbook for those aspiring to oratory, poetry, sculpture, and painting.[25]

Hogarth's education would have continued on a more congenial level at coffee houses, which typically auctioned off paintings and prints every week or so. In these places, as Paulson points out, Hogarth "had an opportunity to see an enormous body of paintings and engravings of the European Renaissance, both north and south, and as his works indicate, he took advantage of the opportunity."[26] At auctions in such coffee houses as the Three Chairs, Covent Garden, he would have encountered the *points du jours* of Jan van de Velde and Crispijn de Passe. Van de Velde's prints would have been especially attractive articles of trade during the first sixty years of the eighteenth century, when the influence of the Netherlandish School dominated English taste in landscape.[27]

23. Ronald Paulson, *Hogarth: His Life, Art, and Times* (New Haven: Yale University Press, 1971), I, 80–81.

24. Jean H. Hagstrum, *The Sister Arts: The Tradition of Literary Pictorialism and English Poetry from Dryden to Gray* (Chicago: University of Chicago Press, 1958), pp. 148–149.

25. An edition of Ripa in English featuring "Morning" and "Evening" was published in 1709 "for the Instruction of Artists in their Study of Medals, Coins, Statues, Bassorelievo's, Paintings and Prints, and to help their Invention" (Cesare Ripa, *Iconologia: or Moral Emblems* [London, 1709], n.p.).

26. Paulson, *Hogarth: His Life, Art, and Times*, I, 60.

27. Herrmann, p. 7.

De Passe's prints were known in London because he himself apparently lived and worked in England for ten years; his eldest son, Simon (1595–1647), certainly resided in London for extensive periods of time; and his third son, Willem (1598–1637), spent the greater part of his life there.[28] As a consequence, de Passe's engravings had a powerful presence in England, particularly among the aristocracy and the upper bourgeoisie, Hogarth's audience in the late thirties and early forties.

In addition to what he saw at school and at auctions, Hogarth would have been able to study yet another great collection of paintings and reproductive engravings at the house of his father-in-law. According to Paulson, Sir James Thornhill's collection included works by Francesco Albani (1578–1660).[29] Thornhill, England's foremost native ceiling painter, would certainly have owned Giovanni Frezza's (1659–1741) engraving of Albani's fresco of *The Four Times of the Day* (1703). Executed for the Verospi Palace in Rome, this design is among the earliest and most elaborate versions of the *points du jour* in a mythological vein.[30]

As a practicing artist Hogarth would also have encountered the times-of-the-day theme. In 1727, he was commissioned by a tapestry maker called Joshua Morris to produce a cartoon of *The Element of Earth*.[31] He could not have researched this subject without becoming familiar with the topoi that are interwoven with it: the seasons, the temperaments, and the times of the day. It was probably in these researches that he encountered Vos's work, a standard source among tapestry designers.[32] It also seems likely that Hogarth discussed this fashionable theme with Bernard Baron (c. 1700–1766), the French engraver whom he employed to execute the print *Evening*. And if Baron did not actually obtain popular versions of the tetralogy for Hogarth, he certainly would have

28. The information on de Passe's residency in England is based upon *Bryan's Dictionary of Painters and Engravers*, rev. ed., ed. George C. Williamson, V (London: Bell, 1905), 233. The information on his sons' English visits is drawn from A. M. Hind, *The Reign of James I*, pt. II of *Engraving in England in the Sixteenth and Seventeenth Centuries* (Cambridge: University Press, 1955), pp. 245, 285. Hind writes that de Passe may have visited England but thinks the evidence is not definitive.

29. Paulson, *Hogarth: His Art, Life, and Times*, I, 60.

30. A. Pigler, *Barockthemen* (Budapest: Akadémiai Kiadó, 1974), II, 519.

31. Paulson, *Hogarth: His Art, Life, and Times*, I, 177–180.

32. Evidence of the popularity of Vos's prints in England is to be found in the tapestry showing "Spring" from William Sheldon's school of weaving at Barcheston, Worchestershire; the design is copied almost literally from Vos's engraving. For reproductions, see F. Saxl and R. Wittkower, *British Art and the Mediterranean* (London: Oxford University Press, 1948), p. 40.

shared his knowledge of the theme with the satirist in his concern to certify himself professionally and please his new employer. Finally, Hogarth had a close relationship with George Lambert (1700–1765), whom George Vertue (an engraver and a chronicler of the contemporary art scene) described as a painter of landscape in imitation of John Wootton and in the manner of Poussin.[33] During the 1730s, in the period just prior to the execution of *The Four Times of the Day*, the two men collaborated on several paintings, including *Landscape with Farmworkers, Hilly Landscape with Cornfield*, and *Ruins of Leybourne Castle*.[34] This fact clearly establishes not only Hogarth's familiarity with, but his direct involvement in, landscape art of a traditional and idealized form.

We can see in the wording and emphasis of Hogarth's advertisement in the *London Daily Post and General Advertiser*, however, that he intended to point out to his audience that *The Four Times of the Day* is not just another version of the old theme but a comic interpretation of it. The purposes of the advertisement are not only to announce the completion of the engravings, but also to alert subscribers and prospective buyers to the work's references, and to prepare these people to appreciate the specialized ways in which the prints play upon the history of the *points du jour*.

The particular objects of Hogarth's wit are Dutch and Flemish art and the morals of his countrymen. His assaults on both are powered by the artist's special vision of the changed nature of modern life. For him, Eden no longer lives in art or in nature (that is, contemporary London). The harmony between man and nature and man's joyful coexistence with his fellows are not an observable part of Georgian England. Hogarth's own experience in a turbulent age offers images of alienation, class division, and sexual conflict adding up to a picture of prevailing corruption and approaching doom.[35] Even the nature of time itself is changed in Hogarth's urban world. It is transformed from the sun's lyrical and beneficent visits to the countryside into an economic reality, an artificial and tyrannical force dominating people's lives, as the overshadowing presence of the clocks in *Morning* and *Noon* reveals. From an ideological point of view, Hogarth shares little with Pope, who reacts to a corrupt age by creating his own triumphant alternative to it, a garden community

33. George Vertue, *Note Books III, Walpole Society 1933–1934*, 22 (Oxford: University Press, 1934), 6.

34. Paulson, *Hogarth: His Art, Life, and Times*, I, 345.

35. The best discussion of this important subject is Carole Fabricant's "The Garden as City: Swift's Landscape of Alienation," *English Literary History*, 42 (1975), 531–555, to which I am indebted.

at once edenic and civilized.[36] But Hogarth has a great deal in common with the antithetic vision of Swift, in which relationships between people are depersonalized, human values are converted into economic ones, and humanity is at odds with its contemporary environment—the turbulent, ugly, and sinful city.

In addition to its roots in his ideological perspective, Hogarth's ridicule of the Dutch and Flemish *points* grows out of a deep hostility to the achievements of Northern art; this hostility is perhaps best known in *Paul before Felix Burlesqued* (1751), which he characterized as "designed and scratched in the true Dutch taste," and which presents a sublime religious drama in realistic, vulgar—even scatological—"Dutch" terms. The first fruits of this animus, *Times of the Day* has three artistic targets, which are based upon the chief branches of the *points du jour*. The first target is allegory and myth, the second is genre-style *staffage* with its strong Arcadian flavor, and the third is landscape. To his three-pronged assault on insipid realizations of the *points du jour*, Hogarth adds a satirical account of the moral and cultural wasteland of London and its postlapsarian population. The most obvious humor in this satire grows out of the disparity between his pictures' formal referents, which are heroic and sublime-appearing, and their social contents, which are low, trivial, unsavory, and, in a number of cases, even criminal. But Hogarth's wit takes many other forms: parody, inversion, travesty, paradoxical transformation, low realism, false logic, denial of an expected métier—any technique to ridicule the prevailing inanity of the "times of the day" and lampoon the conduct of contemporary Londoners.

The first and perhaps most subtle comic element in Hogarth's progress is its satire of mythological allegory.[37] As the history of the *points du jour* reveals, Dutch prototypes commonly personify the divisions of diurnal time as classical gods and goddesses.[38] A

36. Ibid., pp. 551–552.

37. Hogarth's interest in personifications of the seasons is documented; on his famous "peregrination"—the five-day jaunt he took through Kent in 1732—he and his friends noted, in Rochester, "on the Front of a House four Figure's in Basso Relievo after the Antique Done by Some Modern hand representing the Seasons & then Came to ye. Crown Inn at Twelve" (William Hogarth, *Hogarth's Peregrination*, ed. Charles Mitchell [Oxford: University Press, 1952], p. 5).

38. The vogue of this kind of allegory extended beyond the boundaries of the Dutch *points du jour*. One of the most famous of the period was Sir James Thornhill's exuberant *Morning*, painted on the ceiling of Queen Anne's bedroom at Hampton Court Palace. An Italianate fresco personifying dawn as Aurora rising out of the ocean in a golden car and surrounded by Night and Sleep and attended by Cupids, this was the class of baroque performance that the chauvinistic Hogarth found

close look at Hogarth's *Morning, Noon, Evening,* and *Night* reveals that his sequence also includes personifications of the parts of the day. Though these personifications seem like ordinary city dwellers, they exhibit characteristics that reveal their hidden identities as modern imitations of the ancient light-givers—characteristics proving that eighteenth-century Londoners were drawn not to the virtues of the pagan gods and goddesses but to their vices.

Just as Swift's "Description of the Morning" features Betty the chambermaid as a dawn goddess, so Hogarth's *Morning,* by a similar witty metamorphosis, contains a modern sunrise in the scrawny woman making her way across the snow. Though she seems like a human being rather than a goddess, she plays a role and possesses certain qualities that identify her with Aurora. Her divine status is suggested by her religious purpose and her destination—a pagan temple. Like the woman in Crispijn de Passe's baroque *Aurora* (Fig. 25), she and not the sky is the center of light in the engraving. In the painting she is actually the source of light; where the sky is dull, her gown is a radiant yellow, and her apron is a light, mythopoetic saffron. Her regular appearance, not in the sky but in the streets of London, announces to the inhabitants of the city that it is morning. Quite earthbound, this female does not rise above the Covent Garden landscape at all, but plods along the ground on her snow shoes (thus her odd-shaped footprints), in comic contrast to Vos's and van Mander's ethereal allegories, who float in the heavens (Fig. 1) or trip lightly across the clouds (Fig. 5).

Just as Aurora's habitat is reduced from the celestial to the terrestrial in this modern *Morning,* so her beauty is transformed from the divine to the human and the frail. For the most part, Aurora fails to meet the standards of pulchritude set by de Passe's two female allegories of dawn. Her figure, stiff and middle-aged, lacks the youth and suppleness of the Dutch artist's mannerist goddess (Fig. 29). And her awkward bearing is a caricature of his poised, baroque allegory (Fig. 25)—compare the inelegant way Hogarth's lady holds her fan to her mouth with the graceful manner in which de Passe's goddess gestures with her arrow. Most of all, the sublunary Aurora's shriveled countenance and flat chest (exposed in an ineffectual show of vanity, despite the freezing weather) pro-

distasteful, even from the brush of his beloved father-in-law (Fritz Saxl and R. Wittkower, *British Art and the Mediterranean* [London: Oxford University Press, 1948], p. 50, illustrations b., 4, 5). How else are we to account for the fiercely loyal artist's qualified defense of Thornhill's work in the "Britophil Essay" (*St. James Evening Post,* 7–9 June 1737) as England's "noblest Performance (in its Way)."

claim her as Hogarth's realistic response to the artificial standards of womanly beauty proposed by mythological renditions of the *points du jour*.

Aurora's destination is the classical temple of the Tuscan order which looms over Tom King's Coffee House. In appearance, it is a pagan house of worship in the manner of the Parthenon; in reality, it is Saint Paul's Church, Covent Garden—a building executed in a style whose heathen connections Hogarth probably considered inappropriate to a Christian church and whose Palladian associations he certainly viewed with distaste. The dawn goddess is accompanied by Eosphoros, modernized from the nude *putti* in van Mander's *Aurora* (Fig. 5) into the shivering page carrying her prayer book. Instead of preceding Aurora, this morning star trails unwillingly behind her. Henry Fielding mentions Hogarth's Aurora in his *Tom Jones* (1749) in a manner that suggests he saw her as a comic, modern dawn. The novelist identifies Bridget Allworthy with her:

> I would attempt to draw her Picture; but that is done already by a more able Master, Mr. *Hogarth* himself, to whom she sat many Years ago, and hath been lately exhibited by that Gentleman in his Print of a Winter's morning, of which she was no improper Emblem, and may be seen walking (for walk she doth in the Print) to *Covent-Garden* Church, with a starved Foot-boy behind carrying her Prayer-book.[39]

Not only does Fielding specifically identify Hogarth's Aurora as a personification of morning, he uses the correct technical term to describe her, calling her an emblem.

The warm-blooded young woman in *Noon* (oil: right foreground; engraving: left foreground) is the maid Hogarth seems to refer to in his "Britophil Essay." Her expressive face, her full, exposed bosom, and her amorous inclinations identify her as a London Venus, a proletarian goddess of beauty and love. Unique among Hogarth's many lovely female servants for her striking physique, she has a natural attractiveness that outshines the artificial, unconvincing allurements of emblematic Venuses like de Passe's, who in the satirist's words have "not Beauty enough for the Character of an *English* Cook Maid."

39. Henry Fielding, *Tom Jones*, vol. I of *The Works of Henry Fielding*, ed. Martin Battestin and Fredson Bowers (Middletown, Conn.: Wesleyan University Press, 1975), p. 66. As an emblem of winter, Hogarth's figure is an interesting anticipation of Reynolds's *Lady Caroline Scott as "Winter"* (1777). The picture is reproduced by E. K. Waterhouse, *Reynolds* (London: Kegan Paul, 1941), p. 184.

In dalliance with her sunstruck companion, she represents an explicit and compellingly human interpretation of the noontime themes of passion and sexual love which de Passe's *Meridies* (Fig. 26) renders in mythological and coyly oblique terms. The entwined lovers personify "Europe" and "Africa" as well as Apollo and Venus, the male and female regents of noon. In allegorical interpretations of midday, such as de Passe's baroque Noon, the goddess of love is accompanied by her son, Cupid, the beautiful but roguish messenger whose teacher was Mercury. Hogarth's cook-maid is also accompanied by a youth who may indeed be her son, if her amorous disposition counts for much. Whatever his relation to this Venus may be, he is certainly her errand boy (though a bumbling one, for he has dropped the hot pie he is in the process of delivering).

Across the kennel or open sewer from Cupid, Venus, and Apollo stand another trio. These high-life characters, said to be French refugees, mirror the attitudes and postures of the maid and her entourage and bear the same mythological identities, but from the perspective of a different social class. Purged of all explicit sexuality, they court by contemplating each other, not by touching. The gentleman's bright red garments give him all the splendor of an Apollo in the painting; the lady's expressive fondness identifies her as Venus. But while the cook-maid, by her conduct, is a terrestrial Venus, the French lady is a celestial goddess of love. Classical art's twin Venuses reappear in a contemporary landscape. The common Venus assumes the identity of a domestic, while the divine appears as an affected Frenchwoman. In the modern world, however, the appearances of these two figures are reversed. By tradition, the heavenly Venus is naked to symbolize her purity and innocence. Here she is dressed—more properly, overdressed. Traditionally, the earthly Venus, on the other hand, is usually clad. Here she is half-naked and her nakedness is an emblem of her carnality. Perhaps the most illuminating commentary on this family of figures and its bold aesthetic purposes is Hogarth's own. In the *Apology for Painters* he writes, "No man will say there is more variety or truer characters or expressions in a print, statues, and picture than in the ever varying life. Will the greatest biggot [*sic*] to the antique compare the stony features of a painted or sculptured Venus to the blooming young girl of fifteen or the artificial cupid to lovely children?"[40]

The dominant figure in *Evening* is the spouse of the little London

40. Hogarth, *Apology for Painters*, 86.

dyer, a formidable woman with a melancholy countenance who makes for a convincingly modern Diana. Her most striking characteristics are her immense bulk and sour disposition. These attributes allude to visual clichés in personifications of evening. Diana's Brobdingnagian size offers a witty perspective (carefully differentiated from the emaciated Aurora's) on the petite physique and overrefined beauty of de Passe's allegory of dusk (Fig. 27) and its relatives, most of which ignore this deity's reputation in myth as a fertility goddess and a "mountain-mother" type. Her depression is a comic demystification of the sublime melancholy of evening figures. Diana's disposition, expressed in her strained countenance and flushed face (a deep red in the oil and in the second state of the engraving, where it was colored with a special ink), is the result of the evening's intense heat.[41] By contrast, the mood of deities like de Passe's Evening seems to be without any visible cause and a trifle affected.

The goddess of sunset acquired a halo of associations in her journey from classical antiquity to the eighteenth century, and Hogarth's Diana reflects on many of these ties in a critique that extends beyond the *points du jour* to mythological art in general. As Diana, this "suburban" wife is a wood goddess and protectress of nature, so she is the only person in the progress to appear in a grove (or what passes for one in London—Sadlers Wells), the place where Diana is customarily worshiped. The patroness of animal husbandry, she walks beside a milking cow whose fertile nature she mirrors. Patroness of childbirth, she is pregnant herself; guardian of children, she has three trying offspring. Like de Passe's Diana, this modern huntress is accompanied by her hound; shrunk from a retriever to a bedraggled mongrel, it is pregnant too. Hogarth's Diana understands the hunt in sexual terms, and, as the placement of the cow's horns indicates, she has cuckolded her husband by engaging in a number of successful pursuits. Like Hogarth's Aurora, who appears hostile to amorousness, and his Hades (in *Night*), who is an enemy to justice, she completely misunderstands the mythic ethos she patterns herself upon, for she is an unchaste moon goddess, a Diana in name only, a Venus in reality.

The Diana-like personality of *Evening*'s wife also governs her relationship to her spouse. As patroness of women, she has established her preeminence over him; his burdened condition and mes-

41. Ronald Paulson, *Hogarth's Graphic Works*, rev. ed. (New Haven: Yale University Press, 1970), I, 180.

merized expression betray his defeat and subjection. His horns suggest his staglike fate; he is Diana's victim and trophy, her Actaeon—it is she who has given him his antlers. Her fan, which retells the couple's story in mythological terms, shows Actaeon gazing in astonishment before Diana, a formidable woman armed as a hunter. The fan itself is of course an expression of the wife's affectation; but it is also the key Hogarth provides to her foolish and dissolute behavior. A work of art, it may be expected to embody the ideals this lady strives for and the character she wishes to emulate—both of which are pagan. Apparently she has given ear to legends about the moon goddess and has been misled by them into thinking that she is herself a modern Diana, a figure whose character she misinterprets. Mythological art is a dangerous force for it corrupts morals, Hogarth suggests here. Behind this couple, an affected little girl (she wears earrings and cuffs in the painting) poses as a diminutive Diana; she continues the battle of the sexes in her attack on her brother. He carries empty symbols of male supremacy in the ironically phallic cane and the gingerbread king, changed from a cookie in the painting to underline the picture's theme of male impotence.

Night contains two figures with mythological identities, the woman in the coach whose hat is tied down with a scarf and the intoxicated freemason lurching home in full ceremonial dress (center foreground, oil and engraving). The female in the overturned coach is a translation of de Passe's Proserpina (Fig. 28) from an idiom that is ancient and sublime into one that is modern and vulgar. Compare the imperturbable look and stately pose of de Passe's goddess, who is about to mount her chariot, with the frantic expression and wild gesture of Hogarth's bourgeois Proserpina, who is trying to escape from hers. Hogarth's chariot, in an ironic reflection on its broken-down condition and in its status as the triumphal car that Night drives across the sky, is called the Salisbury "Flying" coach.

The drunken freemason is a reinvention of Proserpina's husband, Hades, who personifies the fourth part of the day in such *points du jour* sequences as that of Dirck Barentsz. (1534–1592).[42] But this terrifying deity is modernized as not just another anony-

42. Barentsz.'s *Times of the Day* is reproduced in J. Richard Judson, *Dirck Barentsz.* (Amsterdam: Hertzberger, n.d.), figs. 49–52. Judson identifies the bearded satyr in *Nox* (fig. 52) as a personification of night (p. 148), but the deity's cavelike abode, with its ill-omened owls, overturned oenochoë, infernal candelabra, and gnawing black rat, makes clear that the place is the underworld and the god is Hades.

mous or typical Londoner. He is realized as an actual contemporary of Hogarth with a true-life identity mockingly tailored to his mythic ethos. He was widely recognized by people purchasing *Times of the Day* as Sir Thomas De Veil, a strict and notoriously venal justice of the peace. A paraphrase in bourgeois terms of the grim lord of the underworld, this unpitying punisher of wrongdoers is, ironically, the most criminal of all the nefarious inhabitants of Charing Cross depicted in *Night*. Drunk and disorderly, he brandishes his stick magisterially in mock execution of his office as a just and terrible judge. His sword has been confiscated by his servant to prevent him from further violations of the law—his bloody head and mouth show that he has been in one affray or more already.

The second comic strain in Hogarth's *Four Times of the Day* grows out of the series's restatement of that whole arsenal of genre motifs which often makes the *points du jour* seem like a collection of scattered impressions of daily life, especially in the compositions of Vos and Verhaecht. These motifs populate the countrysides of allegorical genres, accompany emblematic images as background figures, and proliferate as animals, shepherds, and shepherdesses in landscapes. Identical types of *staffage* appear throughout Hogarth's cityscapes to give them the same busy, reportorial aspect as Vos's additive countrysides. But in the satirist's art, they take the form of base, low-life transformations of Arcadian characters and situations that occur in certain classic originals. These metamorphosed repetitions, by their aggressive and irreverent familiarity, call into question the inherent worth of the heroic characters and conditions and flatly deny the appropriateness of their values to eighteenth-century life.

Morning pieces usually show people warming themselves by the fire, men and women working, and children rushing off to school. All these activities appear in Hogarth's *Morning* but not as they do in the tetralogies of earlier artists. The triangle of men and women gathered around the little blaze is a restatement of the familiar theme of "warming oneself by the fire." But it is a paraphrase in which the theme's characters are transposed to reflect the realities of eighteenth-century London. Instead of the industrious people warming themselves in preparation for work in van de Velde's *Aurora* (Fig. 17, left foreground), Hogarth's *Morning* features an assembly of beggars, idle footmen, sluggish hawkers resting on their baskets, and behind them, charlatans selling "cures" for social diseases, debased reinventions of the men laboring in the

background of van de Velde's composition. Instead of the woman feeding her infant before the fire in Vos's *Aurora* (Fig. 1, right foreground), Hogarth's *Morning* shows the antithesis of this maternal image in coquettishly dressed market girls and willing whores—the hardest workers in Covent Garden (of which Sir John Fielding said, "One would imagine that all the prostitutes in the kingdom had picked upon that blessed neighbourhood for a general rendezvous").[43] And instead of shepherds disagreeing politely over their share of the morning repast from Verhaecht's golden world (Fig. 9, left foreground), Hogarth's composition shows London "shepherds" engaged in a bloody altercation in Tom King's Coffee House. This detail does not appear in the oil. Its application is so specific that it is tempting to conjecture that Hogarth added it in the engraving specifically to satirize Verhaecht's *Aurora* with its utopian emphasis, though there is no evidence to prove this connection.

Across from the footmen who make their purchased love in public (an activity customarily reserved for privacy and for nightfall), two little schoolchildren gaze at a lady with an immense basket on her head. These are quoted, not from Shakespeare's schoolboys who creep along like snails or from Swift's who lag with satchels in their hands, but from the children in Vos's *Aurora* (Fig. 1, right middle distance) who hurry to a classroom already filled with attentive pupils. Hogarth, raising Vos's banal motif to a comic level, shows these London urchins loitering on their way to a school not even in sight—which may mean they are truants. Whether truant or merely tardy, however, they are instructive emblems of London sunrise where everyone's behavior is the reverse of what it ought to be and where all customary morning activities are slowing down instead of starting up.

One saintly character does stand apart from *Morning*'s many sinners by reason both of her censorious reaction to the misconduct she sees around her and her own apparent piety. She is the lady hurrying to early prayer service at Saint Paul's, Covent Garden. More devout even than the dutiful women with whom she invites comparison in Vos's *Aurora* (Fig. 1, right foreground), she is also the only person in Hogarth's entire cycle whose intentions seem unqualifiedly religious. As we have seen, Fielding identifies Bridget Allworthy with her in *Tom Jones*; a Londoner like the painter, the novelist based Mrs. Allworthy (famed for the discrepancy

43. Quoted by Michael Kitson, "Morning: Covent Garden," *The Listener*, 73 (1965), 526.

between her virtuous professions and abandoned practices) on a well-known Covent Garden type, who would have been immediately recognizable to contemporaries. Ned Ward recognized her at the end of the seventeenth century and knew why she was hurrying to Saint Paul's. He captured her in *The London Spy* (1698–1700) in a portrait that is uncanny in its similarity to Hogarth's:

> We then took our leaves of this Cloister of kind Damsels, so turn'd up by the *Half-Moon Tavern* and proceeded towards *Covent-Garden,* where we over-took abundance of *Religious Lady-birds,* Arm'd against the assaults of *Satan* with Bible and *Common-Prayer-Book,* marching with all Good speed to *Covent-Garden-Church.* Certainly, said I, the People of this *Parish* are better *Christians* than ordinary, for I never observed, upon a *Week-Day,* since I came to *London,* such a *Sanctified Troop* of *Females* flocking to their *Devotions,* as I see at this part of the Town. These, says my Friend, are a *Pious* sort of *Creatures,* that are much given to go to *Church,* and may be seen there every Day at *Prayers,* as constantly as the *Bell* Rings; and if you were to Walk the other way, you might meet as many *Young Gentlemen* from the *Temple* and *Grays-Inn,* going to Joyn with them in their *Devotions;* we'll take a turn into the *Sanctuary* amongst the rest, and you shall see how they behave themselves: Accordingly we step'd into the Rank, amongst the *Lambs* of *Grace,* and enter'd the *Tabernacle* with the rest of the *Saints,* where we found a parcel of very Handsome Cleanly well-Drest *Christians,* as a Man would desire to Communicate with of both *Sexes;* who stood Ogling one another with as much *Zeal* and *Sincerity,* as if they Worship'd the *Creator* in the *Creature;* and Whispering to their next Neighbours, as if, according to the *Liturgy,* they were *Confessing* their *Sins* to one another; which I afterwards understood by my Friend, was only to make Assignations; and the chief of their *Prayers,* says he, are that *Providence* will favour their *Intrigues.*[44]

Noon, as the lunch hour and the zenith of the day, is frequently illustrated with diners or lovers. Men and women sit at table or picnic in the open countryside for pleasure or refreshment in the *Meridies* of Vos, van Mander, Verhaecht, and Crispijn de Passe (in both the baroque and the mannerist versions). The traditional *donnée* of dining is also honored in Hogarth's *Noon.*[45] Its mere setting, Hog Lane, conjures up with purposeful inelegance the picture's dominant concerns, supping and drinking. Two taverns and an inn advertising "Good Eating" comprise the setting of the action,

44. Ned Ward, *The London Spy* (London: The Casanova Society, 1924), p. 217.
45. Despite its religious *staffage,* even Pieter Stevens's *Meridies* deals with noontime refreshment, however indirectly. Abraham is shown inviting his angelic visitors to a bountiful meal.

though the fact that the taverns consume almost half the picture space argues a disproportionate interest in alcohol. Before these buildings, six figures are absorbed in paradoxical relations with food—paradoxical because Hogarth's treatment of dining lies somewhere between the conventionally ironic and the playfully evanescent. The couple at the window of The Good (i.e., "Silent") Woman lose their dinner because they squabble. Their derivation is unmistakable: they are transcriptions of the type of diners in the background of de Passe's *Meridies* (Fig. 26). But while de Passe's couple enjoy personal harmony and epicurean fulfillment, Hogarth's endure physical strife and gastronomic deprivation. In a London comically remote from the Silver Age when accord was universal, the choleric lady and gentleman in The Good Woman lose their food because they fight. Below them two servants lose theirs because they make love, interpreting Verhaecht's ideal of universal concord in terms of an impersonal sexual encounter.

Rather than dining, the people in *Noon* exist in a world filled with gastronomic frustration; in it the possibilities of enjoying food are everywhere thwarted. Or almost everywhere. The only satisfied diner in the picture is the little city hoyden crouched at the feet of the pastry cook. She, in parody of the folk eating their food from baskets laid out on the earth in the *Meridies* of Vos and of Verhaecht (Fig. 2, right foreground; Fig. 10, right foreground), enjoys a city picnic. She wolfs her food directly from the street, not far from the unappetizing corpse of a cat. In doing this, she uses no other utensil than her two hands, in a greed motivated by real hunger and a haste inspired by fear that her theft may be interrupted.

In all cases, the foods depicted in *Noon* are English pies and roasts. They are not the grapes, pears, apples, and other set-piece pictorial foods that Apollo carries in de Passe's *Meridies* (Fig. 30) and that give that composition a still-life aspect. In the same vein, the omnipresent wine from earlier versions of midday is here metamorphosed into beer, England's national drink (at least in Hogarth's oeuvre); its presence is emphasized by the long lines of mugs decorating the outsides of the taverns.

Two sets of lovers appear in *Noon,* one profane (opposite the tavern), the other sacred (opposite the church). The profane couple are naturally sanguine-humored in appearance; the girl has bright red lips and cheeks in the painting, and the man possesses a chocolate pigmentation. Typically hot-blooded in conduct as well, they offer a critique of the amorous delicacy of de Passe's couple (Fig. 26) from a real-life perspective. While de Passe's lovers court with

propriety, these two engage in an act of lovemaking that is violently sexual. More explicitly erotic and more public even than the acts of the lovers in *Morning,* the hungry encounter of this pair exposes one of the girl's nipples to public view in the print (both nipples are revealed in the painting, which was designed for a more sophisticated, less public audience).

Across the kennel from these trysting servants stand another amorous couple, of a more elevated social station. Like the proletarian lovers, they too are sanguine—but artificially so. In the oil two red cosmetic circles are painted on the woman's cheeks; the man's stockings are crimson, and his coat is rust colored. In other respects, this French pair differ completely from the footman and the cook-maid. They are elegant in dress and refined in manner. Faithful to the models they are familiar with in continental art, this continental couple woo each other with the refinement of the lovers in de Passe's versions of *Meridies.*

The little boy who walks ahead of them shares their exquisite sense of dress. Wearing a wig, a sword, and a richly embroidered frock, he makes his way along the street with the help of a cane, just as another youth behind him does. People with canes are common in early versions of the "parts of the day." A number of them stream out of the church in Vos's *Vespera* (Fig. 3)—the aged and the decrepit, who are in the evening of their lives. But in an English *Noon,* the figures armed with this aristocratic emblem of helplessness and frailty are, perversely, the youngest persons in the picture.

Evening scenes are often filled with ambling lovers making their way across pastoral landscapes, the ideal setting for amorousness, away from the inhibitions and conventions of city life. The sunsets of Vos, Verhaecht, and de Passe all feature men and women taking evening walks. Among these de Passe's mannerist *Hesper* (Fig. 31, cartouche) stands out for its treatment of rambling as a carefree, bourgeois-sentimental experience. It shows a chivalrous gentleman escorting a lady across a quiet countryside; their lively dog trots ahead of them and their child follows behind. Strollers are also the main concern of Hogarth's *Evening* (as they are of its sister picture, *Strolling Actresses,* though in a playfully different sense). Perhaps the most striking fact about Hogarth's evening strollers is their resemblance to de Passe's. In each case, the amblers are made up of a gentleman and his pregnant wife, preceded by their dog and followed by their male child. To these figures Hogarth has added two female children and a nurse. But if the formal similarities between the two sets of strollers are daringly close, the

differences in their moods and attitudes are extreme to the point of satire. Just as food is everywhere being lost in *Noon*, in *Evening* the stroll these London "cits" have come to the country to enjoy is being physically impeded and its lyrical purposes are being frustrated.

Everyone in *Evening* is suffering from the intense heat. It causes depression and irritability in this Bronze Age, when people are cruel in their tempers but not yet villainous. Even the dog droops, unlike its lively prototype. Shoes have come off to obstruct the progress of the walk; the aggressive little girl with the fan is angered and temporarily immobilized by the loss of her shoe, retrieved by her nurse. Her sleepy sister, who seems to have lost her right bootee irretrievably, can no longer advance on foot because the amble has caused her shoe to wear away the heel of her right sock and blister the flesh. She burdens her father (who seems hypnotized by the heat) and impedes the saunter of both her parents. The alienated husband and wife, united only in their melancholic humor, chronicle a stage in the progress of love from the joys of courtship in *Morning* and *Noon* to the sorrows of marriage, represented here in the couple's disillusioned relationship. Amusingly ill-matched, they invert the traditional family hierarchy by the wife's physical and psychological dominance over her husband.

A time of shepherding and relaxation, sunset, as Verhaecht's *Vespera* (Fig. 11) depicts it, finds people enjoying themselves at an inn over drinks while, nearby, milkmaids tend their cows. Both of these activities reappear in Hogarth's *Evening*, but without their usual lyricism. The picture's tavern goers are crowded together inside the smoky Sir Hugh Middleton and, in a realistic exploration of one of the central clichés of the pastoral tradition, the milkmaid, reduced to a pair of hands and feet around a pail, suffers from the lash of the cow's tail and no doubt from the huge animal's body heat.

Nocturnes conventionally feature sleepers and saturnalian revelers. In their night pieces, Vos, van Mander, van de Velde, and de Passe all show men and women retiring or already asleep. The most romantic treatment of sleepers in these compositions is van de Velde's (Fig. 20), whose *Nox* depicts linen workers slumbering in the fields beneath a cloud-filled, starry sky. Hogarth's *Night* features an urban, antiromantic version of van de Velde's laborers, presenting instead the unemployed and the vagrant huddled together under the barber-surgeon's window. The bed of these city slumberers is not a spacious field but a tiny, confined lean-to; it is

not in a quiet countryside but at a noisy urban roadside. These London sleepers, unlike van de Velde's idealized country folk, who stretch out in the lap of a nature benevolent, restful, and beautiful, crowd under an ugly wooden canopy that protects them from the hostile elements. Packed together into an indistinguishable mass, they mock van de Velde's individualized, rustic sleepers and burlesque even more tellingly the graceful, elegant nude slumbering in de Passe's nightscape (Fig. 32, cartouche). The presence of nudes in Hogarth's *Night*, reclining if not sleeping, is implied by its many bagnios and houses of assignation.

For the most part, the inhabitants of London are not asleep but wide awake. Some are quite obviously preparing for a saturnalia. A linkboy stimulates his torch in anticipation of a busy night's trade, a gentleman visits his barber-surgeon for a shave, and a drayman pours beer into a barrel in readiness for a street celebration. Others, like the intoxicated barber and freemason, have begun celebrating long ago. But what is the event these people are observing with ceremonies of energy and respect so characteristic of eighteenth-century London? Unlike the saturnalias in the nocturnes of Vos (Fig. 4, left foreground) and Verhaecht (Fig. 12, left foreground), which do not seem to be tied to any particular date or cause, this London saturnalia commemorates a specific historical event. The oak branches on the hats of the freemason and the youth with the wooden sword specify the date of the picture's activities as the third of September—not the twenty-ninth of May as previous commentators claim. On this date many people wore oak leaves in memory of Charles II's hiding in a hollow oak tree after his defeat at Worcester on September 3, 1651. The nocturnal saturnalia in progress honors the Stuart monarch, whose return promised to bring with it law and order but instead served only to introduce immorality and chaos, as *Times of the Day*'s panorama shows.

The custom of wearing oak leaves on the third of September is documented by Cesar de Saussure in his *Foreign View of England* (1902).[46] As a result of Saussure's information, it is now possible to assign *Night* to autumn. Previous chronological calculations placed it in spring with *Noon*, making nonsense of the quartet's seasonal arrangement. Under the new placement, the four designs follow sequentially from winter to fall, and Hogarth's satire of vapidity in the four-seasons topos (a secondary theme in the *points du jour*) is

46. The relevant passage in Saussure is quoted by Herbert M. Atherton, *Political Prints in the Age of Hogarth* (Oxford: Clarendon Press, 1974), p. 118 n. 31.

illuminated. In idealized pictures of the seasons and the parts of the day, morning is always set in spring, noon in summer, evening in fall, and night in winter to indicate a perfect synchronization between nature's different chronologies. But in the modern, disjointed London that Hogarth portrays in his suite, art's order and nature's harmony are undone. Spring is replaced by a frigid winter in *Morning*, summer by a dry, barren city spring in *Noon*, fall by a scorching hot summer in *Evening*, and icy winter by a sultry fall in *Night*.

The saturnalias in Vos's and Verhaecht's nocturnes are made up of processions of revelers accompanied by torchbearers. One such procession, directly attributable to these prototypes, appears in Hogarth's *Night*. It is composed of the merrymaking freemason and his guide. Unlike the formal processions upon which it is modeled, this modern, two-man retinue is neither orderly nor dignified. It is "led" by the freemason. He threatens the air with his stick, shouts aloud, and sways drunkenly to the left while his guide sways to the right in an attempt to keep the mason on his feet. And thus they both zigzag through the streets of London in parody of all that is decorous and orderly about public processions. To the left of this incongruous "couple" (Vos's saturnalia is composed primarily of lovers walking arm in arm), a torchbearer is reinterpreted in modern commercial terms as a linkboy.

Though morning pieces usually depict the flurry and bustle of sanguine men and women, Hogarth's shows a population governed by the phlegmatic humor and engaged in a minimum of human activity. His *Night* tells a different story. Reflecting the sense of inversion appropriate to a modern *Times of the Day* (and poking fun at ossified versions of the four temperaments), it shows a population—not of phlegmatics—but of choleric and sanguine folk. The choleric group, represented by the bellicose freemason and the two youths who literally play with fire, engage in various vengeful and warlike acts. The phlegmatic figures, including the barber-surgeon and his bleeding victim, take part in activities that have a specifically matutinal character: the customer attending his barber for a shave, the drayman delivering ale, and the linkboy getting ready for work.

The city's youth, who especially ought to be in bed asleep, are notably present and active, unlike their reluctant but equally unshepherded morning counterparts. In contrast to Aurora's recalcitrant page, the linkboy in *Night* is fully alert and eager to begin his "daily" labors. Unlike the two tardy schoolboys, an urchin with a wooden sword and a butcher's apprentice play with demonic

energy and restlessness.[47] Pretending to be soldiers, the boys engage in activities which seem playful; but the damage they cause with the firebrand they hurl will be real, even life-endangering. Londoners and so rapacious, these young people choose a coachful of defenseless women as their victims. They are modernizations of the soldiers in Verhaecht's *Nox* (Fig. 12, left background) who attack the citizenry they are appointed to defend. But they are not borrowed in an unchanged form. Hogarth attributes the vices of the adults of Verhaecht's Iron Age to the youth of his own period.

Like the children in *Night*, their elders have seldom shown such industry, however misapplied. They ready themselves for the celebration of the merry monarch's escape from his enemies. Or they remember him by attempting their own brand of escape in this Iron Age when men live by plunder. To avoid detection by their former landlords, some are hurrying their furniture across Charing Cross in a cart and horse. They have chosen the last part of the day for its hospitable darkness. But in point of fact, *Night*'s landscape is fully and ominously illuminated by a series of big and little fires, which give it an infernal character.

In this busy landscape, everything seems to move, even the equestrian statue in the background. It, like the fountain sculpture of Neptune at the center of Verhaecht's *Nox,* is a mute image from the noble past, witnessing man's final corruption in the Iron Age, just before the flood. But what is a mythological figure in Verhaecht becomes a historical one in Hogarth. The statue, with characteristic Hogarthian specificity and real-life application, is Hubert Le Sueur's (c. 1595–c.1650) famous equestrian bronze of Charles I. Hidden during the Interregnum and restored to Charing Cross in 1674, the dignified effigy seems to march forward in Hogarth's picture as if to escape from the turbulent world ushered in by Charles II.

The third and most striking comic aspect of Hogarth's cycle is its town landscape. Set in the city, his *points du jour* portrays not countrified utopias or fairy lands of generalized grandeur but actual topographies, the local habitations and the names of specific London spots. Historical squares and streets, most of them well known, popular, and disreputable, are the essence of his pictures. In these cityscapes, the urban topographies are united with their *staffage* by means of a special bond. The historical city thoroughfares are thronged with men and women who exhibit the "peculiar manners

47. I base the age of these figures on the diminutive stature and the toy sword of the smaller of the two.

& characters of the English nation," many of them not just typical Londoners but real-life inhabitants of the capital, such as the quack Doctor Rock and the venal Justice De Veil.[48] Historical figures or types, all are jammed together, dwarfed, and held in confinement by the powerful architectural forces shown in these city versions of landscape.

The replacement of unobstructed rural vistas by paved streets and tall, impersonal buildings in Hogarth's suite creates a sense of sterility and claustrophobia, impressions antithetical to those that the works of Stevens, van de Velde, and Berchem inspire. This somber urbanism is intensified by the crowding and density of the pictures' architectural arrangements, arrangements that are sometimes the product of poetically licensed reorderings of historical topographies. The architectural contents are a jumble of coffee houses, taverns, bagnios, and pretentious churches, all crowded together in what seems to be an insane competition for prominence. These four views, the first ensemble in English art to make London its subject, follow a pointed gradation from one picture to another, beginning with the vulgarly commercial landscape of *Morning* and progressing to the criminal wasteland of *Night*.

Hogarth's new kind of landscape is most vividly illustrated in *Morning*. The picture is based on a commonplace regarded as the special domain of the pastoral in art and literature; John Hughes (1677–1720) characterized this subject in *The Lay Monk* as "a Topick on which they [artists of heroic description] have drawn out all the Copiousness, and even the Luxury of their Fancies."[49] Not Hogarth's picture, however, which shows a cluttered town square enclosed by a wall of miscellaneous edifices. These tall buildings loom up around the square to give the picture a confined tone. The oppressiveness of this effect of enclosure and immuration is clear when Hogarth's *Morning* is compared with van de Velde's (Fig. 17), with its panorama of sky and earth sweeping all the way to the horizon. Hogarth's claustrophobic effect, produced by a horizon of slates and chimneys, is even clearer when his view of Covent Garden is compared with another from the same period, specifically the composition by his friend Samuel Scott, who imitated the style of the van de Velde family and whose oil is marked by an architectural clarity and a sky-filled lyricism.[50]

48. Hogarth, *Analysis of Beauty*, p. 201.

49. John Hughes in *The Lay Monk*, no. 39 (12 February 1714), 228.

50. Scott's ambitious painting, *A View of Covent Garden on a Market Day* (c. 1756), was completed with the assistance of his apprentice, Sawrey Gilpin, who probably added the carts, houses, and some of the figures. Now in the collection of the Duke

The satirist's effect results in part from his low perspective on the square. It also follows from his rearrangement of the individual buildings there. Tom King's Coffee House, situated on the south side of the square, juts out to its center. It seems to thrust itself forward as if to masquerade as the church's sacristy or even to eclipse Saint Paul's entirely.[51] The rivalry between these two buildings, one sacred and the other profane, is a commentary on Inigo Jones's decision to locate both in the same vicinity. The decision, as Hogarth shows, is manifestly lacking in architectural decorum and seems to have been guided, rather perversely, by the eighteenth-century aphorism, "The nearer the church the farther from God." Swift, in his "Legion Club," makes the same telling point as Hogarth about Sir Edward Lovett Peach's placement of the Irish Parliament House next to Saint Andrew's Church, Dublin:

> By the prudent Architect
> Plac'd against the Church direct;
> Making good my Grandames Jest,
> *Near the Church*—you know the rest.[52]

Looming over everything else in *Morning*, the massive facade of Saint Paul's stands as a ponderous, Palladian backdrop to the commerciality and the immorality of modern life. This monumental structure reaches up to the sky blackened by coal smoke, and it obscures the horizon where the sun is rising. The clock in its tympanum underscores the comic displacement of the natural by the artificial, the hallmark of modern life. This similarly shaped mechanical substitute sits where the sun is supposed to rise, blotting out the dawn to become the true herald of the day. "A London morning," as Samuel Johnson observed, "does not go with the sun."[53]

The setting of Hogarth's *Morning* is not any town center but a city "garden"—Covent Garden, London's first artificially enclosed

of Bedford, it was exhibited at the Guildhall Art Gallery, 4 May–3 June 1972 (*Samuel Scott Bicentenary: Paintings, Drawings, and Engravings* [Loxley, 1972], p. 24). Scott's picture may be seen in Christopher Hibbert's widely available *London* (New York: Morrow, 1969), p. 58. Even the cluttered engraving of Covent Garden after Thomas Rowlandson is open by comparison with Hogarth's *Morning*. Rowlandson's design also appears in Hibbert, p. 149.

51. Georg Christoph Lichtenberg, *Lichtenberg's Commentaries on Hogarth's Engravings*, ed. Innes and Gustav Herdan (Boston: Houghton Mifflin, 1960), p. 279.

52. Swift, *Poems*, III, 829.

53. Quoted by Lawrence Wright, *Clockwork Man* (New York: Horizon, 1969), p. 109.

square, constructed in 1630. This paradoxical *locus amoenus* is at once an urban garden and a man-made landscape. It is also London's largest vegetable market (from 1656 on).[54] Within it are none of the shrubs and flowers that decorate the landscapes of morning pieces from previous ages. However, in the left foreground of the picture, in precisely the location where Aurora's bloom appears in de Passe's baroque landscape (Fig. 25), there lies a collection of kitchen vegetables, carrots and turnips, mostly. This root crop—lowly, unpicturesque, and appropriate to a less artificial, more utilitarian world than de Passe's—are the sparse and insubstantial emblems of a sterile, ungenerous Hogarthian nature imported from the country into London's ironical garden.

This whole picture, showing a countrified city brought into existence by a collection of dubious commercial enterprises, is a witty reversal within a reversal. Expectations about an idealized nature flourishing in a Golden Age, which the morning topos generates because of the landscape tradition, seem at first not to be fulfilled but are. They are fulfilled in ways so partial, incongruous, and playfully contradictory, however, that they parody the notion of "Morning" as a pastoral. Swift described this *concordia discors* in "To Quilca," painting a nature that, like Hogarth's, is sterile, refractory, and destructive of all expectations of country delight:

> Here Elements have lost their Uses,
> Air ripens not, nor Earth produces:
> In vain we make poor *Sheelah* toil,
> Fire will not roast, nor Water boil.[55]

The setting of Hogarth's *Morning* is a fallen landscape in the sense that it is an example of "modern" or urban nature. But it is fallen in another sense too. The scene is Covent Garden, a square that had become a fallen neighborhood for contemporary Londoners. Originally the garden of the Earl of Bedford, it was later developed by Inigo Jones (1573–1652) upon a continental model, the Rialto in Venice. Given the elegant name "Piazza of Covent Garden" by its promoters, the square was intended as a city residence for aristocratic persons and other patrons of distinction. By 1730, however, this pretentious scheme had aborted, and the "Piazza" had become the demesne of artists, actresses, writers of "temporary [i.e., ephemeral] poems," and prostitutes.[56] It was a

54. Mary Cathcart Borer, *Covent Garden* (London: Abelard-Schuman, 1967), pp. 12–19.

55. Swift, *Poems*, III, 1035.

56. Kitson, p. 526.

favorite target of Swift, who ironically christened it "the largest Nunnery in the whole Town" because of the reputation of its ladies; he further lampooned it in *The Battle of the Books*, asking rhetorically of the Goddess Criticism, "what Blessings did she not let fall upon her Seminaries of *Gresham* and *Covent-Garden*."[57] Reduced in this way to the haunt of the impecunious and the criminal, the square appears in Hogarth's print as an emblem of the fate reserved for English imitations of sublime continental models in the field of architecture—and, by extension, in related fields like landscape and mythological art.

Hogarth's amusing rejection of pastoral settings in favor of city scenes with base overtones did not escape the notice of all his contemporaries. In his famous *Commentaries*, Georg Lichtenberg (1742–1799), whose familiarity with the movements of European art made him an ideal explicator of Hogarth's *points*, interprets *Morning* as an attack from an urban perspective upon the mechanical repetition of rusticity in a falsely sublime manner:

> Hogarth, who had a very good sense of what many a writer and artist prefers to ignore, that is, the part for which Nature had intended him, has chosen to represent this time of day, not by any of the great soul-uplifting scenes of a spring or summer morning, but a winter one, and there again, not the funereal pomp of the frost-encrusted bushes where winter sleeps until its resurrection, or the pine forest moaning under its flaky burden of snow, but—Covent Garden vegetable market in London. That is where he feels at home. What, in fact, could his particular genius have made of a May morning in the country? No doubt a few wretched nightingale catchers with their all-too-familiar courtier faces, enticing those sweet songstresses into a trap without even noticing that the sun is rising over their noble occupation; or a few belles of doubtful reputation engaged in emptying bottles of May dew over one another's heads, with gestures and grimaces which no May dew will ever wash off. What he would make of a winter landscape, the reader will be able to surmise from what he is going to see and read here about a winter morning at the vegetable market.[58]

The same playful treatment of the landscape tradition is evident in *Times of the Day*'s remaining pictures. In *Noon*, the sense of the

57. *The Writings of Jonathan Swift*, ed. Robert A. Greenberg and William Bowman Piper (New York: Norton, 1973), p. 458; Swift is speaking in the voice of the man who tends certain parish lions renowned for their ability to discriminate between women who are virgins and women who are not. Jonathan Swift, *A Tale of a Tub To which is Added The Battle of the Books and the Mechanical Operation of the Spirit*, ed. A. C. Guthkelch and D. Nichol Smith, 2d ed. (Oxford: Clarendon Press, 1958), p. 242.
 58. Lichtenberg, p. 275.

city as an artificially enclosed space—confined, incoherent, competitive—is even more oppressive than in *Morning*. Closing the vista in the background, a tavern has succeeded in obscuring all but the steeple of Saint Giles-in-the-Fields. In the boxed-in foreground, The Good Woman and The John the Baptist stand in defiant opposition to the church of the French immigrants, an antithesis going all the way back to the first *points du jour*.[59] Hogarth is indebted to Vos's *Vespera* (Fig. 3) both for the general structure of this contrast and for a number of individual details, such as the worshipers emerging from the church. The intensity of the ethical opposition and the chaotic tone of the picture are, however, Hogarth's own, created by the way the flat, expressionless buildings crowd in to reduce the foreground to a narrow passage that sandwiches together London's diverse, swarming populations—a mob at comic variance with the modeled, distant *staffage* of Dutch art.

The midday landscapes of the *points*, notably Stevens's (Fig. 14) and van de Velde's (Fig. 18), are varied by shrubs and trees. Hogarth's landscape is enlivened by none of these, but it does feature some comic urban substitutes. If Hog Lane has no trees, its buildings with their impassive brick textures serve as a replacement or a city analogue. Instead of varying the landscape, however, they only clutter it and render it monotonous. They shrink the meridian sky (which in the *points* reveals nature at its fullest) to a slice that is thinner than *Morning*'s. These expressionless buildings even preserve the immemorial hostility of trees to kites; the church roof has captured one and seems to display it as a trophy. Despite the intensely urban feeling of this brick landscape, *Noon* is not without foliage entirely. In the engraving, a patch of greenery appears on one of the tavern windows; like the little bunch of vegetables in Covent Garden, the shrubs in these three pots, complemented by the artificial flowers on the French woman's dress and hat, represent the full extent of Hog Lane's sylvan charm, the token presence of a vanished landscape.

Of the many decorative motifs in the countrysides of the *points du jour*, one of the most charming is the river so often depicted in interpretations of midday. A winding current divides the hilly landscape of Vos's *Meridies* (Fig. 2). A picturesque stream twists through van Mander's *Meridies* (Fig. 6). No such brook babbles

59. The historical identity of the church patronized by the print's French population has never been discovered. The district is certainly Soho. Hog Lane is now part of Charing Cross Road.

through Hogarth's *Noon*, but in its place is a paradoxical equivalent, a *lusus urbis* rather than a *lusus naturae*. Hogarth's composition is decorated by a modern river, the city kennel—the sewerage gutter of eighteenth-century London. This urban stream is an artificial phenomenon rather than a natural one, an eyesore (and a stinking one) rather than an adornment. It does not snake decoratively through the scene like nature's line of beauty. Instead it runs in a straight line right down the middle of the landscape. It cuts *Noon* in two quite literally, separating the immigrant French from the native English, the rich from the poor, the profane from the sacred. The contents of this city river is not the fresh water people use to support their existence; it is the filth and refuse left over from an urban style of living. This modern brook is man-made in its form *and* in its contents. It is a close sister to the stream in Swift's "City Shower":

> Sweepings from Butchers Stalls, Dung, Guts, and Blood,
> Drown'd Puppies, stinking Sprats, all drench'd in Mud,
> Dead Cats, and Turnip-Tops come tumbling down the Flood.[60]

Swift's and Hogarth's "rivers" share a number of features, most notably the corpses of the cats. This domestic animal has been stoned to death in *Noon*, apparently by a mob of London children (if it is possible to extrapolate from the satisfied expression of the boy with the cane). The only other cat in this suite of pictures, the players' tabby in *Strolling Actresses*, suffers a similar fate in the living death it endures. It is wounded daily to provide blood for each evening's dramatic performance. The fate of both cats, but especially the smiling sadism of the boy (in *Noon*) and the old lady (in *Strolling Actresses*), are critiques of the golden world that Berchem features in his landscapes, and particularly in his *Meridies* (Fig. 22), where people and animals live peacefully and piously together in primitive simplicity.

Landscape painting is fundamentally an expression of the wish to exchange the confusion and turmoil of the city for the peace, the innocence, and the tranquillity of the countryside.[61] At first glance, Hogarth's *Evening* seems a perfect embodiment of this impulse, comparable in many ways to the *Vesper* of van de Velde (Fig. 19) and of Berchem (Fig. 23), with their wistfulness and Vergilian quiet. In the midst of a narrative of turmoil and vexation, this

60. Swift, *Poems*, I, 139.
61. Kenneth Clark, *Landscape into Art* (1949; rpt. New York: Harper & Row, 1976), p. 10.

"pastoral oasis" shows the entertainments of a city dyer and his family at "Half-rural Sadler's Wells."[62] In fact, this "London pastoral," as Trusler called it, is designed to prove that the untroubled enjoyment of open-air life is no longer possible, in part because the city's worldy population and institutions have invaded the country, a theme to which Hogarth returns in *Strolling Actresses Dressing in a Barn*. Though the picture does employ a landscape, it does so only as a backdrop to the main action, which is set between two characteristic urban phenomena—Sadlers Wells, a house of popular entertainments, and the Sir Hugh Middleton, a smoky tavern. The oppressions of the city, especially overcrowding and hostility, are writ large in the foreground and seem immediate and real. These are compounded by the unseasonable weather; evening scenes usually have an autumnal temperateness to them. Van de Velde's *Vesper* has a crisp, sequestered climate, while Hogarth's is enveloped in the scorching heat of summer. The pleasures of the country are embodied in the distant hills. Rendered in cool, inviting greens in the painting, they appear tantalizing, remote, and unattainable. Or if the picture's rural delights are not chimerical, they are actually false. The attractive river in the foreground, which the dog gazes on so longingly, is not a natural stream like the waterway that gives such pleasure to the villagers in Verhaecht's *Vespera* (Fig. 11). It is an artificial brook called the "New River," a canal designed to serve the city people by bringing the countryside's water supply to London. As an artificial source of water, it stands in witty juxtaposition to the Sir Hugh Middleton Tavern (named after the man who projected the canal), another man-made source of less pure liquids drawing Londoners from the city into the countryside. The whole picture has the character of a mock pastoral to it, exploding falsely romantic notions of rural renewal and refreshment as mirages that shift forever and forever when we move.

Evening's apparent Arcadianism serves as a piquant contrast to the dominant tone of *Night*. Of all the pictures in the progress, this is the most intensely urban. In this town nocturne, the familiar cityscape is nefariously commercial and degraded, the perfect antithesis of the idyllic pastoral realm. The monumental, stabilizing presence of the churches—which unites the first and second pictures as chronicling the beginning and the conclusion of divine

62. William Wordsworth, *The Prelude 1799, 1805, 1850*, ed. Jonathan Wordsworth, M. H. Abrams, and Stephen Gill (New York: Norton, 1979), p. 240. In the second state of the engraving, the man's hands were inked blue to show his trade (Paulson, *Hogarth's Graphic Works*, I, 180).

service—has vanished in the third and fourth, and with it all *appearances* of higher motives. But while the churches have been replaced in *Evening* by the bourgeois Sadlers Wells and the innocuous Sir Hugh Middleton, they are supplanted by houses of prostitution in *Night*. Bagnios and taverns, one with the pointedly aristocratic name the "Earl of Cardigan," line the street. These signal the supremacy of impersonal economic and sexual motives, which gain ascendancy as the day declines and darkness encourages the city populace to give expression to its true nature, turning London into the Babylon of Revelation.

All of Hogarth's great progresses are constructed upon cause-effect movements and conclude in apocalyptic scenes; this sequence is no exception. If *Times of the Day* begins in an Edenic "garden," it ends in a mad, stygian city. To the degree that it describes a Tartarean realm, *Night's* relationship to other nocturnes in the *points du jour* is more complex than that of *Morning, Noon,* and *Evening*. *Night's* landscape offers an iconoclastic perspective on the type of *Nox* created by van de Velde and Berchem. These romantic nocturnes depict landscapes virtually empty (Fig. 20) or staffed by a few figures frozen in contemplation or sleep (Fig. 24). Hogarth's nocturne offers a realistic cityscape that is crowded and turmoil-filled. Berchem's and van de Velde's nightscapes—but especially the latter's—stand out for their picturesque panoramas of clouds illuminated by moonlight. So does Hogarth's. However, once more his cityscape shrinks the heavens to a miserly slice of sky visible between two rows of buildings. And even that slice is further obscured. A man-made cloud—that is to say, a cloud of smoke—billows up from the city, disfiguring the heavens and rendering them only partially visible. The bright crescent shining prominently in the London sky is not the lamp of the firmament which imparts such harmony to the romantic *clair de lune* landscapes of van de Velde and Berchem, where God is in his heavens and all is right with the world. It is the giddy moon governing the chaotic Londoners who are her true children.

Charing Cross, the official center of London, is marked not by the mild sense of disorder present in Covent Garden or Hog Lane, but by complete lawlessness and anarchy. Physical and moral confusion are everywhere. The overturned coach, the willfully "adult" youths, the perverse, slovenly chambermaid, the injurious barber-surgeon, the drunk and disorderly justice of the peace—all bespeak a world turned upside down, a Bedlam where everything is the opposite of what it ought to be.

But if Hogarth's *Night* satirizes the lyricism that predominates in

most nocturnes, it also embraces the jeremiad that is developed in one of them. It paraphrases Verhaecht's *Nox* (Fig. 12) to the extent that that composition is an image of man in his final stage of degeneration. It does not cannibalize Verhaecht's design, however; it sophisticates it by means of an application uniquely Hogarth's. The sense of penultimate disorder and corruption that is peculiar to Charing Cross is intensified by the numerous fires raging across the landscape. The tiny, benevolent street fire of *Morning* has here multiplied and spread beyond control. As a result, *Night* has become a blazing landscape that makes the city seem both the image of an Iron Age from pagan myth and a version of hell from Christian theology.

If London is a modern form of the underworld, it is even more obviously a contemporary Sodom and Gomorrah. Like those regions, it too is a place of proverbial corruption and wickedness, a city of drunkenness, lust, and idleness where not a single innocent person can be found, to say nothing of ten righteous men. Like those cities, it too is about to be destroyed for its depravity. The agent of this punishment is not a rain of brimstone but a purgative with more frightening powers of allusion to a London that had been burned down in 1666. It is a conflagration, the natural and inevitable consequence of the sins of its demonic children: the carelessness of the linkboy, which will result in his torching the post; the willfulness of the butcher's apprentice and his companion, which will ignite the coach; and the intoxication of the barber-surgeon, which will cause the candles to burn down his house. In the confined Charing Cross street, this impending house fire will create another blaze to meet the approaching bonfires kindled in honor of Charles II, patron and architect of England's moral climate since the Restoration.

There is a direct parallel between Swift's "devoted town" in his "Description of a City Shower" and Hogarth's London in *Night*. The first is doomed to annihilation by an impending flood of refuse from its kennels; because of its comparable physical and moral evil, the second is threatened with destruction by another biblical cleansing, a terminally destructive conflagration. As complementary portraits of London in visual and verbal media, both progressively strip off the city's protective appearances and disguises. Both expose a town unredeemably profligate, consuming all, and itself consumed by its own nature. And both show a city facing an apocalyptic annihilation, a holocaust that will purify and reclaim the earth for nature.

This account of *The Four Times of the Day* in its aesthetic context

may properly conclude with a footnote on another of the suite's contexts—a very different one—the physical setting in which the paintings were to be placed. Tradition has it that the original paintings were commissioned by the well-known impressario Jonathan Tyers to hang in a concert hall or a supper box at Vauxhall, the most famous pleasure garden in early Georgian London. Ronald Paulson describes the oils as "executed around 1736 for Jonathan Tyers as decoration for a Vauxhall pavilion."[63] Joseph Burke and Colin Caldwell repeat Paulson's assertion and interpret the cycle on the basis of the audience that would have viewed it at this popular London resort. "*Morning, Noon* and *Night* were executed by Hogarth, *Evening* by B. Baron after four paintings commissioned by Jonathan Tyers about 1736, for the decoration of Vauxhall Gardens. . . . Because the pictures were painted for the private Vauxhall Gardens, then attracting the patronage of the aristocracy, they parody well-known public scenes of middle-class and vulgar entertainment in London."[64]

The assertion that this cycle of paintings was commissioned by Tyers is contradicted by one simple fact: the four original oils were sold at auction by Hogarth on 1 March 1744/5, with *Morning* and *Night* going to Sir William Heathcote and *Noon* and *Evening* to the Duke of Ancaster.[65] In the absence of evidence of any kind linking Tyers with the original paintings, neither the cycle nor its program for purging British art and promoting morality can be directly connected with Vauxhall Gardens. In all likelihood, this piece of apocrypha is an embroidery upon John Nichols's statement that Francis Hayman made copies of *The Four Times of the Day* for Vauxhall and that *Evening* and *Night* still hung there in 1808.[66] Hogarth, who was friends with Tyers, undoubtedly gave Hayman permission quite readily to execute these copies, aware that in the Gardens the possibilities for propaganda were exceeded only by the possibilities for irony. Vauxhall's reputation was built upon the licentiousness of its patrons and the dizzying variety of its architecture, which

63. Paulson, *Hogarth's Graphic Works,* II, 178. It is worth mentioning that in *Hogarth: His Life, Art, and Times,* Paulson is more reserved: "The paintings were, according to tradition, originally made as designs for the Vauxhall supper boxes; copies hung there for years afterward" (I, 398).

64. Joseph Burke and Colin Caldwell, *Hogarth: The Complete Engravings* (New York: Abrams, 1968), commentary to pls. 177–180.

65. Paulson, *Hogarth: His Life, Art, and Times,* I, 494–496.

66. John Nichols and George Steevens, *The Genuine Works of William Hogarth* (London, 1810), II, 150.

embraced Greek, Roman, Turkish, and Gothic styles. Its Grand Walk, moreover, terminated in a gilded statue of Aurora.[67]

<center>III</center>

At the same time that he was working on the paintings of *The Four Times of the Day*, Hogarth was finishing the oil of *Strolling Actresses Dressing in a Barn* (Fig. 42). This monumental endeavor has been read in isolation as "all Hogarth's comments on society up to this point but in Fielding's particular idiom"; has been paired with *Southwark Fair* (January 1733/4) on the hypothesis that both are "statements of the metaphor of life as a stage"; and has been viewed as "a parody of a grand baroque decoration," in an interpretation that is accurate but fails to specify the nature and extent of the parody.[68] The artist issued the engravings to *Strolling Actresses* and *Times of the Day* as a single subscription, and after it had expired continued to sell them only as a set. His proposals describe the engravings as "Five large Prints from Copper-Plates" and his more fastidiously worded publication announcements refer to them exclusively and emphatically as "a Set of Prints" or "a Set, Five Prints."[69]

What is the rationale for this seemingly miscellaneous if not patently incongruous grouping? Is it no more than a matter of coincidence or merely a function of commercial packaging, as scholars have tacitly assumed? The reading of Hogarth's *Four Times of the Day* developed above seems to provide some answers. All five pictures share certain common themes. They offer a humorous account of the contradictory nature of daily life in the modern, topsy-turvy world, where such established values as chastity and historical orders as male dominance are abandoned, where appearances differ radically from realities, and where traditional identities are shed in order for new ones to be assumed. They view the mythic and the Arcadian pasts, with their symbols, conventions,

67. Warwick Wroth, *The London Pleasure Gardens of the Eighteenth Century* (London, 1896), p. 301.

68. Paulson, *Hogarth: His Life, Art, and Times,* I, 395; Paulson, *Art of Hogarth* (London: Phaidon, 1975), commentary to pl. 48; Lawrence Gowing, *Hogarth* (London: Tate Gallery, 1971), p. 38.

69. *The London Daily Post and General Advertiser* carried an announcement of Hogarth's proposals on 23 January 1737/8; the paper repeated them regularly throughout February and March. *The Country Journal or the Craftsman* carried notice of the delivery of the subscribed sets (29 April 1738) and their sale to the general public (6 May 1738, repeated 21 and 27 May 1738).

and values, as inflated, anachronistic, and false. And they argue that these pasts in the form of history painting in the grand manner have injured the country's taste and morality.

Within this broad program, *Strolling Actresses* extends and intensifies the satire of Hogarth's *Four Times of the Day*. It brings to a climax two of the principal strains of his *points,* the antipastoral and the antimythological. This picture, instead of being merely a reaction to Walpole's Licensing Act of 1737, as Austin Dobson hypothesizes, is a major codification of Hogarth's own aesthetic, ideological, and philosophical objections to the classical manner of history painting.[70] *Strolling Actresses* (reminiscent of Carl van Mander's swirling *Nox* [Fig. 8], both in its ability to turn thought into drama by mythological means and in its witty play on the evanescent distinction between appearance and reality in art), stands as an epilogue to *Morning, Noon, Evening,* and *Night*. Of cardinal importance among the engraver's oeuvre, the full set of five pictures is a manifesto of Hogarth's own artistic practice, designed for those genuine connoisseurs who, in the words of Britophil, "venture to see with their own Eyes" and such as "Let but the Comparison of Pictures with Nature be their only Guide."

This point is emphasized by two small tickets directly connected with the five pictures.[71] The first of these is *Boys Peeping at Nature* (first and second states, 1730/1; third state, 1737/8). Originally designed as the subscriber's receipt for *A Harlot's Progress,* Hogarth's first attempt to modernize the iconography of high art, it shows an independent, empirical-minded satyr examining nature's private parts, which his more conventional-minded brethren wish to deny him.[72] It was revived as the subscription ticket for the engravings of *Times of the Day* and *Strolling Actresses* because it also condemns artists who admire only pictures and exhorts them to copy nature ("Antiquam exquirite Matrem"), not other art.

The second ticket is *The Battle of the Pictures* (1744/45), the bidder's token for the auction at which the five oils under discussion were sold. This small engraving satirizes the mass production of conventional religious and mythological paintings—*Saint Andrew with His Cross, Apollo Flaying Marsayas,* the *Rape of Europa*—and the puffing of these copies of copies by brokers motivated only by

70. Austin Dobson, *William Hogarth* (London: Heinemann, 1902), p. 63.

71. These tickets are reproduced in Burke and Caldwell, figs. 130, 131, 190; Paulson, *Hogarth's Graphic Works,* II, pls. 125, 126, 175; and Sean Shesgreen, *Engravings by Hogarth* (New York: Dover, 1973), pls. 17, 50.

72. Ronald Paulson, *Emblem and Expression* (London: Thames & Hudson, 1975), p. 38.

42. William Hogarth, *Strolling Actresses Dressing in a Barn*, Second State. 42.5 × 53.9 cm. (Courtesy The Huntington Library, San Marino, California)

135

pecuniary advantage. It also spells out the opposition between Hogarth's history painting and history painting in the sublime manner, by showing an aerial struggle between the comic and the serious, the modern and the traditional genres. Together *The Battle of the Pictures, Boys Peeping at Nature, Times of the Day*, and *Strolling Actresses* offer variations on a single theme; they function as a coherent structure, a single declaration of principles about the place of imitation in the creative process.

In the skirmish depicted by *The Battle of the Pictures*, three of Hogarth's paintings have been punctured while only two old masters are gored. Among the victims is *Morning*, stabbed by a *Saint Francis*. This motif, contrasting the devotions of the saint with the apparent piety of a Covent Garden Aurora, is surely an expression of Hogarth's deepening pessimism about the reception of his work in general and *Times of the Day* in particular.[73] Certainly, it was a prophetic motif. In the auction that the ticket announced, the suite under discussion was broken up. *Morning* and *Night* went to William Heathcote for twenty and twenty-six guineas respectively, *Noon* and *Evening* to the Duke of Ancaster for thirty-seven and thirty-eight guineas. *Strolling Actresses* was bought by Francis Beckford for the paltry sum of twenty-six guineas, only to be returned by its dissatisfied owner. Sold to a Mr. Wood for the same price, it was destroyed by fire at Lyttleton on 18 December 1874.[74]

The detailed correspondences of subject and theme between *Strolling Actresses* and *The Four Times of the Day* and the particularly close ties between *Strolling Actresses* and *Evening* unlock the subtle relations among these works of art. Like *Evening, Strolling Actresses* is set outside the city and chronicles a town-country conflict. Like *Evening, Strolling Actresses* takes place in the late afternoon and concerns itself with "strollers." Both pictures center around imposing Dianas who differ radically in appearance but little in character. *Evening* is dominated by women, the tyrannical little girl and her formidable mother; *Strolling Actresses* improves upon this domination by showing a world that excludes men almost entirely: the only certifiable male in the barn is the distorted, base image of man represented by the little ape who urinates into a helmet. There is one other male in the picture, the Actaeon figure peeking in at Diana from the roof; he appears as a mythological personage on the fan of *Evening*'s Diana. Whereas real people in *Evening* are metamorphosed into mythological folk in *Strolling Actresses*, by yet

73. Paulson, *Hogarth: His Life, Art, and Times*, I, 492.
74. Paulson, *Hogarth's Graphic Works*, I, 182, 190.

another witty Hogarthian reversal, the mythological Actaeon in *Evening* is metamorphosed into a real man in *Strolling Actresses*.

The fundamental contrast between *Strolling Actresses* and *Times of the Day* lies in the paradox that the latter is enacted out-of-doors in the city (*Evening* excepted), while the former takes place within doors in the country. Set in a barn, *Strolling Actresses* chronicles London's invasion of provincial England by a band of town actresses. Expelled by law from the none-too-innocent city because of their superior corruption, these denizens of the London theater have come to prey upon the provinces. It may be overingenious to speculate that they have come from Covent Garden Theatre, in the neighborhood where *Morning* is set, or *Evening*'s Sadlers Wells. But it is not too fanciful to postulate that their performance would have been well received at either theater and particularly in the Sadlers Wells playhouse where *Humphry Clinker*'s Win Jenkins saw tumbling and dancing upon ropes and wires, witches flying without broomsticks, the firing of pistols in the air, the blowing of trumpets, and the rolling of wheelbarrows upon a wire no thicker than a sewing thread, and where the amazed serving girl declared that everyone was in league with the devil.[75]

The actresses' country home is a building used for storing harvests. In the elevated language of contemporary estate architects and gardeners such as Hogarth's foe William Kent, it is a country house under the aspect of a Temple of Ceres or Flora, the goddess who shares the limelight with Diana in the center of the picture; the barn's consecrated status is underlined by its population of "gods" and goddesses and by its sacrificial altar (placed next to Diana). With its high ceiling, open, "monumental" interior, and neglect of function from a human perspective, this barn (a term used satirically in the eighteenth century for Palladian structures) mocks the architectural taste of those connoisseurs devoted to the revival of Andrea Palladio's (1518–1580) style. Promoted by Richard Boyle, third Earl of Burlington, this cult had by the 1730s dotted the English countryside with neoclassical villas and edifices. Some of these served only decorative ends (such as Henry Flitcroft's Temple of Flora [Ceres] at Stourhead constructed in the 1740s); others were only a little more functional than the actresses' barn with its windy atmosphere and its open spaces that make privacy impossible.[76]

75. Tobias Smollett, *The Expedition of Humphry Clinker*, ed. Lewis Knapp (London: Oxford University Press, 1966), p. 108.

76. Kenneth Woodbridge, *Landscape and Antiquity: Aspects of English Culture at Stourhead 1718 to 1838* (Oxford: Clarendon Press, 1970), pp. 27–29.

In relation to *Times of the Day*, the interior view of the actresses' temple stands in witty counterpoint to Saint Paul's, Covent Garden, Inigo Jones's Palladian "temple" in the Tuscan order, featured from an exterior perspective in *Morning*. Hogarth's distaste for Palladianism is well-known. He condemned this cult in his *Analysis of Beauty* (among other places), where it seems likely he had Jones (known as "the English Palladio") and his Saint Paul's specifically in mind: "nor can I help thinking but that *churches* [italics mine], palaces, hospitals, prisons, common houses and summer houses, might be built more in distinct characters than they are, by contriving orders suitable to each; whereas were a modern architect to build a palace in Lapland, or the West-Indies, Paladio must be his guide, nor would he dare to stir a step without his book."[77] The airy, monumental style of the actresses' barn recalls in a general way the idiom of Saint Paul's, which Jones himself described as "the handsomest barn in England."[78] The barn's distinctive Palladian ceiling, with its emphatic tympanum, specifically evokes the roof of Saint Paul's, of which Horace Walpole wrote: "The barn roof over the portico of the church strikes my eyes with as little idea of dignity or beauty as it could do if it covered nothing but a barn."[79]

Certain objects in the players' repertoire of theatrical devices complete Hogarth's satire of the Palladian country house and its traditions. An antique altar holds a prominent position in the center of the design; leaning against it is a bas relief version of the head of Medusa, comically horror-struck at what she witnesses around her. One of the functions of the country house was to serve as a repository of Roman antiquities. The owner of the Palladian mansion often saw it as his responsibility to preserve the classical past. Paulson's account of this ethos is the most succinct:

> The house is made for his needs, for a person who, collecting Roman antiquities, urges Roman virtue *and* wants to see himself as part of a continuum with the Roman Empire or Republic. . . . the patron sets out his programme, 'Patron as Roman Senator', which is signified in a house, garden, and total landscape reaching to the horizon.[80]

Mocking this elevated set of values, Hogarth shows the outcast female players asserting the same program as the connoisseur. They declare themselves to be the entire Roman Senate, as their

77. Hogarth, *Analysis of Beauty*, p. 62.
78. Borer, p. 89.
79. Ibid., p. 91.
80. Paulson, *Emblem and Expression*, p. 34.

"SPQR" ("Senatus Populusque Romanus") banner proclaims. And they collect objects of classical art. But their altar and Medusa are no more real than their senatorial pretentions. Both "antiques" are copies of copies.

Along with other eighteenth-century archeological zealots, Burlingtonians and their fellow travelers were eager for the revival of Roman and Greek antiquities, but Hogarth charged them with spending their money on old busts and statues—many of them impostures—while they neglected the art of contemporary Englishmen. He characterized them wittily as people who "talk of the antiques in a kind of cant, in half or whole Italian, to the great surprise of standers by, and bring over wonderful copies of bad originals adored for their names only."[81]

On the left side of the barn, a portico wreathed with flowers stands against a wall; next to it is a classical urn of the kind used as flowerpots in gardens. On the right side of the barn two theater wings picturing a forest rest behind the actresses' unseemly laundry. These two sets of objects placed at opposite ends of the engraving satirize the two competing kinds of gardens that traditionally complemented the eighteenth-century country house. The portico and vase evoke the formal or French garden, and the forest evokes the natural or English garden then increasing in popularity. In this witty attack, both gardens are jumbled together (indeed they did appear together in some ostentatious estates, including Castle Howard and Stowe) and are crowded inside the great house rather than outside, where they were supposed to complete the connoisseur's cultural ensemble by extending his elegant dominion as far as the eye could see.[82]

As a consequence of the players' invasion of the barn, its usual contents and inhabitants have been displaced. The harvest that might be expected to fill it has shrunk to a tiny bundle of hay stored in a remote corner of the loft. This ironic displacement by which nature is reduced to a symbolic presence echoes the similar incongruity in *Morning*, where the country is represented only nomi-

81. Hogarth, *Apology for Painters*, 103–104. Some years after *Strolling Actresses*, Hogarth devoted an entire print to these zealots, attacking their scholarship in *The Five Orders of Periwigs* (1761), which carried the following satirical advertisement: "*In about* Seventeen Years *will be compleated, in Six Volumns, folio, price* Fifteen Guineas, *the exact measurements of the* Perriwigs *of the* ancients; *taken from the Statues, Bustos & Baso-Relievos, of* Athens, Palmira, Balbec, *and* Rome, *by* Modesto Perriwigmeter *from* Lagado." This print is reproduced by Burke and Caldwell, pl. 251; Paulson, *Hogarth's Graphic Works*, I, pl. 230.

82. Paulson, *Emblem and Expression*, p. 20.

nally by a few common vegetables piled in a corner of Covent Garden. A flail and a broom, superfluous to both the professions and the dispositions of the barn's new inhabitants, are stored beyond reach. An arsenal of occupational and personal paraphernalia takes their place: bugle, miter, crown, drum, lyre, helmet, scepter, and chamber pot. Most of the animals indigenous to Flora's temple have vanished, to be replaced by exotic species, such as the monkey, and by fabulous or artificial species, such as the painted dragon, the sculptured rams, and the stuffed eagle perching on a Roman standard at the opposite end of the room to the roosting chickens. The animals are joined by a collection of beings part human and part beast: the Siren, half fish and half woman; Ganymede's messenger, half bird and half "man." Recalling the more or less imaginary menagerie in van Mander's *Nox* (Fig. 8), these enigmatic creatures forcefully dramatize the confusion of identities and roles which results from an addiction to myth, a confusion that reaches its apex in the case of the infant who does not recognize its kin and imagines it is being fed by an eagle.

The barn's indigenous animals remaining in their home have not fared well. They include a forlorn hen and her two chicks, who have retreated to the upper reaches of the actresses' stage "waves," where they perch insecurely; already their eggs have been stolen by the players to be used for the evening meal, and there is every likelihood that ultimately they themselves will suffer a similar fate. The predatory nature of the relation between the city actresses and their new country environment is encapsulated in their treatment of the last of the barn's native inhabitants, the cat and its two kittens. Just as *Evening* shows the city despoiling the country of its water, so *Strolling Actresses* shows the city ladies plundering the land of its animals; they separate the cat from its young offspring and amputate its tail to obtain blood for their upcoming performance. In their surgery, they are careful to remove only the end of the appendage and so leave some for subsequent "sacrifices."

These "comedians," as the playbill ironically calls them, have imported into the real country their false version of nature; the stage scenery scattered about the barn replaces the hay, corn, and other fruits of the earth usually found here. That the guardians of the Arcadian are city charlatans is Hogarth's mordant commentary on the paradox that the pastoral in all its manifestations from landscapes to landscape gardens is characteristically the concern of urban dwellers. In the loft hangs the sky composed of two painted rain clouds, one of them an improbable drying rack for Apollo's socks. From behind the other, Night's two dragons spring, pulling

the goddess's immense triumphal chariot. Next to these clouds, a tiny portion of the real sky peaks in competitively through a small hole in the roof. The ocean is balanced vertically against the wall in the form of two rollers representing the waves of the sea. Beside them stands tamed nature (the garlanded portico and the vase) balanced at the opposite side of the picture by wild nature (the two flats of a painted forest). The picture's actual but invisible country setting and bucolic but artificial stage scenery create a comic juxtaposition between the appearance of nature within the barn and its unseen reality without. Just as in *Morning,* the special Arcadian expectations generated by the picture's subject and title ("*in a Barn*") seem at first to be denied by the paradoxes of modern life. But closer examination reveals that such expectations are not entirely frustrated; nature is present in *Strolling Actresses,* though it appears in an artificial form hardly likely to satisfy its devotees or please the connoisseurs of pastoral art who have been tutored by the landscapes of van de Velde, Berchem, and their followers—continental and English.

The existence of targets of an artistic kind in *Strolling Actresses* is indicated by its subscription ticket, *Boys Peeping at Nature,* and further specified by the display of painters' tools of trade within the picture: the palate, brushes, pencils, mortar, and pestle standing before the stage flats of the forest. The bits and pieces of stage scenery lying about the barn constitute the elements of not one but any number of different dramatic backgrounds. Properly combined and varied, these versatile ingredients may be used by the actresses to create any imaginable setting, from a lyrical seascape to a Vergilian grove. The recipelike procedures that these "artists" use to conjure up their plays' scenery are comically analogous to the techniques employed by painters—especially the more mechanical landscapists of the seventeenth and early eighteenth centuries who are the targets of Hogarth's satire. Just as these charlatans arrange and rearrange their forest flats, ocean, gardens, and sky to create different settings, so artists like Berchem, van de Velde, their imitators, and their uninspired successors assemble discrete images of trees, farmhouses, rivers, lakes, and oceans to create their landscapes (see Chapter 2). The theatrical settings of the actresses and the landscapes of Dutch artists are synthetic products; both are made up of discrete, interchangeable elements assembled in conformity with a formula that, in its crudest form, allots each design a certain quota of shepherds, rocks, trees, lakes, and so on. In both cases, the formula may be modified to reproduce the variations required by generic differences. If a mythological flavor is called for

in the theatrical setting or the visual composition (as it was in the landscapes of Vos, Verhaecht, and de Passe, for example), it could easily be supplied by adding to the celestial realm the requisite number of gods and goddesses, complete with their triumphal chariots. But whatever the variation, the result is always the same: a setting that is an idealized or imaginary landscape—in short a landscape whose idyllic and fantasy character stands in contrast to Hogarth's own historical topographies of such urban places as Covent Garden, Hog Lane, Sadlers Wells, and Charing Cross. Little wonder that what seems to be a mortar for mixing paint in *Strolling Actresses* is actually a chamber pot (identical to the one juxtaposed with the crown); as its use against the hypocritical Justice De Veil in *Night* shows, this vessel is among the most contempt-filled of the satirist's weapons. For all the apparent hyperbole in Hogarth's allegorical assault on contemporary artists, the attack derives special piquancy from its daring closeness to fact; several of eighteeenth-century England's well-known landscapists were also employed by theaters like Covent Garden to be scene painters.[83]

As the Scottish poet and man of letters Allan Cunningham (1784–1842) recognized in his *Lives of the Most Eminent British Painters, Sculptors, and Architects, Strolling Actresses* is above all "calculated to ridicule the ornamental painters of those days, who filled parlours and halls with mobs of the heathen divinities."[84] Before reflecting on the identity of Hogarth's divinities and their role in the full suite, we must ascertain more particularly the targets of the work. Is *Strolling Actresses* a general satire on mythological pieces in the grand manner? Or is its target more specific? On the broadest level, Hogarth's composition (with its crowded assembly of deities all armed with their bogus attributes and emblems) is a satire on the mythological machinery to which baroque art is so addicted. On a more specific level, the work burlesques an elaborate, multifigural genre that uses mythic contrivances for purposes of personal glorification. This genre, commonly referred to as the "earthly apotheosis," was traditionally realized as a decoration in the grand manner that showed aristocratic and royal personages in a mythological context. In European art, the depiction of the nobility as gods and goddesses goes back to the period when Alexander the

83. To mention but two prominent examples, John Inigo Richards (c. 1732–1810) and George Lambert (1700–1765) painted landscapes and were employed as scene painters by Covent Garden Theatre (Herrmann, pp. 66–70).

84. Allan Cunningham, *The Lives of the Most Eminent British Painters, Sculptors, and Architects*, I (London, 1829), 117.

Great was cast as Hercules.[85] This class of mythological portraiture was continued without interruption throughout the history of Western art. It was notably popular in the Renaissance, when a change of emphasis took place in the genre. During this and subsequent periods, it was the virtues of the gods and not their superhuman powers which aristocratic people were imagined to possess.

The earthly apotheosis was cultivated in France more widely and enthusiastically than in any other country in Europe. It reached the zenith of its popularity during the reigns of Louis XIII and Louis XIV. In French art, the genre is best exemplified in Jean Nocret's (1615–1672) allegorical *Family of Louis XIV*, showing the royal household, in the guise of pagan divinities, lolling in a Vergilian landscape: the king as Apollo, the queen in the role of Juno, their son the dauphin as Cupid, the king's brother as Lucifer the morning star, the queen mother as Diana or evening, and so on.

From France, the popularity of the earthly apotheosis quickly spread to England. The best-known example of the genre in British art is Gerrit van Honthorst's (1590–1656) *Apollo and Diana* commissioned by Charles I. The painting shows Charles I as Apollo seated on a cloud with Queen Henrietta Maria disguised as Diana. Lucy Percy, Countess of Carlisle, looks over the queen's shoulder while the Duke of Buckingham as Mercury stands below them. Next to him various other courtiers appear as the Seven Liberal Arts, and their children play about the composition as so many cupids and angels.

Apollo and Diana was famous in England as the first large palace decoration to be executed by a Dutch artist, a prelude to Charles I's patronage of other Dutch craftsmen. It was infamous among native English artists for the lavish rewards it brought to Honthorst. For less than nine months' work, the Dutchman received an initial sum of 3,000 guilders, another payment of £500, a lifetime pension of £100, a costly horse, a silver service for twelve, including dishes, plates, and saltcellars, plus fine lace and other accessories—and English citizenship, which he never accepted. The painting was hung in the Banqueting House in Whitehall; in the late 1630s it was stored in Whitehall. In 1735, when the conception of *The Four Times of the Day* and *Strolling Actresses* was taking shape in Hogarth's mind, *Apollo and Diana* brought the genre of the earthly apotheosis to public attention when, George Vertue records, the picture was

85. J. Richard Judson, *Gerrit van Honthorst* (The Hague: Nijhoff, 1959), pp. 112–117, 181–183. I am indebted to Judson's account in what follows.

hung in Hampton Court for all to see. It was rescued from obscurity by none other than Hogarth's archrival, William Kent, to form part of his decorative scheme for the queen's staircase.

Hogarth's *Strolling Actresses* is not a direct attack on Honthorst's *Apollo and Diana*. A swift and pointed assault upon the tastes of the court—tastes expressed publicly and still fresh in the minds of Englishmen in 1738—would have been unthinkable during this crucial period in the artist's professional life. At this time Hogarth was practicing as a portrait painter and actively seeking aristocratic recognition and patronage for his own version of the grand style in such essays as *The Pool of Bethesda* (1736) and *The Good Samaritan* (1737). Furthermore, the resuscitated mythology required no point-by-point critique. Even its apologists remain dismayed by its monotony, its lack of grace, its gaucherie, and its cumbrous, angular sense of narrative.[86]

The satire of *Strolling Actresses* is generic then; it attacks a class of compositions and only obliquely its individual members. Its burlesque follows the pattern of *Times of the Day*'s assault on the *points du jour*; the sublime matter and elevated tone of the latter are transposed into the low subject and vulgar mood of the former. The distinguished, orderly assembly of the earthly apotheosis is metamorphosed into the chaotic, motley collection of players in *Strolling Actresses*, where the women are variously squabbling, crying, or tippling. The elegant, carefully contrived postures of the nobility in the apotheosis are changed into a series of debased attitudes, ranging from Juno's false sublimity to Diana's erotic self-display. But the satire of *Strolling Actresses* is most piquant when it addresses directly the essential character of the apotheosis: its flattery of aristocratic men and women. Hogarth's composition and the earthly apotheosis are forms of mythological portraiture; they show men and women as mythic beings. But whereas the conventional apotheosis depicts the nobility as gods and goddesses, *Strolling Actresses* burlesques this romantic notion by featuring in place of the aristocracy a band of itinerant female players. Finally, *Strolling Actresses* and the courtly allegory attribute divine characteristics to actual men and women. In the earthly apotheosis, the nobility are flatteringly endowed with the virtues of the gods and goddesses. In *Strolling Actresses*, the itinerant players are depicted (not at all implausibly) with the vices of the heathen deities—their vanity, their pride, their hedonism, and their renowned penchant for

86. O. Millar, "Charles I, Honthorst, and Van Dyck," *Burlington Magazine*, 96 (1954), 36–39.

internecine turmoil (which has even infected the women's children).

The players' acquisition of the characteristics of the ancient deities returns us again to the role of *Strolling Actresses* in the full suite, to which it is a key and an epilogue in the apocalyptic Hogarthian mode. The Londoners in *Morning, Noon, Evening,* and *Night,* like the actresses, strive to assume the traits of the divinities of antiquity. But though the city dwellers' vices are easy to spot, the sources of these faults are not, for these urbane people carefully conceal their imitation of pagan models. In *Strolling Actresses,* however, the players' models stand revealed; the women not only mimic the conduct of the heathen divinities, they wear their costumes and sport their emblems. They have "become" the gods and goddesses who are their models. The sources of modern degeneracy—literally the worship of false gods—are implied in *Times of the Day,* but in *Strolling Actresses* they are explicitly stated. Appearances that have been preserved in the city (where Aurora's and the French Venus' fan remained closed) are dropped in the country (where Diana's fan, revealing her mythic persona, is open), and the realities beneath them lie revealed.

The relation between *Strolling Actresses* and *The Four Times of the Day* does not stop here, however. Within *Strolling Actresses* the players form two contradictory religious systems, each representing a different cosmology. Christianity's delegates (assembled by a pagan altar) are the two little devils and the nun (whose surgical operation is a witty reference to her sanguine disposition). The Laocoön-like twosome struggling with the cat and the children next to them battling over a tankard of beer are the most violent of the whole troupe. The adult contingent sacrifice a purloined animal to the gods specified in the playbill. The choleric children struggle over an altar containing bread and wine—probably an irreverent reference to their Catholicism. Within the larger assembly, this religious minority is of an inferior status; chosen from the old and the young and represented in comparative darkness, it symbolizes the Christian underworld, hell being the only part of this out-of-vogue religion with sufficient appeal to compete in a world of debased standards.

The assembly of heavenly divinities who have eclipsed the hellish representatives of Christianity have many different roles in this impacted satire. When the occasion demands, they are the pretentious Palladians of Rome, the "Senatus Populusque Romanus" as their standard proclaims. In their present roles, they constitute an elaborate cosmological scheme matching the earthly

cosmology of the stage scenery in the background. One set of figures is connected with the four elements. The other set represents the four times of the day. *Strolling Actresses* is thus linked explicitly with *Morning, Noon, Evening,* and *Night:* it is the key that unlocks the hidden identities of the principals in *Times of the Day.*

The first of the four elements is identified with Ganymede and his eagle (left foreground), who are denizens of air. In this heaven the role of the gods' cupbearer is reversed; "he" receives rather than dispenses the degenerate nectar of the players—gin. The golden grapevine given to recompense his loss appears not in this celestial realm but upon the earth; it decorates the Sir Hugh Middleton in *Strolling Actresses*'s sister picture, *Evening.* The Siren standing next to the waves makes her home in the water, though her liquid on terra firma is alcohol. Between the garden portico and forest stage flats, Flora, the ancient goddess of spring and flowering plants, represents the earth with its fruits—usually stored in this barn. Juno, goddess of the hearth, custodian of the tinderbox, and usurper of her husband's thunderbolt, is associated with the element of fire.

This treatment of the elements unlocks another satirical level in *Morning, Noon, Evening,* and *Night,* tying the five works of art closer together still. In the progress, the four parts of the day correspond in certain important respects to the four elements. With its candles, torch, bonfire, and background conflagration, *Night* is a landscape of fire—infernal fire. *Evening,* with its tavern and New River, is dominated by water, however artificial and man-made. *Noon* represents air, though it ironically features the smallest slice of sky in the progress. And *Morning,* set in a city garden, represents the earth in the same paradoxical spirit as the rest of the sequence.

The remaining mythological characters in *Strolling Actresses* stand for the four times of the day. Placed in chronological order from left to right and set in light or darkness according to their functions and ascendencies, they span the full breadth of the picture to give it a thematic unity some scholars have failed to see.[87] The day's pageant begins with a dusky Aurora, whose "rosy" fingers are stained with the blood of the lice that this sanguine lady kills on the costume of the Siren (a melancholic, like the tearful Ganymede). In the center of the picture, at its structural apex, Apollo and Diana stand back to back. Wearing a sunburst helmet,

87. According to Dobson, this engraving has no central interest to it (Dobson, p. 64).

the god of noon is accompanied by his traditional adversary in archery, Cupid. The winged youth—a more effective messenger boy than his counterpart in *Noon*—climbs a ladder at the command of a phlegmatic sun god to retrieve a pair of socks that Apollo has "dried" on a wooden cloud. The climactic figure in the scene, Diana is identified as the goddess of evening by the half-moon on her forehead. Her eclipse of Apollo and her shining preeminence grow out of the fact that the picture's activities take place in the late afternoon. Like the Diana of *Evening*, this woman is anything but virginal; her wanton nature is betrayed by her sensuous pose and immodest dishabille, the latter comically remote from the dress of the Diana of high art who was sometimes called *"bis cincta,"* or twice-girdled, to stress her chastity. She is an audaciously literal transcript of de Passe's baroque Diana (Fig. 27), down to her identical *figura serpentina* pose with its raised arm and tilted, wistful head. Like de Passe's goddess, Hogarth's is partially nude. Her body is exposed by a rumpled shirt that burlesques the elegant drapery cloth swirling artfully around de Passe's Diana.

This goddess of evening, even more than the partially nude Flora and Ganymede, makes the proper title of the engraving not "Actresses Dressing" but "Actresses Undressing." The players' revealing mode of costume is not without its purposes, however. It argues that Diana and her companions are encouraged by the tendentious subject matter of their drama to heighten their performance with a certain amount of sexual coloring, just as artists like de Passe were encouraged by the suggestiveness of mythological art to emphasize the sexual appeal of their nude gods and goddesses. By this calculated address to venereal motives, the actresses (and by analogy, their counterparts in the visual arts) are able to attract larger audiences than their unconvincing performances might otherwise win. The players' only spectator in the picture is certainly motivated by sexual curiosity and not by artistic interest; Diana's Actaeon on the barn roof is modernized as a peeping tom.

Night, placed in the right foreground of the picture, ends the mythological pageant of the four times of the day. A Negro and perhaps a personification of Africa like the black serving man in *Noon*, she wears a sable costume and an "evening veil." In her role as a seamstress, she darns a hole in Juno's stocking with dark thread, just as nightfall appears to cover with darkness the faults and errors of the Charing Cross crowd in the last part of the day.

The "gods" and goddesses of the four times of the day and their companions possess certain identifying emblems and properties. A

close examination reveals that these sublime symbols are nothing more than a collection of household objects. Aurora's morning star is a scoured tin mold for baking tarts;[88] her mantle of the heavens and Juno's (worn by sky gods such as Verhaecht's Vespera [Fig. 11]) is a rumpled scrap of linen stiffened with starch. Apollo's crown is nothing but a piece of gold paper. The wanton goddess of chastity's half-moon (identically placed and similarly shaped to the crescent on de Passe's Diana [Fig. 27]) is made of sublunary cardboard, and her flowers—forever in bloom—are produced from paper. Night's evening star is nothing more than a pastry cutter. Her chariot, transformed into a coach in *Times of the Day*, is here restored to its epic status. A huge triumphal machine drawn by two fierce dragons, it is stored under the barn roof. On the ground below, the goddess herself elevates Juno's foot on that deity's triumphal car—an overturned wheelbarrow.

Behind this witty confusion of sublime but empty symbols from the past with lowly gadgets from the present lies Hogarth's critique of mythological art. In his view, the imagery of mythopoetic painting is counterfeit and sham. It is as real as a paper moon, as sublime as a kitchen utensil, as terrifying as a cardboard dragon, as heroic as a wheelbarrow. The pagan identities of the actresses, of course, make the basic metaphorical statement: mythological art is as ridiculous as the performance of a group of strolling players. But the perniciousness of this kind of painting is not confined to the promoting of bad art and the debasing of taste. Worse still is its effect on morality and on the Christian religion. Under the sponsorship of an immoral Hanoverian court (the play is to be performed at the "George Inn"), myth has inspired the bourgeoisie and those below them to imagine that they are gods and goddesses, and has led them to ape the dispositions and the abandoned conduct of the heathen divinities—their lusts, their cruelties, their idleness, but most of all, their pride or hubris.

Perhaps the inconspicuous little monkey in the right foreground of Hogarth's *Strolling Actresses* offers the most trenchant summary of the five pictures' main themes. Dressed in a Spanish mantle, sporting a cravat, and wearing a pouch called a French hair bag behind his neck, this foppish creature masquerades as a man of fashion, just like the ape in *The South Sea Scheme* (1721), who is appareled as a gentleman and who attempts to clothe himself in

88. John Trusler identifies Night's star as "formed of a brass instrument used in making pastry" (*Hogarth Moralized* [London, 1831], p. 204). Aurora's emblem, much more in evidence, belongs to the same set.

Honor's garments.[89] That the little monkey remains an animal, or rather that he becomes a gentleman only in sartorial terms (despite his surprisingly human semblance), is clear from his indelicate conduct. A little higher up the great chain of being, the actresses (and with them the entire population of London from *Times of the Day*) attempt to assume the character of those above them, just like the monkey; indeed in the case of the actresses and their fellow Londoners, they aspire to become the highest link in the entire chain. In dress or behavior or both, they presume to become gods and goddesses, to violate the chain's principle of subordination. But if their appearances have changed, the realities of their natures remain substantially the same. Or, more accurately, their natures have been altered for the worse by their prideful and discordant aspirations. The worst evil and degeneracy shown in *The Four Times of the Day* and *Strolling Actresses* can be traced to the attempts of men and women to become gods and goddesses, and heathen ones at that. It is because of this hubris that the great chain of being is broken, established orders are reversed, time-honored hierarchies are turned upside down, and a sense of apocalypse hangs over the modern world in the *points du jour* and its epilogue.

It seems worth pausing here to reflect briefly on some of the contradictory values that operate in *Strolling Actresses,* and indeed throughout Hogarth's oeuvre, and to elucidate a paradox in his artistic career. As we have just seen, the programmatic social values of *Strolling Actresses* and *Times of the Day* are the orthodox ones of hierarchic order, fixed degree, and the great chain of being. These conservative norms are generally the ones to which the artist gives lip service in his work. Temperamentally and ideologically, however, his affinities are not with these static hierarchic values, whether social or artistic. His democratic allegiances are evident from his professional activities in support of such egalitarian institutions as Saint Martin's Lane Academy. They are equally clear in the major portion of his art, with its dependence upon popular forms, the curved line of beauty, and images of vital and attractive chaos in contrast to inert, empty forms of order. Indeed Hogarth's revolt against the ossified interpretations of subjects and forms, which were based on the work of old masters in the case of the *points du jour*, suggests his dissatisfaction with immutable aesthetic systems.

89. *The South Sea Scheme* is reproduced in Burke and Caldwell, pl. 25; Paulson, *Hogarth's Graphic Works*, I, pl. 12; Shesgreen, pl. 2.

At the heart of this paradox is the conflict in Hogarth between, on the one hand, his professional ambitions and his desire for aristocratic recognition as a history painter in the grand style, and, on the other, his democratic sympathies and deep sense of class antagonism. His intense desire for professional recognition of the most traditional kind led him to assert Christian and neoclassic values, while his egalitarian instincts and class consciousness led him to express revolutionary bourgeois norms and iconoclastic values. The two contradictory impulses coexisted and battled each other both in his career and in his art. The dominance of one and then of the other explains in part the radical, almost schizophrenic, shift in his output between such disparate kinds of productions as *The Pool of Bethesda* (1736), *Before and After* (1736), and *The Four Stages of Cruelty* (1750).[90]

The presence of these tensions in *Strolling Actresses* accounts for certain common misreadings of the work. Writing about the engraving, Ronald Paulson has claimed, "The satire is therefore not directed to the actresses themselves as people, nor to their pretensions, which are, after all, part of their job."[91] There is a great deal of appeal in Paulson's reaction, for the energy and vitality of the actresses have an engaging quality to them that is undeniable. But on the didactic level (the level he is attempting to explicate), Paulson's reading misses the mark. Hogarth's satire is directed at the actresses' fraudulent ideals and at their characters.

This point about the social targets of Hogarth's work is an important one and deserves elaboration. It bears upon the most fundamental understanding of his methods as a comic painter, in this sequence and throughout his art. And it has been seriously misunderstood, as Paulson's and Gowing's views of *Times of the Day* indicate. "These four paintings, finished and engraved in 1738, may be Hogarth's most balanced representation of his world," Paulson writes. "The pull of consequences has been replaced by the calm juxtaposition of opposites, without judgment on either party."[92] Gowing's commentary emphasizes much the same point: "Ways and conditions of life are the subject [of *Morning, Noon, Evening*, and *Night*]; for once the artist passes no judgment, unless it is an endorsement of natural pleasure in the prime of life and a distaste for restraint, excess and dogma."[93]

90. *The Pool of Bethesda* is reproduced in Paulson, *Art of Hogarth*, pls. 44, 45. *Before and After* and *The Stages of Cruelty* appear in Paulson, *Hogarth: His Life, Art, and Times*, I, pls. 87–90; and Shesgreen, pls. 37–38, 77–80.
91. Paulson, *Hogarth: His Life, Art, and Times*, I, 397.
92. Paulson, *Art of Hogarth*, commentary to pl. 52.
93. Gowing, p. 37.

In their remarks about social context, surely these two scholars overlook what is most unique about the artist's satiric technique. Hogarth adapts aesthetic tradition in a way that is many-sided. He draws upon "models" for purposes of social satire and at the same time demolishes them, removing any sense of the "alluded-to" as an ideal. Because the paintings and prints he introduces or refers to are not meant for artistic emulation in the usual sense, he subverts iconography rather than building upon it, as previous artists had done. On one level, he recreates the apparently heroic past in terms of the commonplace present so as to produce a comic collision between the two at the expense of the latter—as in *Noon* when Cupid is metamorphosed into a messenger boy and a fumbling one at that. On another level, he renders the sublime past in a realistic contemporary idiom so as to define, clarify, and scrutinize that past and its implications in moral and aesthetic terms. As a result of this aggressive scrutiny-by-transformation, certain aesthetic interpretations of this past are revealed as operatic, and certain of its themes, actions, and characters are exposed as ideologically misleading, morally false, and inappropriate to Georgian London. For example, Hogarth often shows that the iconography in mythological art is vacuous, and he reveals the ethos of antique characters as worldly, vainglorious, prideful, idle, amorous, and so on. Imitating them, the men and women in Hogarth's art are exposed as either patterning themselves upon exemplars worthy only of contempt and ridicule or aping standards incongruous with their contemporary social positions and Christian professions.

Hogarth's many-sided technique is analogous to certain satirical methods common not in the visual arts, but in literature. Among contemporaries, his method is different from John Dryden's and Alexander Pope's. But it is similar to Samuel Butler's (1613–1680) and Jonathan Swift's and may be associated with certain complex forms of literary travesty which grew out of Paul Scarron's (1610–1660) *Virgile travesti* and were very much in vogue in the seventeenth and eighteenth centuries. In *Hudibras* (which Hogarth illustrated in 1725/6 and again in 1726), Butler imitates the chivalric romance but also burlesques it, at the same time that he uses it to deride the Puritans of the Interregnum. In "Baucis and Philemon," Swift (Hogarth's model by his own proud confession) modernizes Ovid's *Metamorphoses*. But he also mocks it and its mythopoetic conventions, while employing it to chide middle-class fondness for economic advantage and social position. By contrast, Dryden does not poke fun at the Old Testament and *Paradise Lost* in *Absalom and Achitophel* any more than Pope jeers at the *Aeneid* in *The Rape of the Lock*.

There can be no doubt, then, that Hogarth means to disparage the actresses and their fellow Londoners for their hypocrisy, lewdness, adultery, drunkenness, and the many other vices they have acquired by their adherence to a false heroic vision. But what is the ultimate source of their corruptions? How have these actresses and their fellow Londoners learned about the false deities that have led them astray and where have they seen them? In addition to symbolizing the aping of wrong standards and erroneous models in personal life, the monkey stands for another kind of imitation, artistic aping—that is, sculpture and painting.[94] The artist's craft was traditionally regarded as imitative and became identified with the animal known for its mimetic powers. The idea expressed by the dictum *ars simia naturae* was especially popular among Flemish painters of the seventeenth century.[95] The most celebrated expression of this metaphor is David Teniers the Younger's (1610–1690) pair of paintings in the Prado, the first showing a monkey painter surrounded by pictures in many different styles and subjects, the second depicting a monkey sculptor at work on a collection of classical subjects. Among contemporary works featuring the monkey as a personification of art, two deserve mention. Both were certainly known to Hogarth and in addition to illustrating the links between visual and literary forms of art in the eighteenth century, they illuminate Hogarth's view of artistic aping. Jacob Huysmans's (1633–1696) famous portrait of Lord Rochester shows Wilmot crowning with laurels an ape that is both a debased man and artist.[96] William Kent's *Congreve Monument* (1736) at Stowe— almost exactly contemporaneous with *Times of the Day* and *Strolling Actresses*—consists of a pyramid with a blunted point, atop which sits a monkey gazing at himself in a mirror. The *Monument*'s motto reads: "Vitae imitatio, / Consuetudinis speculum, / Comoedia": "Comedy is the imitation of life and the reflection of manners."[97]

Hogarth's own monkey in the "Tail-piece" to the catalogue of pictures exhibited in Spring Garden in 1761 belongs to this family of emblems. Dressed as a coxcomb and half-blind, the little animal waters the tree stumps of painting, sculpture, and architecture, all

94. The classic account of this subject is Horst Janson, *Apes and Ape Lore in the Middle Ages and the Renaissance* (London: Warburg Institute, 1952).

95. James Hall, *Dictionary of Subjects and Symbols in Art* (New York: Harper & Row, 1974), p.22.

96. A reproduction of Huysmans's painting appears in *The Letters of John Wilmot Earl of Rochester*, ed. Jeremy Treglown (Oxford: Basil Blackwell, 1980), pl. 2.

97. Kent's *Monument* is reproduced in Paulson's *Emblem and Expression*, frontispiece.

of which are long dead.[98] In *Strolling Actresses,* Hogarth's other monkey stands in judgment on history painting in the monumental style. Devoted exclusively to the imitation of other works of art, history painting has ignored nature. In its infatuation with the "sublimity" of previous art, it has become self-referential rather than life-referential, and practices what Joseph Warton termed "that disgusting impropriety of introducing what may be called a set of hereditary images without proper regard to the age or climate or occasion in which they were formerly used."[99] In doing so, it has abandoned its serious mission to teach and instruct. Worst of all, it has purveyed seductive and corrupt doctrines, propagated erroneous beliefs and misleading foreign standards—in a word, embraced false gods. With other creative enterprises, specifically drama and music (whose emblems fill the foreground of *Strolling Actresses*), art has abused its sacred office; by improper applications of its redemptive power and influence, it is the root of the corruption evident in the characters of the players and the London populace.

In English prints of the eighteenth century, the French are commonly pictured as persons of pretentious clothing; the fashionable bag-wig in particular is the mark of a Frenchman.[100] With equal frequency, the French appear as apes or monkeys in popular prints of this period.[101] In *Strolling Actresses,* Hogarth's ape bears all the characteristics of eighteenth-century Britain's stereotypical Frenchman. This dandified monkey, the most subtle expression of the engraver's well-known Francophobia, points to yet another geographic source of England's artistic and social problems and completes the satire on the French begun in *Noon.* England's loss of ethical and aesthetic touchstones, Hogarth implies, is also the consequence of its imitation of things French: its sartorial fashions, its social affectation, and its dead artistic genres, including that Gallic genre specifically connected to *Strolling Actresses*—the earthly apotheosis with its artificial style and servile purposes. Toward the end of his life Hogarth verbalized this same criticism of French art

98. This tailpiece is reproduced in Paulson, *Hogarth: His Life, Art, and Times,* II, pl. 289.

99. Joseph Warton, "An Essay on the Genius and Writings of Pope," *Eighteenth-Century Critical Essays* (Ithaca: Cornell University Press, 1961), II, 730. Hogarth makes much the same point when he writes, "The Italian students avail themselves of antiquity as a coward do of putting on the armour of an heroe" (*Apology for Painters,* 107).

100. Atherton, pp. 85–86.

101. Ibid., pp. 86–87.

in his *Apology for Painters*, making use of the word "aping" to characterize the French utilization of the past. In the course of his discussion, he illuminates a facet of the question not addressed in *Strolling Actresses*—its economic side: "France next aping the glory and magnificence of the ancients, they have attained a foppish kind of splendour sufficient to dazzle the eyes of us Islanders and draw vast sums of money from this country."[102]

What can be the fate of a tribe whose tastes and morals, like those of the London populace, are so vitiated that there can be no hope for its salvation? The stern, didactic answer of an art true to its time-honored obligations to instruct as well as please and to imitate nature rather than other pictures is repeated from *The Four Times of the Day* in a minute but pregnant detail within *Strolling Actresses*. At the next histrionic jolt that Juno gives her trunk, Jupiter's precariously balanced thunderbolt will strike down the posturing monkey.[103] A parallel retribution awaits the actresses, the poetic consequences of a firebolt of their own manufacture. Unnoticed by the vain, self-involved players, a candle near Flora has ignited a straw hamper. The fate engulfing London and its population in *Night* already has begun to envelop the equally careless players and their barn world. An infernal conflagration must soon transform this imaginary heaven into an all-consuming hell and bring to the country the same biblical cleansing that is already annihilating the city. The strolling players' announcement describes their evening's performance as "Being the last time of Acting Before ye Act Commences." Their coyness to the contrary, little do they suspect that the performance they are now giving is indeed their final one. Still less do they imagine that the "Act" to end their comedy has already commenced and is not the parliamentary "Act against Strolling Players," but a deed of their own—the consequences of their adoration of so many false deities. In a final irony among so many, the words of the actresses' playbill are their own epitaph.

102. Hogarth, *Apology for Painters*, 91.
103. Lichtenberg, p. 158.

{ 4 }

Epilogue

CHRONOLOGICALLY *The Four Times of the Day* and *Strolling Actresses* constitute the third of Hogarth's major narrative suites for which he executed paintings and prints, preceded by the *Harlot's Progress* (1732) and the *Rake's Progress* (1735) and followed by *Marriage à la Mode* (1743–1745) and the *Election Series* (1750–1758). The *Times of the Day* ensemble climaxes Hogarth's first great burst of creativity in the short, productive period from 1730 to 1738, when he carefully refined his ideology and honed his expressive powers. Concerned about the lack of critical appreciation of his first two progresses and the withdrawal of aristocratic patrons in the 1730s, Hogarth created this suite to serve as the manifesto of the theory and practice of his new program for British art.[1] He shaped it to vindicate his revolutionary new art form, as Fielding was to justify his comic epic in prose a few years later in the preface to *Joseph Andrews*.

With the other great progresses, *Times of the Day* and *Strolling Actresses* belong to the tradition of modern history painting inaugurated by the *Harlot's Progress*. *Morning, Noon, Evening, Night,* and

1. W. B. Coley, "The Background of *Marriage à la Mode*," *Hogarth on High Life: The* Marriage à la Mode *Series from Georg Christoph Lichtenberg's* Commentaries, trans. and ed. Arthur S. Wensinger with W. B. Coley (Middletown, Conn.: Wesleyan University Press, 1970), p. xxxvii.

Strolling Actresses purvey a plain story for ordinary readers and an allegorical tale for readers of greater penetration.[2] They attempt to breathe new life into old forms of painting. In place of heroic topics, they offer to legitimize a subject matter intermediate between the sublime and the grotesque. Seeking inspiration beneath conventional appearances in the realities of everyday London, they renew history painting as a didactic force in cultural life.[3] Departing from earlier practices based upon a supposed antique classicism, they strive for an art that is comic, English, and contemporary.

Some of Hogarth's modern history paintings—the *Rake* and *Harlot*, for example—are based upon popular traditions in literature and graphic art, while others are without specific precedent.[4] *Times of the Day* and *Strolling Actresses* are based upon two of the most venerable themes in the history of art. With precedents in periods from antiquity to the eighteenth century, these topoi demonstrate, within Hogarth's oeuvre, that modern history painting is not limited to popular themes and contemporary incidents, but can embrace and renew subjects of the most time-honored kind. Attacking the humorlessness of conventional subjects, *Morning, Noon, Evening, Night*, and *Strolling Actresses* show that serious art can be comic and comic art serious without descending to minor genres.

Hogarth's other narrative series focus on character, usually on one or two protagonists. *Morning, Noon, Evening*, and *Night* concentrate secondarily on character and primarily on place and time, because of their unique powers of specification. Every scene in the suite is set in a well-known location and takes place at an identifiable time of the year and day. Every picture overflows with London types or men and women then living. Using actual places, recognizable times, historical dates, and real or typical people, Hogarth shows how it is possible to create an art that is English in a degree not previously imagined. He demonstrates how art's incorporation of the contemporary and even the topical renders it pertinent to daily life in a didactic sense without destroying its universality. When Hogarth wrote in his *Apology for Painters* that "everything requisite to compleat the consummate painter and sculptor may be

2. Ronald Paulson, *Hogarth: His Life, Art, and Times* (New Haven: Yale University Press, 1971), I, 260.

3. I am indebted throughout this discussion to Paulson's account of Hogarth's modern history painting (ibid., 259–279; 376–422).

4. Hilda Kurz, "Italian Models of Hogarth's Picture Stories," *Journal of the Warburg and Courtauld Institutes*, 15 (1952), 136–168.

had with the utmost ease without going out of London at this time," he was reacting to the tyranny of the foreign.[5] But he was also articulating an important tenet of his aesthetic system. He meant this statement to be taken literally and was arguing for an art rooted with daring particularity in English times, places, and people. Within his oeuvre, *Morning, Noon, Evening,* and *Night* are the supreme expression of an artistic chauvinism in which the universal was contained within the particular and the English.

In the final analysis, Hogarth's *Four Times of the Day* and *Strolling Actresses* are works of art about other works of art. They are thus retrospective, for they are allied with three earlier versions of the *points du jour* which address themselves to problems in the history of art: de Passe's two interpretations that illustrate different styles in sixteenth- and seventeenth-century painting and van Mander's single version that takes bold new positions about the origins and the nature of art. But Hogarth's *Times* and its epilogue are also prospective. They represent a self-conscious demonstration of how a theme threatened with fossilization may be revitalized. As a suite of copies about copying, Hogarth's compositions show that recourse to the past does not necessarily produce a rash of look-alike anthologies, because fruitful imitation is possible and moribund imagery may be resuscitated when a tradition and its conventions are properly understood and reinterpreted in terms of contemporary life. In making this point, Hogarth's suite shows that art is not nature's enemy, in the sense Malraux argues, and that only art that draws upon life *and* upon other art is fully alive and vital.

Few other painters and engravers after Hogarth shared his interest in innovative urban subjects or in renewing the parts-of-the-day theme in such a bold and iconoclastic fashion. A number participated in less radical ways in his effort to keep the *points du jour* dynamic and vigorous, so that his *Times of the Day* heralded something of a rejuvenation of the tradition. The engraver Georg Thelot (1711–1775) and the painter Johann Wolfgang Baumgartner (1712–1761) each produced intricate cartouche designs of religious subjects in a complicated baroque idiom.[6] Nicolas Lancret (1690–1743) brought *fêtes champêtres* and *fêtes galantes* versions of the theme to a sophisticated technical level with a rococo set of light, witty boudoir and park scenes.[7] François Boucher (1703–

5. William Hogarth, *Apology for Painters,* ed. Michael Kitson, *Walpole Society 1966–1968,* 41 (Glasgow: The University Press, 1968), 85.

6. A. Pigler, *Barockthemen* (Budapest: Akadémiai Kiadó, 1974), II, 520.

7. Ibid.

1770) introduced court genre into the *points du jour* by means of four elegant portraits chronicling with esprit and preciosity the rituals of the fashionable life of the beau monde.[8] And in the last year of the century, in England, Francis Wheatley (1747–1801) executed a set of fancy pictures as *The Four Times of the Day* (1799), a series he also entitled the *Rustic Hours*.[9] Now in the collection of Mr. and Mrs. Paul Mellon, these subjects are the antithesis of Hogarth's in every imaginable way. Greuze-like genre pictures, they feature sentimentalized, pseudorural subjects (mostly prettified women, children, and domestic animals) in poses that are wooden, theatrical, and implausible.

Apart from the work of these artists and a small number of others, the most celebrated realizations of the *points* in the second half of the eighteenth century belong predominantly to the realm of decorative art. Claude-Joseph Vernet (1714–1789), France's most famous landscape and marine painter of the eighteenth century, executed no fewer than four different versions of the "times of the day."[10] These include a group of oval tableaux of seascapes; a series of river and harbor paintings commissioned as overdoors for the library at the royal Chateau de Choisy; four marines interpreting nature in her different moods; and an ensemble of elegantly shaped coast scenes for the Bibliothèque du Dauphin, Versailles, which Vernet wished to deliver as a group and hang himself because, in his words, "these pictures are made to act together [*jouer leurs rolles ensemble*] and to set each other off."[11] In the nineteenth century the theme was popularized by Alphonse Mucha (1860–1939), among others, who rendered it as four idealized full-length portraits of subjects from the fashionable world of the salon.[12] Art Nouveau creations showing beautiful but sexless, childlike women in niches, these life-size posters have about them an elaborate aestheticism and a pure decorativeness reminiscent of the designs created by Crispijn de Passe to enshrine the figures who had captured the imagination of the seventeenth century.

In contrast to ornamental artists like Vernet and popular graphic

8. Ibid.

9. Mary Webster, *Francis Wheatley* (London: Routledge & Kegan Paul for the Paul Mellon Foundation for British Art, 1970), pp. 154–155.

10. *Claude-Joseph Vernet* (London: Greater London Council, 1976), nos. 25–29; 25–28; 39; 70–73.

11. Ibid., Introduction, n.p.

12. *Alphonse Mucha* (New York: St. Martin's Press, 1974), pp. 126–127, nos. 139–142.

craftsmen like Mucha, landscapists of the nineteenth and twentieth centuries were not engaged by the *points du jour*. In the romantic period, they were drawn to the more sentimental or crepuscular times of the day, such as dawn and twilight, rather than to depicting the series of four times ordained by tradition. And finally Claude Monet (1840–1926), painting haystacks at virtually every hour of the day and committed to a methodical study of light, threw out, with Impressionism, everything—or almost everything—the *points du jour* offered. Redefining time as a continuous stream and not a quartet of epiphanies handed down from one painter to another, he elaborated numerically upon the notion of sequence, expanding it from four to an indefinite count. He also retained an emphasis upon sequential unity and interrelation, claiming, for example, that his *Haystacks* acquired their meaning only through comparison with one another.[13] Avoiding even the hint of satire, he rejected the old vocabulary of conventions and topics, banishing form and substance in their usual senses. With a commonplace subject and a technique hailed as new, but actually evolved from landscapists like Jan van de Velde, Monet created powerful narratives of the hours of the day and the seasons which, in their devotion to subjectivity, *émotivité*, serenity, decorativeness, and surface appearance, affirmed the values of a bourgeois audience that was a trifle more complacent than Hogarth's.

13. John House, *Monet* (London: Phaidon, 1977), p. 11.

Index

Library of Congress Cataloging in Publication Data

Shesgreen, Sean, 1939-
 Hogarth and the times-of-the day tradition.

 Includes index.
 1. Hogarth, William, 1697-1764. 2. Days in art.
I. Title.
N6797.H6S5 1982 760'.092'4 82-71597
ISBN 0-8014-1504-7